B E A U T Y S H O T S

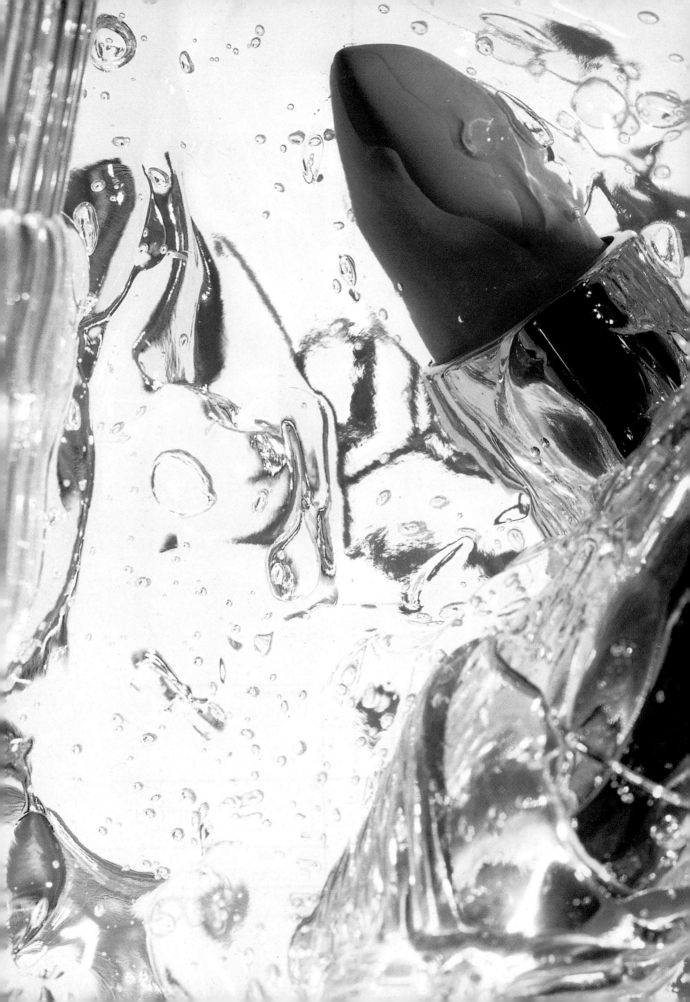

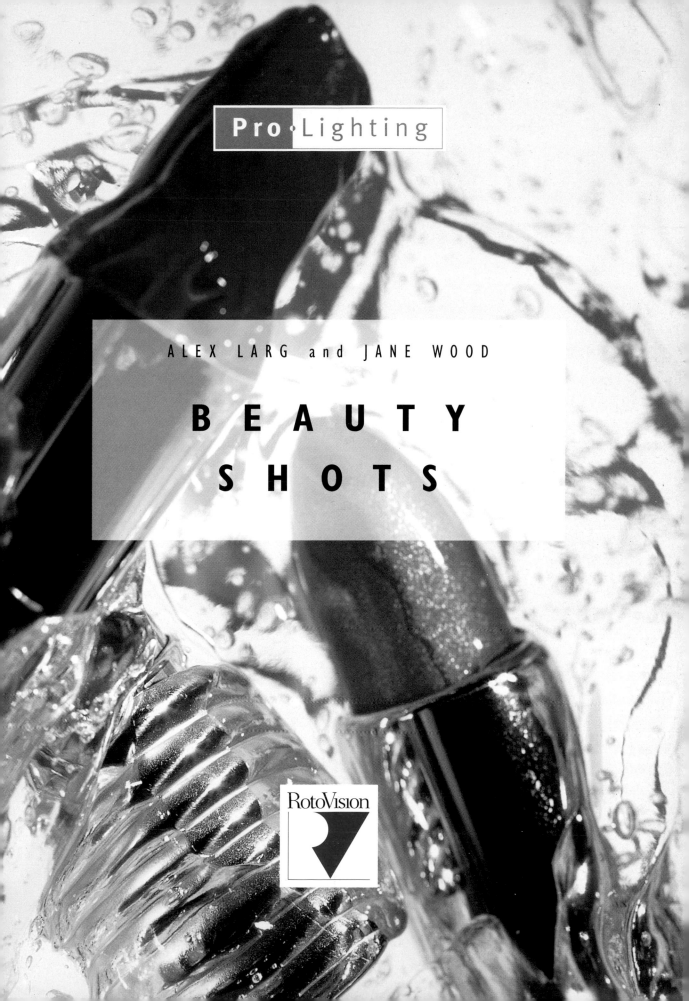

Pro·Lighting

ALEX LARG and JANE WOOD

BEAUTY
SHOTS

RotoVision

A Quintet Book

Published and distributed by
RotoVision SA
7 rue du Bugnon
1299 Crans
Switzerland

RotoVision SA Sales Office
Sheridan House
112/116A Western Road
Hove, East Sussex BN3 IDD
England
Tel: +44 1273 72 72 68
Fax: +44 1273 72 72 69

Distributed to the trade in the United States:
Watson-Guptill Publications
1515 Broadway
New York, NY 10036

ISBN 2-88046-323-8

This book was designed and produced by
Quintet Publishing Ltd.
6 Blundell Street
London N7 9BH

Creative Director: Richard Dewing
Art Director: Clare Reynolds
Designer: Fiona Roberts
Senior Editor: Anna Briffa
Editor: Bill Ireson
Picture Researchers: Alex Larg and Jane Wood

Typeset in Great Britain by
Central Southern Typesetters, Eastbourne
Printed in Singapore
Production and Separation by ProVision Pte. Ltd.
Tel: +65 334 7720
Fax: +65 334 7721

CONTENTS

▼

THE PRO-LIGHTING SERIES

▼

THE MOST COMMON RESPONSE FROM THE PHOTOGRAPHERS WHO CONTRIBUTED TO THIS BOOK, WHEN THE CONCEPT WAS EXPLAINED TO THEM, WAS "I'D BUY THAT". THE AIM IS SIMPLE: TO CREATE A LIBRARY OF BOOKS, ILLUSTRATED WITH FIRST-CLASS PHOTOGRAPHY FROM ALL AROUND THE WORLD, WHICH SHOW EXACTLY HOW EACH INDIVIDUAL PHOTOGRAPH IN EACH BOOK WAS LIT.

Who will find it useful? Professional photographers, obviously, who are either working in a given field or want to move into a new field. Students, too, who will find that it gives them access to a very much greater range of ideas and inspiration than even the best college can hope to present. Art directors and others in the visual arts will find it a useful reference book, both for ideas and as a means of explaining to photographers exactly what they want done. It will also help them to understand what the photographers are saying to them. And, of course, "pro/am" photographers who are on the cusp between amateur photography and earning money with their cameras will find it invaluable: it shows both the standards that are required, and the means of achieving them.

The lighting set-ups in each book vary widely, and embrace many different types of light source: electronic flash, tungsten, HMIs, and light brushes, sometimes mixed with daylight and flames and all kinds of other things. Some are very complex; others are very simple. This variety is very important, both as a source of ideas and inspiration and because each book as a whole has no axe to grind: there is no editorial bias towards one kind of lighting or another, because the pictures were chosen on the basis of impact and (occasionally) on the basis of technical difficulty. Certain subjects are, after all, notoriously difficult to light and can present a challenge even to experienced photographers. Only after the picture selection had been made was there any attempt to understand the lighting set-up.

This book is a part of the fourth series: BEAUTY SHOTS, NIGHT SHOTS, and NEW GLAMOUR. Previous titles in the series include INTERIOR SHOTS, GLAMOUR SHOTS, SPECIAL EFFECTS, NUDES, PRODUCT SHOTS, STILL LIFE, FOOD SHOTS, LINGERIE SHOTS and PORTRAITS. The intriguing thing in all of them is to see the degree of underlying similarity, and the degree of diversity, which can be found in a single discipline or genre.

Beauty shots feature beauty accessories and cosmetics for a commercial market so the lighting set-ups tend to be bright and strong to give powerful, bold images to grace the pages of many a beauty magazine or advertisement. Glamour shots, by contrast, concentrate on models, often nudes, and altogether softer lighting tends to be used, though having said that, many of the bold new-style shots are deliberately stark and provocative and the choice of harsher lighting can be used to good effect in these cases. For night shots, inevitably the use of available light without much by way of additional lighting features much more prominently than in any other book in the series.

The structure of the books is straightforward. After this initial introduction, which changes little among all the books in the series, there is a brief guide and glossary of lighting terms. Then, there is specific introduction to the individual area or areas of photography which are covered by the book. Subdivisions of each discipline are arranged in chapters, inevitably with a degree of overlap, and each chapter has its own introduction. Finally, there is a directory of those photographers who have contributed work.

If you would like your work to be considered for inclusion in future books, please write to Quintet Publishing Ltd, 6 Blundell Street, London N7 9BH and request an Information Pack. DO NOT SEND PICTURES, either with the initial inquiry or with any subsequent correspondence, unless requested; unsolicited pictures may not always be returned. When a book is planned which corresponds with your particular area of expertise, we will contact you. Until then, we hope that you enjoy this book; that you will find it useful; and that it helps you in your work.

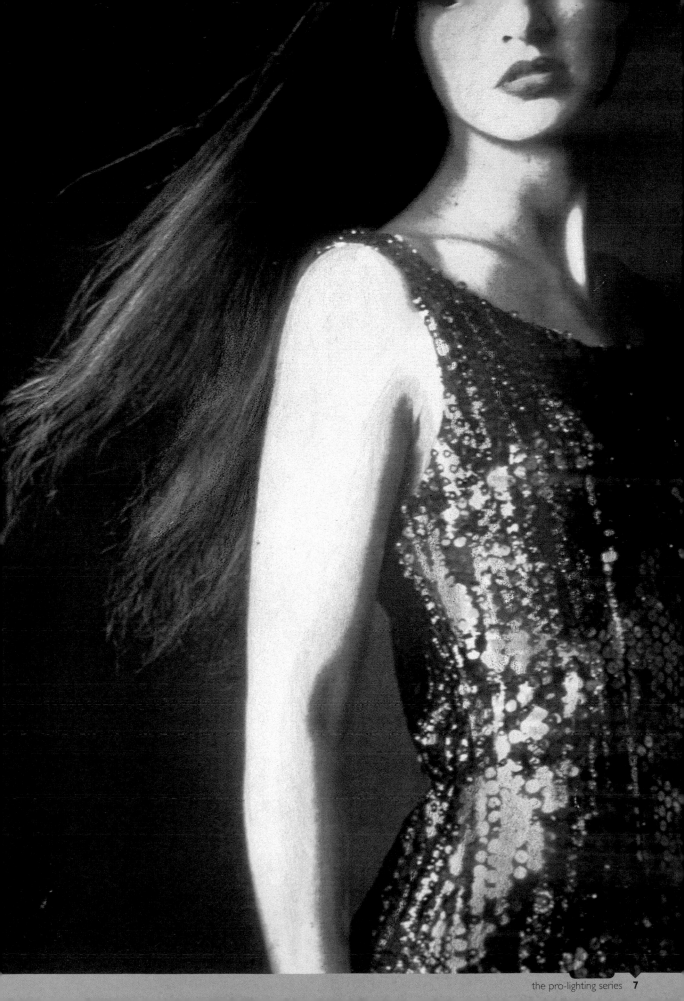

HOW TO USE THIS BOOK

▼

THE LIGHTING DRAWINGS IN THIS BOOK ARE INTENDED AS A GUIDE TO THE LIGHTING SET-UP RATHER THAN AS ABSOLUTELY ACCURATE DIAGRAMS. PART OF THIS IS DUE TO THE VARIATION IN THE PHOTOGRAPHERS' OWN DRAWINGS, SOME OF WHICH WERE MORE COMPLETE (AND MORE COMPREHENSIBLE) THAN OTHERS, BUT PART OF IT IS ALSO DUE TO THE NEED TO REPRESENT COMPLEX SET-UPS IN A WAY WHICH WOULD NOT BE NEEDLESSLY CONFUSING.

Technical information on the equipment used for each picture

Three-dimensional diagrams show how the lighting was set up

Plan views clarify the lighting set up

Bullet points give quick-reference information

Full page colour picture of the final image

Commentary explains how the lighting set up was approached by the photographer

Photographer's personal comment on his or her picture

Distances and even sizes have been compressed and expanded: and because of the vast variety of sizes of soft boxes, reflectors, bounces and the like, we have settled on a limited range of conventionalized symbols. Sometimes, too, we have reduced the size of big bounces, just to simplify the drawing.

None of this should really matter, however. After all, no photographer works strictly according to rules and preconceptions: there is always room to move this light a little to the left or right,

to move that light closer or further away, and so forth, according to the needs of the shot. Likewise, the precise power of the individual lighting heads or (more important) the lighting ratios are not always given; but again, this is something which can be "fine tuned" by any photographer wishing to reproduce the lighting set-ups in here.

We are however confident that there is more than enough information given about every single shot to merit its inclusion in the book: as well as purely

lighting techniques, there are also all kinds of hints and tips about commercial realities, photographic practicalities, and the way of the world in general.

The book can therefore be used in a number of ways. The most basic, and perhaps the most useful for the beginner, is to study all the technical information concerning a picture which he or she particularly admires, together with the lighting diagrams, and to try to duplicate that shot as far as possible with the equipment available.

A more advanced use for the book is as a problem solver for difficulties you have already encountered: a particular technique of back lighting, say, or of creating a feeling of light and space. And, of course, it can always be used simply as a source of inspiration.

The information for each picture follows the same plan, though some individual headings may be omitted if they were irrelevant or unavailable. The photographer is credited first, then the client, together with the use for which the picture was taken. Next come the other members of the team who worked on the picture: stylists, models, art directors, whoever. Camera and lens come next, followed by film. With film, we have named brands and types, because different films have very different ways of rendering colours and tonal values. Exposure comes next: where the lighting is electronic flash, only the aperture is given, as illumination is of course independent of shutter speed. Next, the lighting equipment is briefly summarized — whether tungsten or flash, and what sort of heads — and finally there is a brief note on props and backgrounds. Often, this last will be obvious from the picture, but in other cases you may be surprised at what has been pressed into service, and how different it looks from its normal role.

The most important part of the book is however the pictures themselves. By studying these, and referring to the lighting diagrams and the text as necessary, you can work out how they were done; and showing how things are done is the brief to which the *Pro Lighting* series was created.

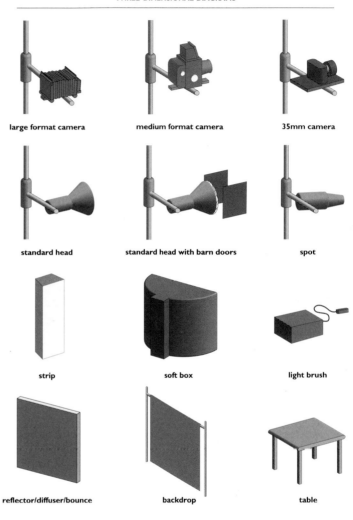

DIAGRAM KEY

The following is a key to the symbols used in the three-dimensional and plan view diagrams. All commonly used elements such as standard heads, reflectors etc., are listed. Any special or unusual elements involved will be shown on the relevant diagrams themselves.

THREE-DIMENSIONAL DIAGRAMS

large format camera medium format camera 35mm camera

standard head standard head with barn doors spot

strip soft box light brush

reflector/diffuser/bounce backdrop table

PLAN VIEW DIAGRAMS

large format camera medium format camera 35mm camera bounce

standard head standard head with barn doors spot gobo

diffuser

reflector

strip soft box light brush backdrop table

GLOSSARY OF LIGHTING TERMS

▼

LIGHTING, LIKE ANY OTHER CRAFT, HAS ITS OWN JARGON AND SLANG. UNFORTUNATELY, THE DIFFERENT TERMS ARE NOT VERY WELL STANDARDIZED, AND OFTEN THE SAME THING MAY BE DESCRIBED IN TWO OR MORE WAYS OR THE SAME WORD MAY BE USED TO MEAN TWO OR MORE DIFFERENT THINGS. FOR EXAMPLE, A SHEET OF BLACK CARD, WOOD, METAL OR OTHER MATERIAL WHICH IS USED TO CONTROL REFLECTIONS OR SHADOWS MAY BE CALLED A FLAG, A FRENCH FLAG, A DONKEY OR A GOBO — THOUGH SOME PEOPLE WOULD RESERVE THE TERM "GOBO" FOR A FLAG WITH HOLES IN IT, WHICH IS ALSO KNOWN AS A COOKIE. IN THIS BOOK, WE HAVE TRIED TO STANDARDIZE TERMS AS FAR AS POSSIBLE. FOR CLARITY, A GLOSSARY IS GIVEN BELOW, AND THE PREFERRED TERMS USED IN THIS BOOK ARE ASTERISKED.

Acetate
see Gel

Acrylic sheeting
Hard, shiny plastic sheeting, usually methyl methacrylate, used as a diffuser ("opal") or in a range of colours as a background.

***Barn doors**
Adjustable flaps affixed to a lighting head which allow the light to be shaded from a particular part of the subject.

Barn doors

Boom
Extension arm allowing a light to be cantilevered out over a subject.

***Bounce**
A passive reflector, typically white but also, (for example) silver or gold, from which light is bounced back onto the subject. Also used in the compound term "Black Bounce", meaning a flag used to absorb light rather than to cast a shadow.

Continuous lighting
What its name suggests: light which shines continuously instead of being a brief flash.

Contrast
see Lighting ratio

Cookie
see Gobo

***Diffuser**
Translucent material used to diffuse light. Includes tracing paper, scrim, umbrellas, translucent plastics such as Perspex and Plexiglas, and more.

Electronic flash: standard head with parallel snoot (Strobex)

Donkey
see Gobo

Effects light
Neither key nor fill; a small light, usually a spot, used to light a particular part of the subject. A hair light on a model is an example of an effects (or "FX") light.

***Fill**
Extra lights, either from a separate head or from a reflector, which "fills" the shadows and lowers the lighting ratio.

Fish fryer
A small Soft Box.

***Flag**
A rigid sheet of metal, board, foam-core or other material which is used to absorb light or to create a shadow. Many flags are painted black on one side and white (or brushed silver) on the other, so that they can be used either as flags or as reflectors.

***Flat**
A large Bounce, often made of a thick sheet of expanded polystyrene or foam-core (for lightness).

Foil
see Gel

French flag
see Flag

Frost
see Diffuser

***Gel**
Transparent or (more rarely) translucent coloured material used to modify the colour of a light. It is an abbreviation of "gelatine (filter)", though most modern "gels" for lighting use are actually of acetate.

***Gobo**
As used in this book, synonymous with "cookie": a flag with cut-outs in it, to cast interestingly-shaped shadows. Also used in projection spots.

"Cookies" or "gobos" for projection spotlight (Photon Beard)

***Head**
Light source, whether continuous or flash. A "standard head" is fitted with a plain reflector.

***HMI**
Rapidly-pulsed and

effectively continuous light source approximating to daylight and running far cooler than tungsten. Relatively new at the time of writing, and still very expensive.

***Honeycomb**

Grid of open-ended hexagonal cells, closely resembling a honeycomb. Increases directionality of light from any head.

Honeycomb (Hensel)

Incandescent lighting

see Tungsten

Inky dinky

Small tungsten spot.

***Key or key light**

The dominant or principal light, the light which casts the shadows.

Kill Spill

Large flat used to block spill.

***Light brush**

Light source "piped" through fibre-optic lead. Can be used to add highlights, delete shadows and modify lighting, literally by "painting with light".

Electronic Flash: light brush "pencil" (Hensel)

Electronic Flash: light brush "hose" (Hensel)

Lighting ratio

The ratio of the key to the fill, as measured with an incident light meter. A high lighting ratio (8:1 or above) is very contrasty, especially in colour, a low lighting ratio (4:1 or less) is flatter or softer. A 1:1 lighting ratio is completely even, all over the subject.

***Mirror**

Exactly what its name suggests. The only reason for mentioning it here is that reflectors are rarely mirrors, because mirrors create "hot spots" while reflectors diffuse light. Mirrors (especially small shaving mirrors) are however widely used, almost in the same way as effects lights.

Northlight

see Soft Box

Perspex

Brand name for acrylic sheeting.

Plexiglas

Brand name for acrylic sheeting.

***Projection spot**

Flash or tungsten head with projection optics for casting a clear image of a gobo or cookie. Used to create textured lighting effects and shadows.

***Reflector**

Either a dish-shaped surround to a light, or a bounce.

***Scrim**

Heat-resistant fabric diffuser, used to soften lighting.

Electronic Flash: projection spotlight (Strobex)

Tungsten Projection spotlight (Photon Beard)

***Snoot**

Conical restrictor, fitting over a lighting head. The light can only escape from the small hole in the end, and is therefore very directional.

***Soft box**

Large, diffuse light source made by shining a light through one or two layers of diffuser. Soft boxes come in all kinds of shapes.

Tungsten spot with conical snoot (Photon Beard)

Electronic Flash: standard head with parallel snoot (Strobex)

Tungsten spot with safety mesh (behind) and wire half diffuser scrim (Photon Beard)

Electronic flash: standard head with large reflector and diffuser (Strobex)

and sizes, from about 30x30cm to 120x180cm and larger. Some soft boxes are rigid; others are made of fabric stiffened with poles resembling fibreglass fishing rods. Also known as a northlight or a windowlight, though these can also be created by shining standard heads through large (120x180cm or larger) diffusers.

***Spill**

Light from any source which ends up other than on the subject at which it is pointed. Spill may be used to provide fill, or to light backgrounds, or it may be controlled with flags, barn doors, gobos etc.

***Spot**

Directional light source. Normally refers to a light using a focusing system

with reflectors or lenses or both, a "focusing spot", but also loosely used as a reflector head rendered more directional with a honeycomb.

***Strip or strip light**

Lighting head, usually flash, which is much longer than it is wide.

Electronic flash: strip light with removable barn doors (Strobex)

Strobe

Electronic flash. Strictly, a "strobe" is a stroboscope or rapidly repeating light source, though it is also the name of a leading manufacturer.

Tungsten spot with removable Fresnel lens. The knob at the bottom varies the width of the beam (Photon Beard)

Strobex, formerly Strobe Equipment.

Swimming pool

A very large Soft Box.

***Tungsten**

Incandescent lighting. Photographic tungsten

Electronic flash: standard head with standard reflector (Strobex)

lighting runs at 3200°K or 3400°K, as compared with domestic lamps which run at 2400°K to 2800°K or thereabouts.

***Umbrella**

Exactly what its name suggests; used for modifying light.

Umbrellas may be used as reflectors (light shining into the umbrella) or diffusers (light shining through the umbrella). The cheapest way of creating a large, soft light source.

Windowlight

Apart from the obvious meaning of light through a window, or of light shone through a diffuser to look as if it is coming through a window, this is another name for a soft box.

Tungsten spot with shoot-through umbrella (Photon Beard)

BEAUTY SHOTS

▼

"BEAUTY IS THE SPLENDOUR OF FORM SHINING THROUGH THE PROPORTIONED PARTS OF MATTER"
(SAINT THOMAS AQUINAS).

Beauty, and the nature of beauty is a theme that has run through art, literature and philosophy for centuries. Historically it has a double-edged reputation. On the one hand beauty has been associated with virtue, as in the phrases "As fair as an angel"/"As ugly as sin", but on the other hand beauty has been distrusted as a superficial characteristic, capable of misleading the unwary, as in the saying "Beauty is only skin deep". The fact that the language contains so many sayings and turns of phrase related to beauty gives some indication of its importance as a theme. Literature, from folk tales to poetry, has taken up the idea, so much so that we know in every fairy tale that the older two sisters will always be ugly and wicked and the youngest sister will be beautiful, good and deserving, whatever the detail of the plot, from Cinderella to King Lear. Keats's famous closing couplet in "Ode on a Grecian Urn" is another touchstone when considering the literary history of the theme.

" 'Truth is beauty, beauty truth,' - that is all
Ye know on earth and all ye need to know".

Whatever the approach, beauty has exercised a fascination over artists of all kinds over the centuries. Of course, the history of photography only began in earnest in 1839 with the work of the likes of William Henry Fox Talbot, Nicéphore Niépce and Louis Jacques Mandé Daguerre; but it is no surprise that from the outset those working with the new art medium of photography wanted to use the form to explore and record beauty in its many forms. Early portrait photography, such as that by Julia Margaret Cameron and Lewis Carroll consisted of elaborate backdrops, costume, posing, coiffure and so on, to show off the subjects to best advantage.

More recently, beauty as a personal concern and as an industry is of huge general interest, with advertising, magazines and books – almost every aspect of commercial life – all promoting beauty in its many and various forms. As far as the question of whether beauty equates with good or beauty equates with artifice is concerned, a new twist to the debate has emerged in recent years. There is now a widespread view that there has been a shift, in this post-feminist era, away from women trying to look beautiful to please men, to women wanting to look beautiful to please themselves, and for many people beauty is an expression of image, personal choice and, perhaps, of power. From a commercial point of view, the moral argument is irrelevant: beauty is merely a commodity. Whichever view we take, it is perhaps time for the old adage, "Beauty is in the eye of the beholder", to be updated to: "Beauty is in the eye of the consumer".

THE PURPOSE OF BEAUTY PHOTOGRAPHY

Beauty photography falls into several categories, most of which are to do with selling a product, image or lifestyle that the photograph is intended to convey to the consumer. In many cases where there is a direct advertising requirement, a flawless model displaying perfect features is required to set off either a beauty product or some item relatively unrelated to the notion of beauty that is being promoted; anything from a holiday to headache remedy. Product shot still lifes are also of importance, since the cosmetics industry is huge and varied, and each product and brand has its own particular requirements for promotion.

Magazine and editorial requirements are another, and larger, area of demand for beauty photography. The plethora of women's magazines, hair, beauty, fitness, diet and general interest magazines – all need endless images of the looks and lifestyle that they want to put across to their readership. These images may appear in "how to . . . " features giving advice on cosmetics, hair styling and fashion tips, or make-over features, where the work of the make-up artist and hair stylist are of paramount

importance, or in general interest features where an illustrative image of a person may be of importance in defining the overall image and readership of the magazine. Of course decorative, fantastic and escapist images of beauty also have their place.

Occasionally the photograph itself is the saleable item. Personal beauty portraiture to commission and art photography, either for gallery exhibition or for postcards and posters, are two main areas of work in the field. Traditional and experimental beauty shots are also often done as portfolio work, whether for the photographer, make-up artist, hair stylist or model.

STUDIOS AND SETTINGS

Most of the photographs featured in this book come from studio work rather than location work, and this imbalance is representative of the work that was submitted for inclusion in the book overall.

The reasons for this are straightforward and obvious when you pause to consider the point and purpose of beauty shots. Beauty photography is a very particular art, often concentrating on precise details of features, faces and products at very close range, or striving to achieve a particular effect or illusion by whatever technical means. Since beauty photography is, on the whole, by its very nature, an area of photography with a high level of artifice, it follows that absolute control over the conditions is required. Some of the shots in the book quite simply could not have been achieved on location.

Günther Uttendorfer's "Susanne" shot (page 63), for example, needed absolute stillness of air, to the extent that the model was not even allowed to breathe for fear of disturbing the fine powder that comprised the set. Another consequence of the typical tightly cropped, close-in beauty shot is that a background or location is largely irrelevant, and probably not visible. Beauty shots tend to concentrate on particular details, not on general views, and a location setting is not necessarily a high priority.

Having said that, for a shot that emphasises lifestyle or some personal element, setting can be important to establish context to show off the product or person in a meaningful way. There is no doubt that the clothing is an important element of the shot, but the location setting successfully establishes both context and an image of lifestyle that will help to sell an item that might, in isolation, appear less appealing.

MAKE-UP, HAIR AND CLOTHES

For beauty shots even more than for most other kinds of shots, it is essential that make-up, hair and clothing should be absolutely pristine (or not, if this is the requirement!). The very purpose of many beauty shots is, after all, to promote the make-up, the hair and/or clothing. Cosmetics, hair products and fashion accessories of all kinds, colours, finishes and styles, and for every conceivable purpose, are constantly being put forward into a busy and competitive market that is worth an enormous amount of money. The consumer's on-going high level of

interest in all these aspects of beauty guarantees that a great deal of beauty photography will be aimed at meeting the needs of the market.

When shooting general stock photography, it usually pays to be wary of up-to-the-minute fashionable styles of make-up, hair and clothing, because they date a picture so quickly. In beauty photography, however, the very idea is often to show the ephemerally flitting changes of fashion. The contemporary styles of the moment, with an admittedly shorter shelf-life than less specialist stock images, will often be exactly what is required for advertising and editorial use in a market of quickly changing short-lived images.

By the same token, for a more enduring classic beauty shot, a timeless and less obviously fashionable style will be more appropriate and add longevity to the relevance of the image as a saleable item. A "period" feel can be created by the deliberate use of hair, make-up and clothing styles of another era remarkably effectively, if this is what is wanted.

Needless to say, excellent make-up artists and hair stylists are essential members of the team for a shot where the make-up and hair are under such intense scrutiny as they are in a professional beauty shot.

CAMERAS, LENSES AND FILMS FOR BEAUTY SHOTS

One might expect that medium format is the obvious choice for this type of work, yet many photographers use 35mm, either for ease of use or possibly because it gives more the "look" that

they require. The 35mm negative or transparency inherently requires more enlargement in the reproduction process and thus gives larger grain and adds to the texture of the final image. Having said that, with modern film stock technology, grain is finer on certain films so a photographer needs to know the whole range of stocks on the market and choose the right one for the moment. More and more people are experimenting with stocks such as Polaroid Polagraph, and infrared black and white and colour stocks, among others.

Interestingly, very few of the photographers featured in this book have used 10x8in plate cameras, which at one time would have been a more widely used format. The relatively small, lightweight, modern electronic cameras have obvious appeal and versatility and it may be that the older larger formats are simply being used less, so newer assistants and practitioners in studios coming into the trade have less experience and familiarity with the format – and so the decline in usage continues. This seems a pity, for anyone who has handled a 10x8 trannie will know what marvellous quality can be attained: a perfect transparency of such size is a sheer delight to hold and behold. Far more common, however, is medium format work (645, 6x6cm and 6x9cm, etc.) which is more than adequate for most purposes. A large proportion of beauty shots will be aimed at the huge magazine and editorial market, and for quick turn-around for these clients, who will be using the transparencies for fairly small

reproductions, 35mm originals will be fine, whereas for larger reproductions used on large-scale advertising images, or for digital work, for example, larger format transparencies will be more appropriate.

LIGHTING EQUIPMENT FOR BEAUTY SHOTS

As already mentioned, the beauty photographer is a combination of a portrait photographer, still life photographer, special effects photographer, and so on; and is likely to need to call on a large amount of lighting. The absolute basic piece of equipment is a white reflector which is quite often enough in conjunction with available light. Of course, you also need several standard heads, a mixture of flash and tungsten, with a range of accessories such as barn doors, snoots, honeycombs, as well as at least a couple of medium to large soft boxes, plus a range of items like gels, mirrors, on-camera flash and small pocket torches. In many cases the typical shot will consist of a central foreground subject (model, product) with a plain background which may even be so tightly cropped as to be unseen in the final image. Separate lighting for foreground and background is a major consideration and the set-up will be quite different from, say, a complicated room set where background detail contributes significantly to the composition. Often, fairly plain, simple but well-considered background lighting will be needed, increasing in complexity for still lifes where the still-life composition may occupy the whole frame (for example, Salvio Parisi's "Versace perfume for men" shot on page 85).

Finally, it is worth remembering that it is often in the nature of beauty subjects to have shiny surfaces, sparkling eyes, gleaming lips and so on; which means that in the lighting set-up, extra care should be taken to control the reflections and speculas that are bound to be produced – they may or may not be desired.

THE TEAM

Whereas in some subject areas, for example, nudes and still lifes the photographer may quite commonly work alone, beauty photography is a very good example of a situation where there is a considerable team effort. As already mentioned, an excellent make-up artist and hair stylist are of great importance. More often than not there will be an art director representing the company who have commissioned a specifically promotional advertising shot, and there may also be a stylist and a company publicist present to ensure that the "branding", whether direct or indirect, is exactly as required for the product, and in keeping with the company's overall marketing strategy.

This is not to suggest that the photographer's creative impulses will necessarily be stifled by the opinions of other members of the team. As in any profession it is essential to have a clear brief agreed and discussed thoroughly beforehand; in a phoitography situation, visuals will probably have been seen and approved, everyone will know what to expect from the shoot and what their role will be in helping to achieve it. Cooperation and communication are essential.

1

portraits

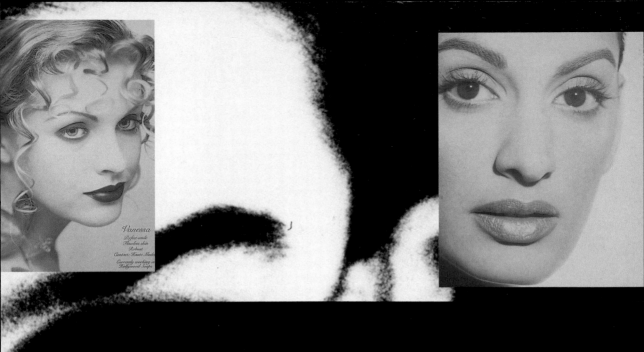

Vanessa
Defrez-vendé
Flawless skin
Robust
Contact: Haute Model
Currently working in
Hollywood Soaps

► Some of the beauty portraits in this chapter are about personal beauty, and are not necessarily intended to feature any particular aspect of the model's appearance such as hair, eyes, make-up, or clothes. Others are about artificially enhanced beauty, focusing on the hair styling, make-up techniques and products, to show off either the individual model or the products being used.

Some people might wonder what the role of the photographer is when the subject is evidently perfectly beautiful: what can there be to do but point the camera and press the shutter? But however beautiful a person is, it is of course always possible to make a perfect set of features appear quite unattractive by using unflattering lighting and not presenting the excellent subject to best advantage (quite apart from the odd phenomenon of some people being quite simply unphotogenic, and unable to present themselves at their best to the camera, however attractive they look in other circumstances). Conversely, judiciously chosen lighting can work miracles on even the most handsome subject.

Lighting is all-important for the portrait of the natural beauty just as much as it is for any other kind of professional shot. The camera is just a mechanical or electronic box that cannot lie – but the photographer is very capable of telling a pictorial lie as long as he or she is fully aware of how different film stocks respond to light and has the knowledge and experience/feel for lighting contrast. Thus can be contrived a chemical untruth in the form of an image on film. The task of the professional photographer is to use lighting that will enhance and flatter the features of even the most perfect model.

Photographer: **Claude Guillaumin**

Client: *Cosmopolitan* **magazine**

Use: **Editorial**

Art director: **Christian Gamby**

Stylist: **D. Eveque**

Camera: **35mm Contax**

Lens: **Zeiss 50mm f/1.2**

Film: **Fuji Provia 100**

Exposure: **1/125 second at f/5.6**

Lighting: **Available light**

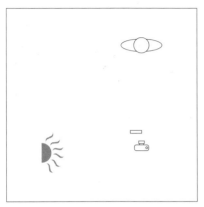

Plan View

► As an alternative to split diopters, a magnifying glass is an effective option

► Judicious placing of shiny props to catch the sun (such as the hair-slide in this shot) can make all the difference

H A I R - D O

▼

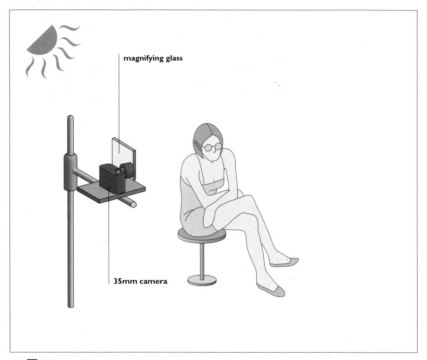

magnifying glass

35mm camera

THE MODEL'S FACE IS TURNED AWAY FROM THE SUN, WHEREAS ONE MIGHT NORMALLY EXPECT IT TO BE TILTED MORE INTO THE LIGHT. BUT THE FACE, WHICH OCCUPIES A LARGE PERCENTAGE OF THE AREA OF THE PICTURE, IS ACTUALLY IN RELATIVE SHADE.

The point of this is two-fold. First, as the title suggests, the hair is the most important element of the picture, and the position and focus of the sharp hair-cut is central. The use of the magnifying glass placed over part of the lens emphasises this, ensuring that the relevant area of hair is the centre of focus. Secondly, the tilt of the head ensures that much of the face is in shade while the hair-slide and the glinting arm

of the sunglasses catch the sunlight to draw attention to the hair.

The mirror lenses of the sunglasses are important too: look at the image reflected in them, which is a composition in its own right. This is not an accidental or casual shot. Careful and deliberate choices have been made regarding styling, props, positioning and use of reflective surfaces, to make the most of the natural sunlight.

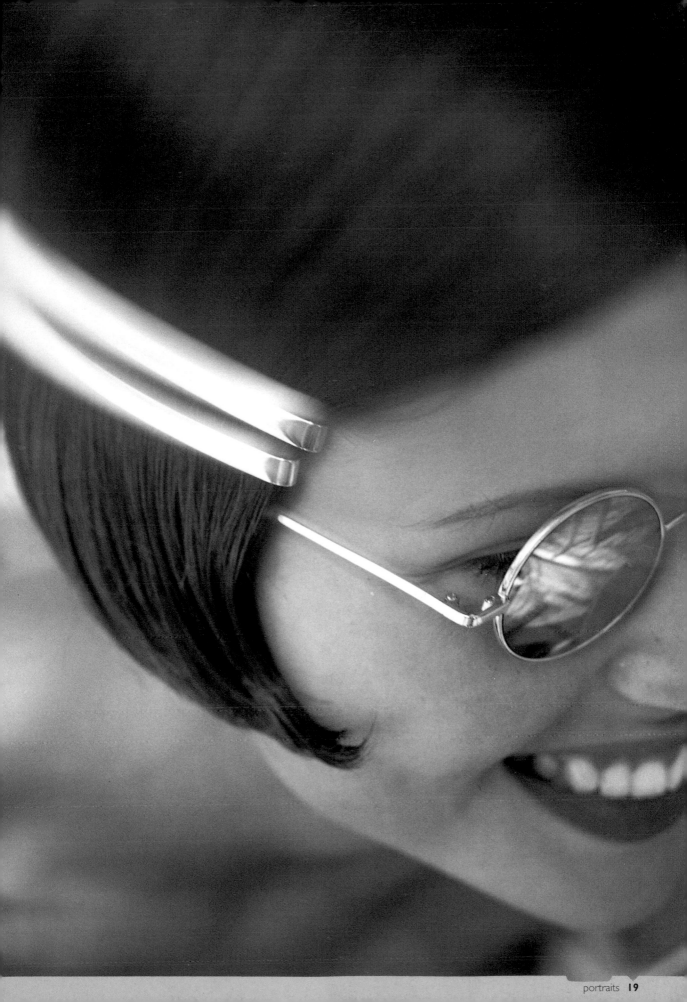

Photographer: **Frank Wartenberg**

Client: **Wella**

Use: **Hair magazine**

Camera: **Nikon F4**

Lens: **105mm**

Film: **Polaroid Polagraph**

Exposure: **Not recorded**

Lighting: **HMI**

Props and set: **White backdrop**

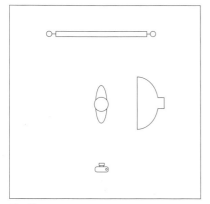

Plan View

THE BLONDE

▼

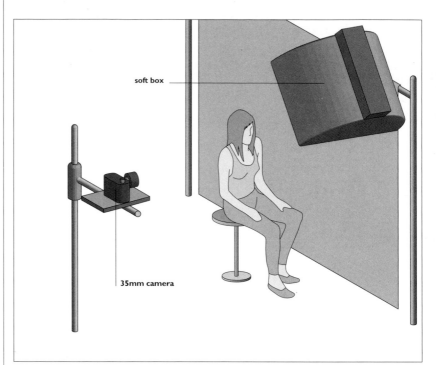

soft box

35mm camera

THIS IS ONE OF THE FEW IMAGES IN THIS BOOK TO USE HMI LIGHTING. THIS IS A CONTINUOUS LIGHT SOURCE WHICH IS ACTUALLY DAYLIGHT BALANCED AROUND 5500 DEGREES KELVIN. OBVIOUSLY THIS IS A BLACK AND WHITE IMAGE, AND SO COLOUR BALANCE IS NOT A PRIMARY CONSIDERATION. WHAT IS VERY IMPORTANT ABOUT THIS PARTICULAR TYPE OF LIGHTING, HOWEVER, IS THAT IT IS A LOT COOLER IN HEAT TEMPERATURE, AND SO DOES NOT OVERHEAT A MODEL OR SUBJECT AT CLOSE QUARTERS EVEN THOUGH IT MAY BE TURNED ON FOR SOME LENGTH OF TIME.

► *Polaroid Polagraph gives particularly good results when photographing Afro-Caribbean skins in low light conditions (for example, photographing musicians in concert), giving marvellous texture and definition to the skin tones*

► *Various Polaroid stocks are available, and although they can be relatively expensive, the convenience of an instant result is sometimes invaluable*

A major advantage of shooting on Polaroid film stock is the fact that the results are almost instant. Once you have loaded the 35mm film into the Polaroid processor, it takes just 2 minutes (for Polagraph) to develop. The roll of silvery transparencies that emerge give a stunning, contrasty look, as well as a tingle of excitement every time.

To add to the contrast, Frank Wartenberg used a blue filter in front of the camera lens, which, when used with black and white film, has the effect of making blues record lighter. The effect on the blue-eyed blonde model is to give pale irises to the eyes in contrast with the dark pupils.

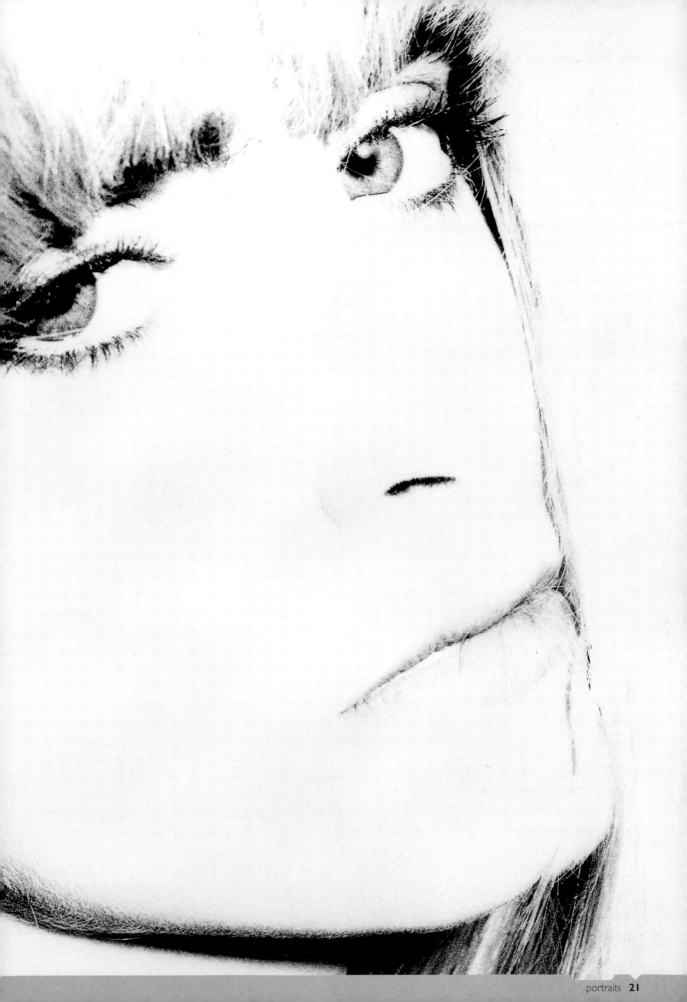

Photographer: **Salvio Parisi**

Client: **Renee Blanche Cosmetics**

Use: **Winter beauty product advertising**

Model: **Emanuela**

Assistant: **Chicca Fusco**

Hair and make-up: **Francesco Riva**

Stylist: **Grazia Catalani**

Camera: **35mm**

Lens: **135mm**

Film: **Kodak Ektachrome 100 Plus**

Exposure: **1/2 second at f/16**

Lighting: **Electronic flash and tungsten**

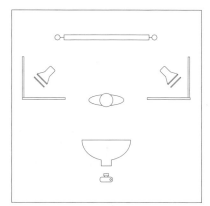

Plan View

EMANUELA

▼

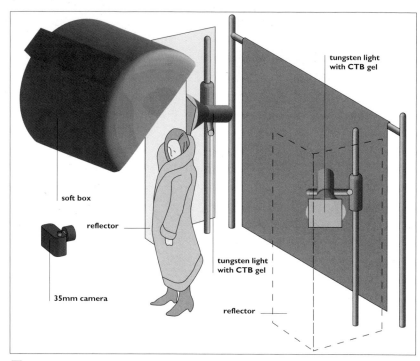

tungsten light with **CTB** gel

soft box

reflector

tungsten light with **CTB** gel

35mm camera

reflector

THE PURPOSE OF THE SHOT WAS TO DEMONSTRATE WINTER MAKE-UP SO IT IS IMPORTANT TO ESTABLISH CONTEXT FROM THE OUTSET. THE MODEL SWATHED IN LUXURIOUS FURS, A HINT OF BREEZE BLOWING THROUGH TOUSLED HAIR AND THE COOL LIGHTING ALL CONTRIBUTE TO ESTABLISHING THE WINTERY FEEL.

The soft box flash gives high-key sharp detail on the face and eyes and Salvio Parisi has chosen to switch off the usual modelling light so that for the remainder of the 1/2 second exposure, only the continuously lit background is predominantly being recorded, throwing the detail of hair and model's outline into silhouette.

An exposure of 1/2 second is a long time for a hand-held shot but this approach has been chosen so that the slight natural movement on the part of both the photographer and the model give a softness and sense of movement to the edge of the hair in particular.

Notice too the attention to detail: the design of the earrings, the cat-like eyebrows, the aristocratic, almost haughty, expression and varied colours in the hair all pick up on the "big cat" imagery set up by the fur. All contribute to frame the *raison d'être* of the shot: the immaculately made-up face.

► *Flash heads with modelling lights can, in effect, be regarded as two lights in one*

► *The cool effect here is achieved by using a 0.5 CTB (colour temperature blue) gel on the main front light*

Photographer's comment:

The purpose of this shoot was to show a kind of "winter" make-up.

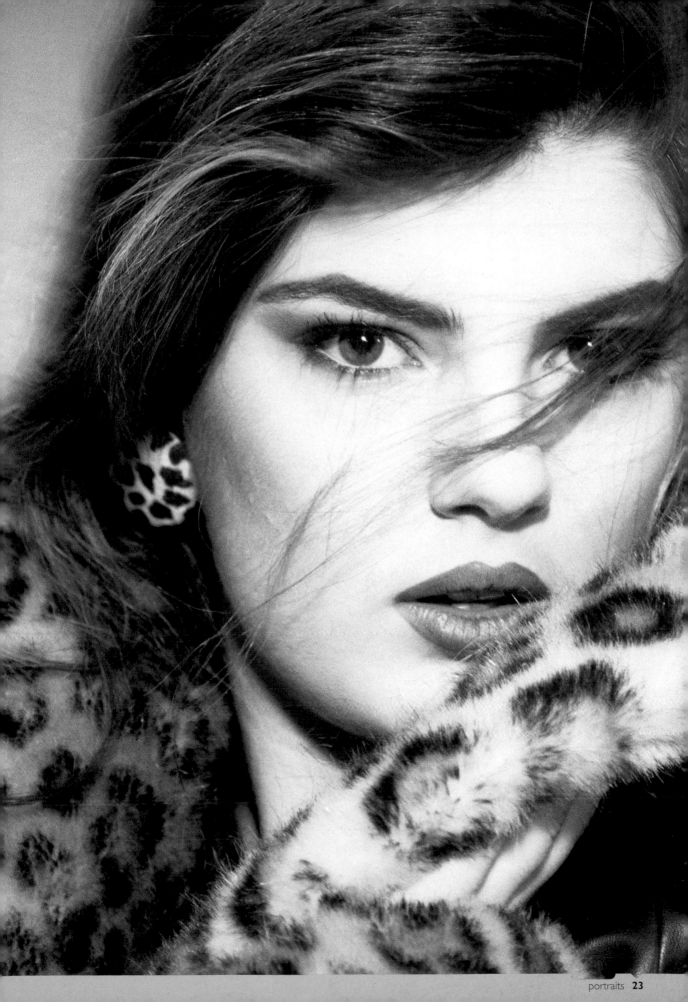

Photographer: **Chris Rout**

Camera: **35mm Canon EOS 1N**

Lens: **100mm macro f/2.8**

Film: **Ektachrome 100**

Exposure: **1/125 second at f/16**

Lighting: **Electronic flash: 2 heads**

Props and set: **Blue Colorama backdrop**

Plan View

B L O N D E G I R L

▼

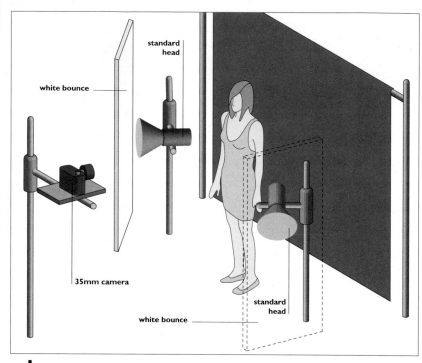

IF THERE IS ANY SUCH THING AS A CLASSIC, STANDARD STUDIO LIGHTING SET-UP FOR A FACE-ON PORTRAIT, THIS IS IT.

This exemplary cover-girl image was achieved with a good, simple, straightforward and unfussy studio set-up consisting of nothing more than two standard heads with a reflector apiece. The heads, set up at eye level, were bounced off two large 8x4 foot white panels, giving complimentary even light over the face and hair. The position of the bounces and the photographer himself create a pleasing reflection in the model's right eye for a touch of added interest.

Of course, the right choice of model is essential. The simple, flowing hair, flawless complexion, full lips, hypnotic eyes and arresting expression are recorded in disarming close-up detail. As the camera is 1m away from the model, a macro lens has been used to get such close focus and capture the intimacy of proximity.

► *You may or may not want reflections in eyes so it is essential to be aware of them happening and to manipulate your set-up to get the effect you want*

► *Screw-on close-up filters can be used if you don't have a macro lens to hand*

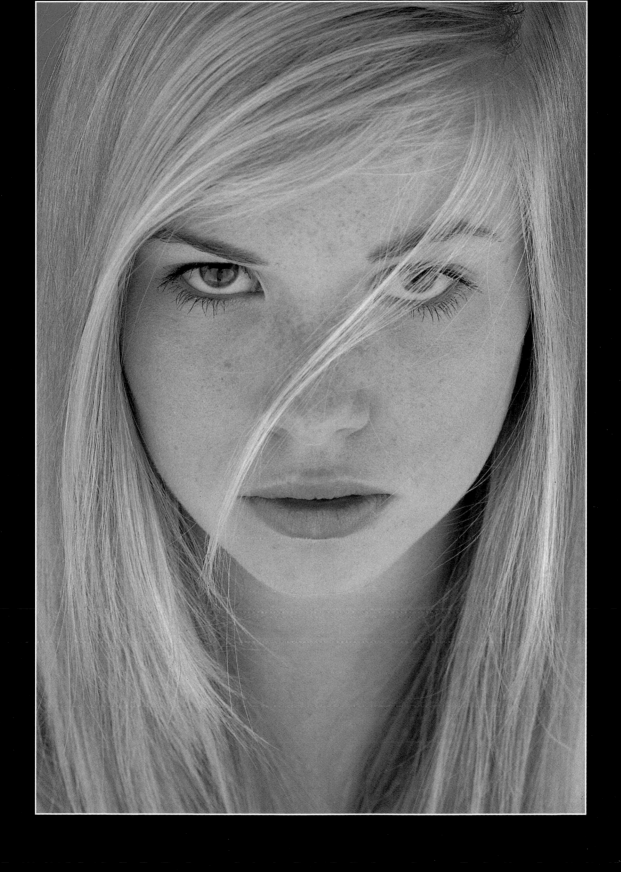

Photographer: **Günther Uttendorfer**

Client: **Unique Cosmetics**

Use: **Magazine**

Model: **Sharon**

Assistant: **Jurgen Weber**

Make-up: **Markus Weinmann**

Art director: **Martin**

Camera: **6x7cm**

Lens: **127mm**

Film: **Kodak EPT 160 (tungsten)**

Exposure: **f/5.6**

Lighting: **Electronic flash: 3 heads**

Props and set: **White paper**

Plan View

▼

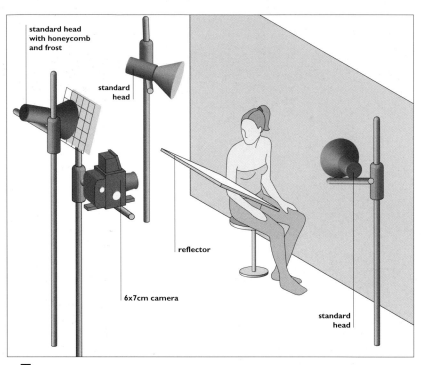

standard head
with honeycomb
and frost

standard
head

reflector

6x7cm camera

standard
head

THIS IS A CLASSIC HIGH-KEY LOOK. THE BACKGROUND IS STRONGLY LIT TO GET A BRIGHT BACKGROUND WHILE THE MODEL'S FACE IS LIT WITH JUST ONE STANDARD HEAD AND A SINGLE REFLECTOR TO EVEN OUT THE LIGHT FURTHER.

Two standard heads evenly light the white paper background. The light on the model's face is softened by both a honeycomb and a frost.

Tight in below the face is a white reflector, sending light in to give some definition to the edges of the facial features. Notice its effect along the very edge of the chin, producing a rim of light that gives the jawline some separation from the shadowy throat behind, and again, look at the light along the right side of the neckline, also bounced in by the same reflector.

The eerie blue coolness is the product of using flash lighting with a tungsten-balanced film and no correction.

► *"Soft" does not mean "blurry". With careful choice of lens and f-stop it is possible to choose what will be soft and what will be sharp*

► *Daylight balanced film used with tungsten light would have given a yellow/gold effect*

Photographer's comment:

For most beauty shots, I love it if the model is addressing the viewer. The picture is stronger in expression the closer you shoot the model (long lens). A good make-up artist is very, very important!

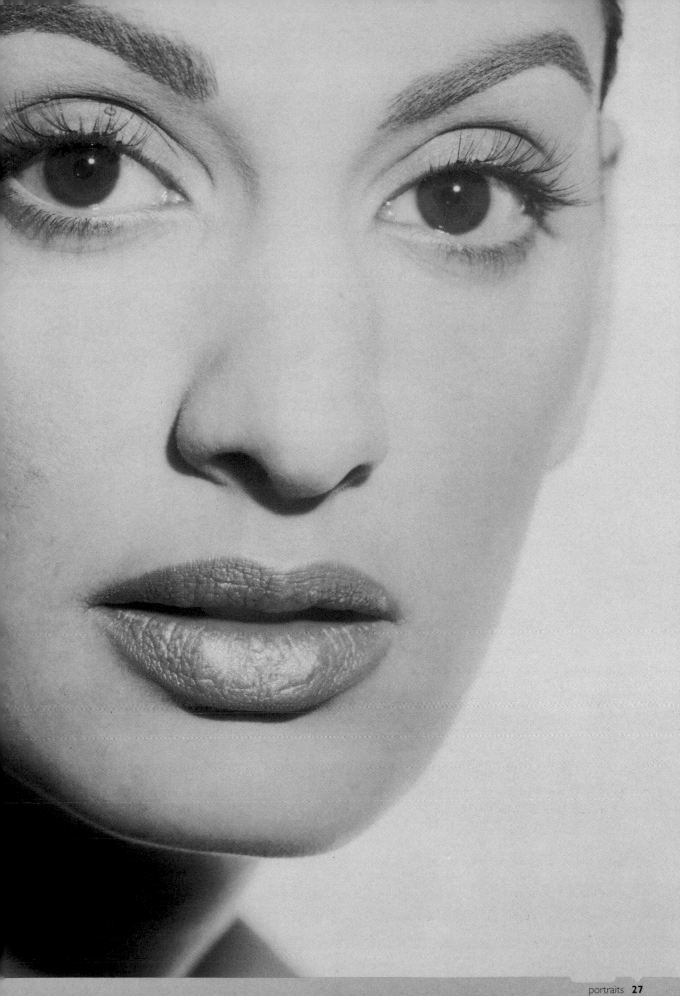

Photographer: **Holly Stewart**

Client: **Ciba Geigy Corporation**

Use: **Trade magazine**

Model: **Cindra**

Art director: **Stephanie Halverson**

Stylist: **Dawn Sutti**

Camera: **4x5in**

Lens: **210mm**

Film: **EPZ**

Exposure: **1/125 second at f/5.6**

Lighting: **Electronic flash: soft box plus reflectors**

Plan View

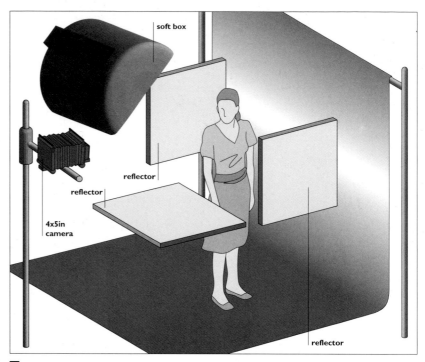

THE CASCADING, CURLING AUBURN HAIR, THE FULL DEEP LIPS, STRONG THROAT, LANGUOROUS EYES AND THE VERY TILT OF THE HEAD ALL SCREAM "PRE-RAPHAELITE". HOLLY STEWART HAS REWORKED THE ICONIC VICTORIAN GENRE FOR THIS MODEL PORTRAIT.

The angle of the face is important not only for emulating the classic pose of the Pre-Raphaelite heroine, but also in terms of using the light for defining the curves of the face. The soft box is positioned above the model so there is modelling under the chin, but there is also fall-off to the far side of the face, which adds to the depth of the picture. The position of the soft box gives shine on the uppermost areas of the hair, while the light also plays through the curling form of the ringlets.

It is important that matt lipstick has been used, since a gloss lipstick would have given a bright shine and spoilt the dreamy effect of the image.

► *Kodak EPZ stock has now been discontinued. The new stock is E100SW which is a warm-toned stock with good colour saturation*

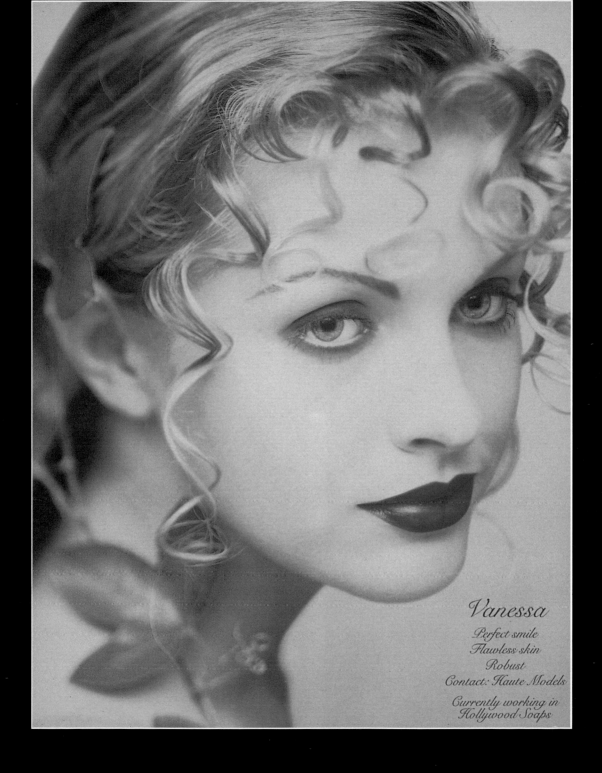

Vanessa

Perfect smile
Flawless skin
Robust
Contact: Haute Models

Currently working in
Hollywood Soaps

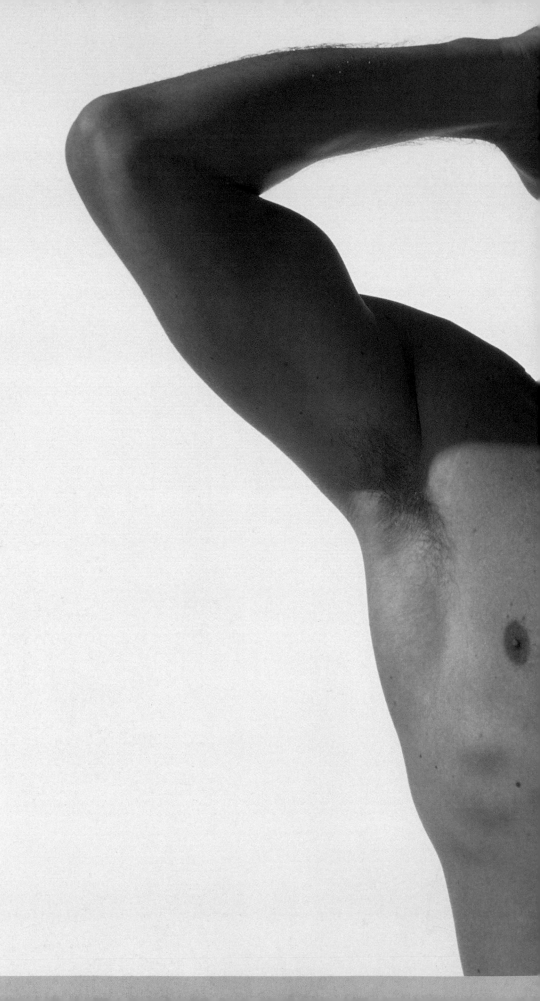

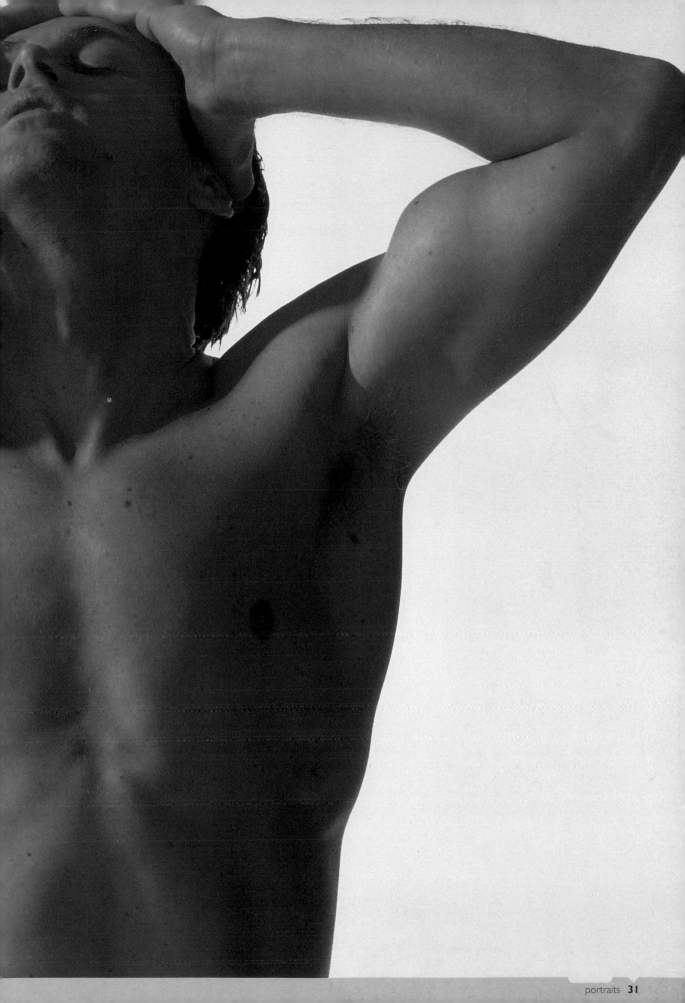

Photographer: **Frank Wartenberg**

Client: **Maxi**

Use: **Editorial**

Camera: **Mamiya**

Lens: **360mm f/5.6**

Film: **Fuji Velvia rated at 40 ASA**

Exposure: **Not recorded**

Lighting: **Electronic flash: 4 heads**

Props and set: **White backdrop**

Plan View

▼

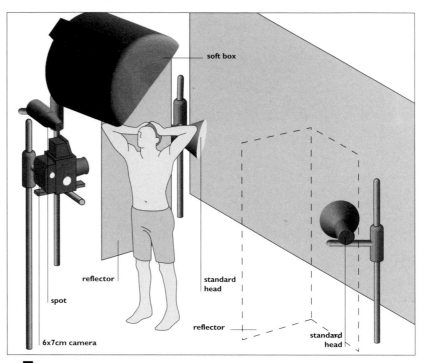

soft box

reflector

standard head

spot

reflector

6x7cm camera

standard head

THE POSE, IN ASSOCIATION WITH THIS LIGHTING, CREATES AN IMAGE OF A YOUNG MAN STRETCHING AND BASKING IN THE LOW SUN OF A LATE AFTERNOON AT THE "GOLDEN HOUR". AS FRANK WARTENBERG COMMENTS, THIS IS A PORTRAIT OF "POWER". THE V-SHAPE OF THE WELL-DEFINED TORSO IS A CLASSIC SYMBOL OF MALE BEAUTY.

The key light is a focusing spot modified with an orange gel, side-lighting the model from the left. A large soft box above the camera adds fill and is, again, modified with an orange gel. These two gels combine to give the warm, golden tones to the skin, giving the impression of a deep sun-tan. Two standard heads light the background and are comprehensively flagged with two pairs of 8x4in polystyrene boards, just out of frame. This prevents any white light from reaching the model, which would undermine and work against the goldenness of the skin; and it also prevents any orange light from falling on the background.

► *Natural "golden hour" pre-sunset lighting is typically rich and orange, but as this shot shows, a similar look can be simulated to good effect in the studio*

► *Trade almanacs and meteorological offices can provide accurate sunset and sunrise times for locations all over the world*

Photographer: **Frank Wartenberg**

Client: **BBDO**

Use: **Magazine**

Camera: **Nikon F3**

Lens: **105mm**

Film: **Polaroid Polagraph**

Exposure: **Not recorded**

Lighting: **Tungsten**

Props and set: **Make-up room, mirror**

Plan View

► *The emulsion on Polaroid instant process 35mm films can be quite prone to scratching so make sure your processor is always very clean*

► *When working with mirrors always check and double-check that you can't see what you don't want to see*

B E A U T Y

▼

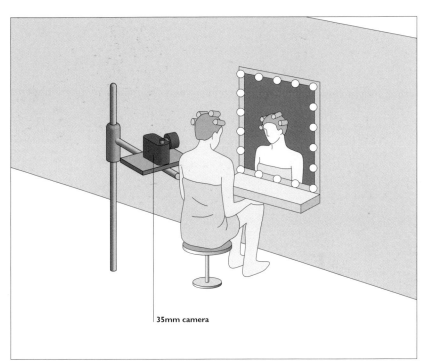

35mm camera

ONCE AGAIN, FRANK WARTENBERG HAS USED HIS FAVOURED COMBINATION OF POLAROID POLAGRAPH FILM STOCK WITH A BLUE FILTER OVER THE CAMERA LENS (SEE ALSO "THE BLONDE" ON PAGE 21).

Both of the shots featured here come from the same shoot with the same set-up, but what is fascinating is how very different are the results. The framing is quite different in each, and the composition along with the model's expressions defines the mood and tone of each. The first is an intimate, sensitive and appealing portrait and the other is a portrayal of an altogether more fierce, moody persona. Direction of the model makes all the difference.

The tungsten light comes from the naked bulbs surrounding a dressing-room make-up mirror, in which the shot was taken as a reflection.

The centre of focus of the second image is the staring, arresting eye, and this is by far the sharpest facial feature. This is the product of a 105mm lens used wide open at close range. The indistinctness of the other features (unclear ear, invisible nose) seem unimportant in comparison with the penetrating gaze of the piercing eye, which effectively expresses the aspect of character that the photographer wanted to capture.

Photographer's comment:

The eyes are great, very strong.

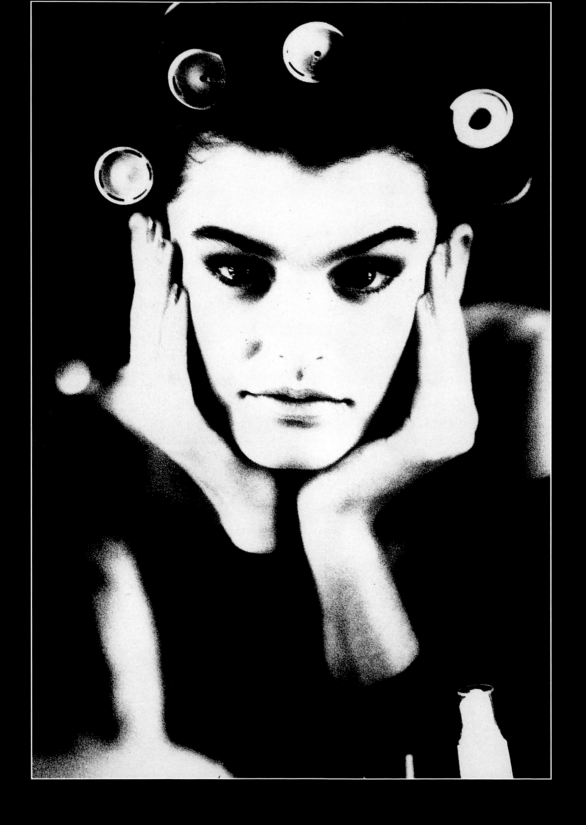

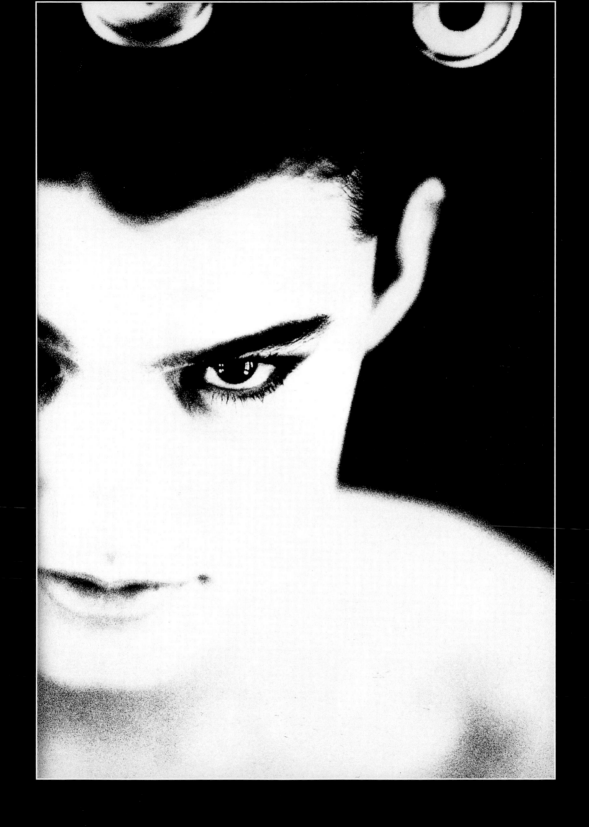

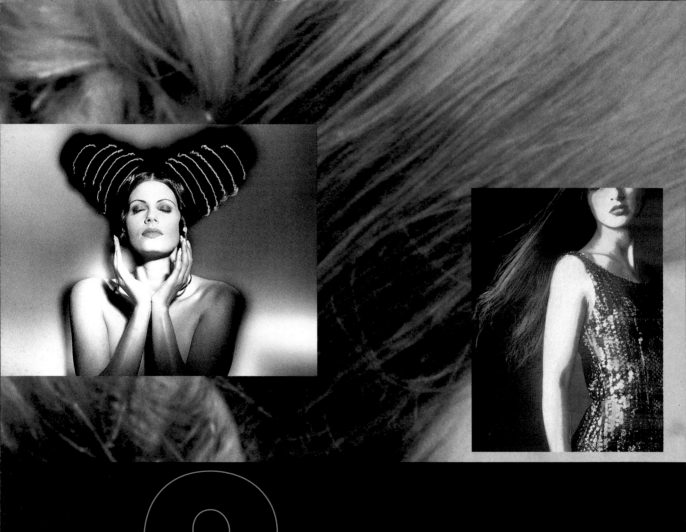

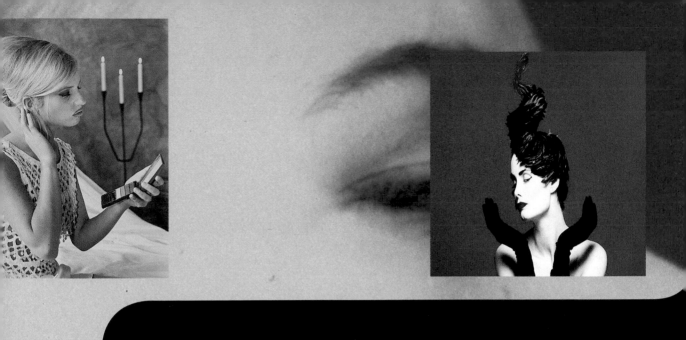

Hair is a wonderful "prop". It can be such a versatile, fun aspect of a person's appearance and while it is something of a truism that "a woman's hair is her crowning glory", hair is certainly one of the most startling, changeable elements of a person's image, being most accessible for changing their looks dramatically. Even the absence of hair can be as striking as its presence in whatever form; hence the inclusion in this chapter of Holly Stewart's shot on page 51 of two people with smooth, presumably hairless heads. Their apparent hairlessness actually adds substantially to the unearthliness of the photograph. There is something quite startling about the absence of hair, particularly on a woman.

It is in the nature of fashion that new styles arrive in regular waves, swiftly displacing what has gone before, and can therefore come to typify a particular era. This is as true of hair as it is of any other aspect of personal appearance (clothes, shoes, make-up, and so on). To see how very evocative of era a hairstyle can be, look, for example, at Julia Martinez's "Vallenders 2" shot on page 53, where the beehive coiffure is instantly recognisable as an iconic style that became almost a by-word for the 1960s, even though the photograph was taken some 30 years after the end of that decade.

Photographer: **Claude Guillaumin**

Client: *Madame Figaro*

Use: **Editorial**

Art director: **Martin Schmollgruber**

Stylist: **D. Eveque**

Camera: **35mm Nikon**

Lens: **180mm f/2.8**

Film: **Kodak EPR 64**

Exposure: **1/60 second at f/16**

Lighting: **Electronic flash**

Props and set: **Blue paper**

Plan View

B R A I D S

▼

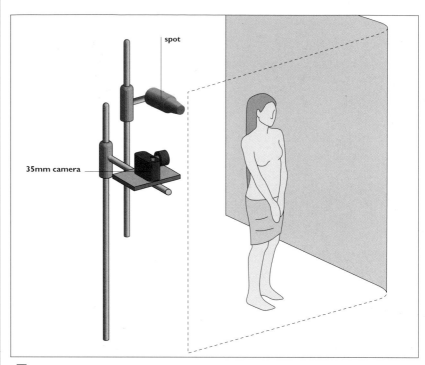

spot

35mm camera

THE STYLING OF THIS IMAGE IS ALL-IMPORTANT. THE HAIR AND BRAIDS HAVE BEEN PERFECTLY ARRANGED TO GIVE A SMOOTH SHEEN OF GLISTENING SILK; A SIMPLE COMPOSITION BUT A STUNNING EFFECT. WITH SUCH A MARVELLOUS MANE OF HAIR AS A PROP, LITTLE ELSE IS NEEDED TO REALISE A MEMORABLE IMAGE.

As ever, it is that "little else" that the photographer must identify. The decision to plait some of the hair into braids accentuates and draws attention to the sheer length and texture of the silky hair, and the choice of a single direct spot light ensures simple but effective highlights and lowlights, making the model's hair glisten brilliantly. The light is positioned square on to the model's back and the light naturally falls away from the braids on the far side, resulting in areas of light and shade that give excellent modelling of the form of the plaits.

The rich, plain purple background contrasts well with golden hair and the model's close proximity to the background causes the interesting deep, focused shadow to the right of the picture, adding to the overall allure and mystery of the shot.

► *Shadow sizes and intensities vary with the distance of the subject from the background. They also vary depending on the distance of the light from the subject, the size of the head and the power*

Photographer's comment:

One flash lights the background and the subject — no reflector.

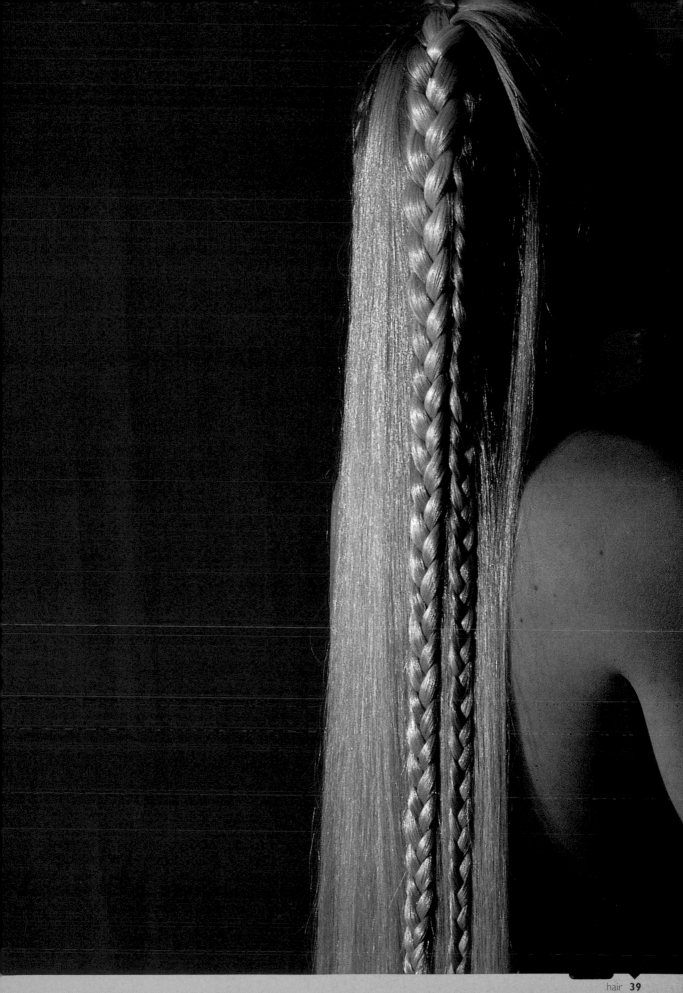

BIG HAIR

▼

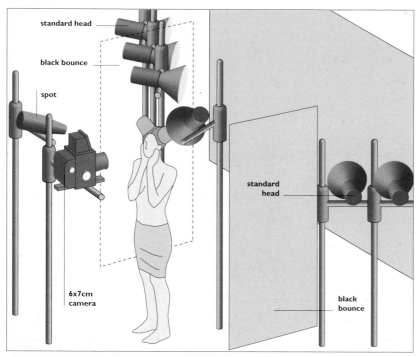

Photographer: **Frank Wartenberg**

Client: **Heye Agency**

Use: **Grundig Magazine**

Camera: **Mamiya RZ67**

Lens: **185mm**

Film: **Agfa 25**

Exposure: **Not recorded**

Lighting: **Electronic flash: 7 heads**

Props and set: **Backdrop light brown to dark brown**

THERE ARE SEVEN HEADS IN ALL, BUT ONLY TWO ON THE MODEL HERSELF. THE OTHER FIVE ARE BARN DOORED TO VARYING DEGREES AND PLAY ACROSS THE BACKGROUND FROM VARIOUS POINTS AND AT DIFFERENT ANGLES, GIVING MOTTLED TONES TO THE BACKGROUND, WHICH IS ALREADY PAINTED WITH A RANGE OF BROWN TONES.

The shimmering effect of the areas outlining the model and across the rest of the backdrop is the product of several elements. First, the focusing spot on the model is actually de-focused to keep the distant shadow edges soft. The model is several metres away from the background and this too adds to the soft definition of the shadows. Finally, the criss-crossing lights give varying depths and intensity of illumination on the background at different points.

As well as the de-focused focusing spot, the model is lit by a standard head positioned quite high up, giving good detail in the face and brightly lighting the arm and hand on the left of the picture. This in turn produces a sharper shadow of that hand across the shoulder (compare this with its soft, slender shadow on the backdrop, visible just to the left side of the hand).

► Soft shadows and hard shadows give totally different "looks"

► There is a time and a place for using large quantities of lights

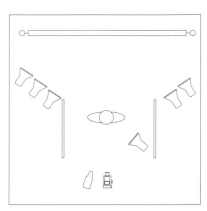

Plan View

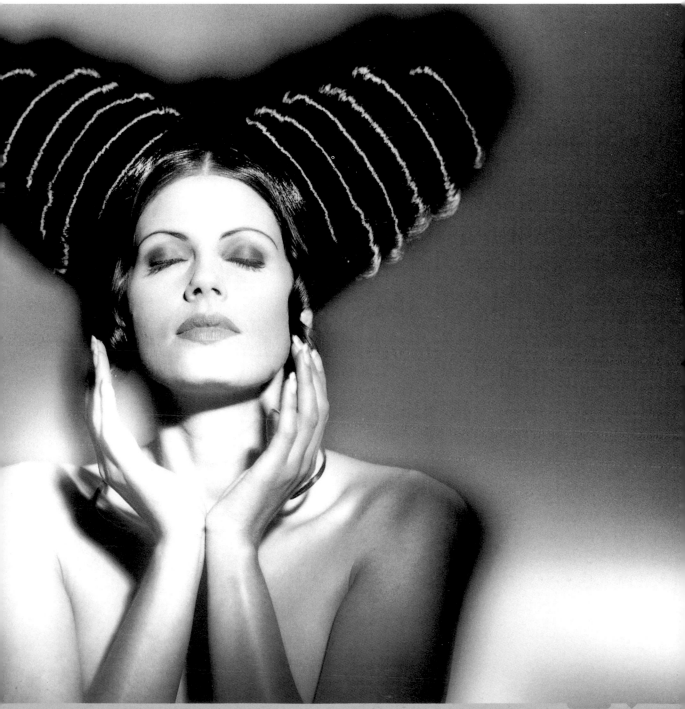

Photographer: **Julia Martinez**

Use: **Personal work**

Model: **Sarah**

Camera: **35mm**

Lens: **135mm**

Film: **Kodak EPP**

Exposure: **f/16**

Lighting: **Tungsten soft box**

Props and set: **Grey background; tracing paper**

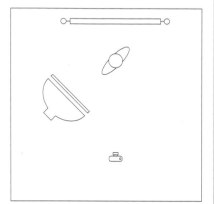

Plan View

▼

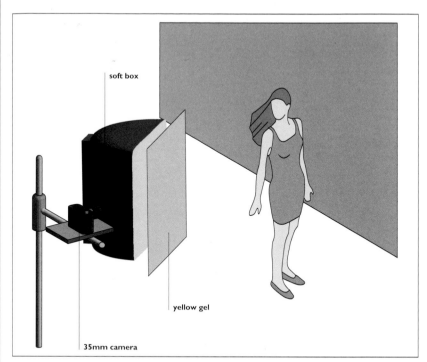

soft box

yellow gel

35mm camera

EVEN THOUGH MOST PHOTOGRAPHERS DEVELOP A PARTICULAR PERSONAL STYLE AND OFTEN TEND TO PREFER TO USE FAVOURITE TECHNIQUES, IT IS NEVERTHELESS IMPORTANT TO EXPERIMENT AND HAVE OTHER WORK AVAILABLE TO SHOW IN A PORTFOLIO, AND A WIDE RANGE OF IMAGINATIVE IDEAS AND TECHNIQUES TO DRAW ON FOR ANY INDIVIDUAL COMMISSION.

Julia Martinez is best known for her simple, natural light, black and white portraits, but here she has moved not only into the realm of colour film but also enhanced it with additional hand-colouring.

The subject was lit simply with a soft box modified with a yellow gel, using only the modelling light. A relatively long shutter speed was used to give a little movement and soft ghosting, and to burn out areas of the face and arm. So far a conventional approach. But the next stage was to take some tracing paper and hand colour areas of this to add colours to the hair and dress. The painted paper was used as an underlay placed behind the transparency, and the whole "sandwich" was shot again onto a second transparency to produce the final image.

► *Using a larger format of transparency with this kind of technique would mean a larger area of hand-painting to be done – not always the preferred option*

► *Hand-colouring is often most effective when not immediately obvious*

Photographer's comment:

This is not typical of my work. I tend to play up on simplicity but here I was experimenting.

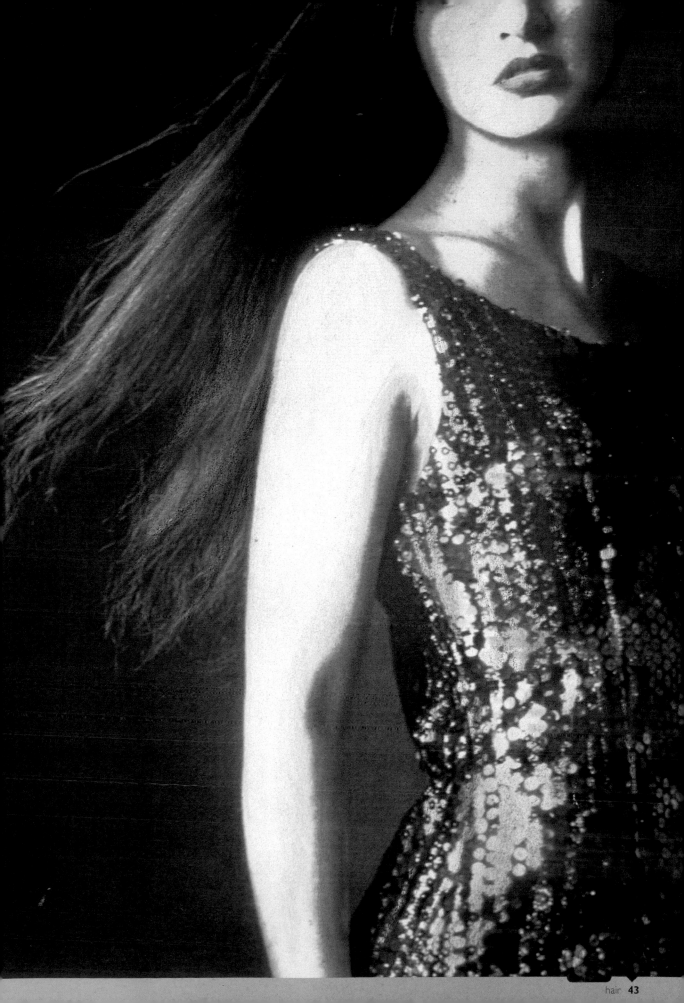

Photographer: **Marc Joye**

Client: **Personal work**

Use: **Portfolio**

Model: **Genevieve**

Camera: **Mamiya 6x6cm**

Lens: **80mm**

Film: **Tmax 100**

Exposure: **1/30 second at f/11**

Lighting: **Electronic flash: 4 heads**

Plan View

COLOURED HAIR

▼

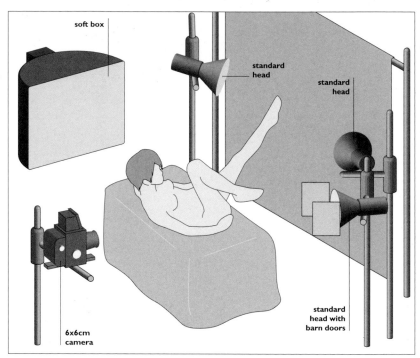

\mathbf{T}HE MODEL IS ON A DRAPED ROSTRUM IN FRONT OF A BRIGHTLY LIT BACKGROUND. ALTHOUGH THE GENRE IS CLEARLY THAT OF SCULPTURE ON DISPLAY IN A GALLERY, THE POSE IS FAR FROM TRADITIONAL, AND THE HAND-PAINTED HAIR ADDS A FURTHER TWIST TO A FAMILIAR THEME.

The clean, cool, impression of art gallery lighting comes from the illumination on the upper parts of the body. A typical sculpture gallery would perhaps generally be lit by natural light coming through high windows at the top of the walls, or, even more commonly, by glass skylights in the roof. For this shot, the standard head with barn doors to the right is the key light and is placed at a height of 3 metres to emulate such an arrangement. A soft box fills the model's back and two standard heads, placed at 45 degrees, light the background brightly and evenly.

► *Photographic paper can be hand-tinted with paint, food colouring, dyes, acrylic, ink – lots of different things*

► *Different papers absorb dyes in different ways so it is sensible to experiment on a gash piece of the same type of paper first*

Photographer's comment:

The photo of Genevieve was nice as it was shot. But while she had short, punky hair, I wondered how it would look with some Tina Turner wild hair. So I painted this on the print.

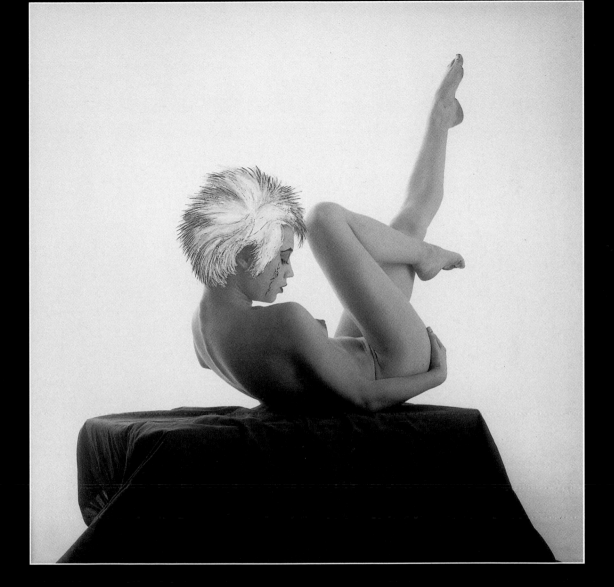

Photographer: **Claude Guillaumin**

Client: **Femme**

Use: **Editorial**

Art director: **Albert Veli**

Camera: **Contax RTS 35mm**

Lens: **135mm f/2**

Film: **Fuji Provia 100**

Exposure: **1/15 second at f/8**

Lighting: **Electronic flash, tungsten**

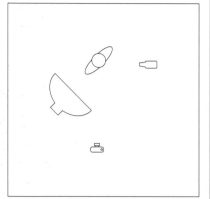

Plan View

CHRISTMAS HAIR-DO

▼

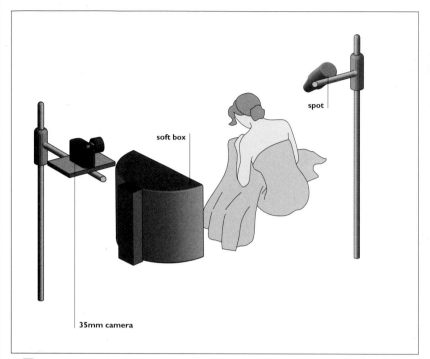

spot

soft box

35mm camera

TWO DISTINCT FORMS OF LIGHTING WERE USED ON THIS SUBJECT, GIVING TWO DISTINCT AREAS OF COLOUR RENDITION.

Claude Guillaumin used daylight balanced film and so the tungsten spot, which falls harshly and directly onto the model's back, causes yellowness with deep black shadows with deeper borders, tending almost to red.

The soft box, meanwhile, picks out the quiff of hair and the upper face, producing "correct" colour balance rendition, appearing as a pool of "blue"-white tones in comparison with the "yellow" tungsten areas. This difference of rendition is particularly apparent over the hair where half the head has an emphatic golden colour tone and the other half of the head has a pool of silvery light.

The mid-ground golden net material gives opportunities to pick up pin-pricks of light, as does the the embroidered cap, while the hair is knotted to give good shapes to catch the light.

► *Choice of lighting does not always have to be an "either/or" decision: it is always worth experimenting with combining sources for special effects*

► *Tungsten studio lamps are normally 3200 degrees Kelvin, whereas electronic flash measures are at about 5600 degrees Kelvin*

► *When tungsten light goes into shadow, the colour temperature drops and the colour tends towards red, whereas increasing depths of shadows in daylight give increasing colour temperature*

Photographer's comment:

You don't need a yellow filter. Tungsten light with daylight film becomes yellow — you can see the white fabric in the background becoming yellow in the tungsten light.

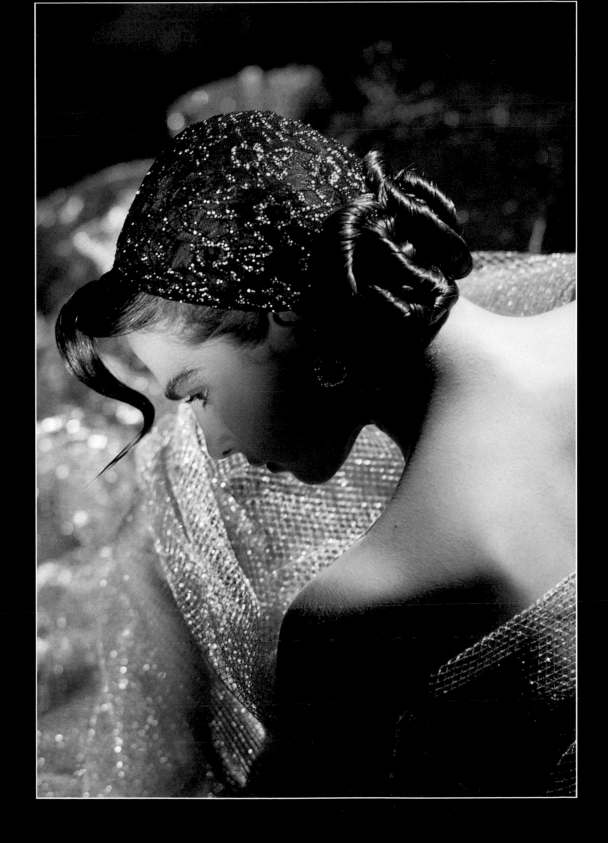

Photographer: **Salvio Parisi**

Client: **Crazy Fashion hair style**

Use: **Poster and magazine**

Model: **Tatyana**

Assistant: **Chicca Fusco**

Hair and make-up: **Anna Alliata**

Stylist: **Xena Zupanic**

Camera: **4x5in with 6x7cm back**

Lens: **210mm**

Film: **VHC Kodak 120 developed in E6**

Exposure: **½ second at f/8**

Lighting: **Electronic flash**

Props and set: **Grey background**

Plan View

T A T Y A N A

▼

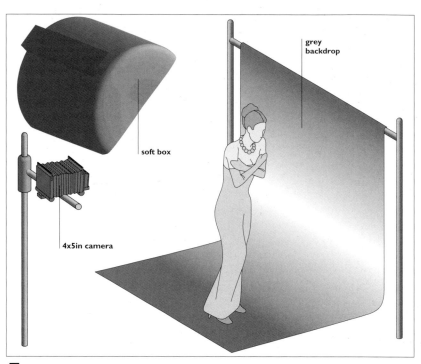

grey backdrop

soft box

4x5in camera

THE HAIR, GLOVES, JEWELLERY AND ELEGANT CLOTHING CREATE A GLAMOROUS, STYLISH FEEL, REMINISCENT OF A 1950S FILM-STAR IMAGE. THE FEMININE ACCOUTREMENTS ALL KEEP THE PERIPHERY OF THE SHOT BUSY WHILE THE MAIN ATTENTION IS ON THE LARGE EXPANSE OF COIFFURE, SET OFF AGAINST THE BOLD DIAGONAL OF PEARLY SKIN.

The simplest of lighting was used. A large soft box above the camera is tilted down towards the model. There is no separate lighting specifically on the background, leaving it quite dark.

The intensely cyan tone comes from the cross-processing which transforms, for example, the colour of the background, which was actually grey, to the deep blue of the final image. Compare the blueness of this picture with another of Salvio Parisi's shots, "Marta", on page 109. The same red and yellow filtration was used but whereas this picture was developed for the standard recommended time, the film for "Marta" was over-developed to give an overall yellow result.

► *This cross-process classically gives a cyan-tinged low contrast result – but the deliberately very high contrast set-up allows for this and retains considerable high contrast result*

► *Cross-processing can upset the ISO film rating so it is advisable to do tests*

Photographer's comment:

The aim with this picture was to produce a typical beauty/hair shot, which means femininity, elegance and a bit of sensuality.

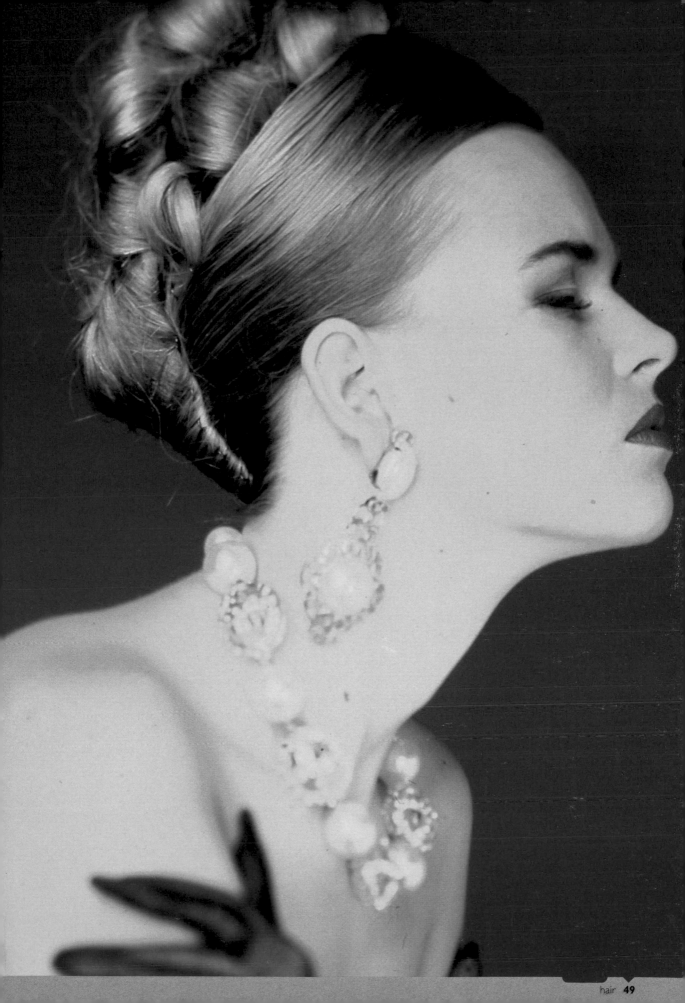

Photographer: **Holly Stewart**

Client: **Self-promotion**

Use: **Mailer**

Models: **Lauren Biagi, Vanessa Nisson**

Stylist: **Dawn Sutti**

Camera: **6x6cm**

Lens: **180mm**

Film: **Kodak Plus-X**

Exposure: **1/125 second at f/16**

Lighting: **Electronic flash: soft box plus reflectors**

Props and set: **Painted background**

Plan View

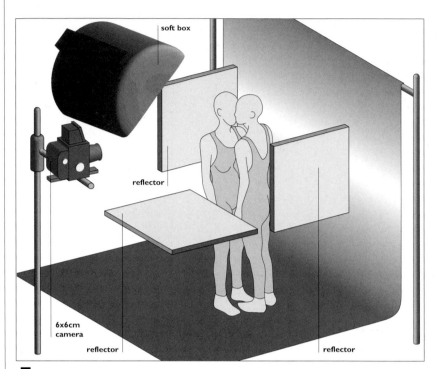

THE STRIKING ABSENCE OF HAIR IMPLIED IN THIS PICTURE HAS A STRONG IMPACT. IT MAY SEEM PERVERSE TO INCLUDE IT IN A CHAPTER THAT IS ENTITLED "HAIR", BUT THE POINT IS THAT THE ABSENCE OF HAIR, JUST AS MUCH AS THE PRESENCE OF HAIR, CAN BE A POWERFUL ASPECT OF A PERSON'S APPEARANCE. HERE THE COOL, CLEAN, BARE CONTOURS OF THE TWO FACES ARE EXPLORED IN A PICTURE WHICH TAKES AN ALTERNATIVE LOOK AT FEMININE BEAUTY.

The two faces are juxtaposed to give a strong graphic composition, with the profiles of the faces overlapping to introduce recessed shadow areas.

The painted background is not specifically lit itself, only incidentally by the soft box which is primarily directed at the models. It records as darker than the models, giving some separation between them and the area behind.

As the soft box is positioned above the height of the models, it produces some modelling on the lower edges of the chins. Otherwise there is very little modelling. The models are bathed in a pool of reflected light by the use of three white cards, one to each side and one in front. The smooth skin is evened out to give a minimum of modelling, resulting in this striking, ethereal image.

► *Imaginative posing can give a whole range of different "looks": the graphic overlapping gives an Escher-like design feel to this shot*

► *The direction the model is looking in relation to the light source will determine whether or not there will be catch-lights in the eyes*

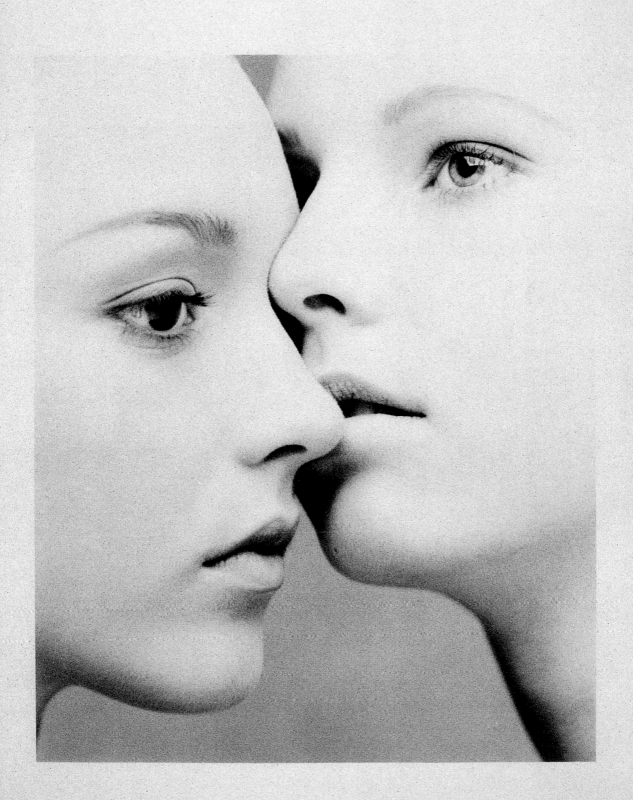

Photographer: **Julia Martinez**

Client: **Vallenders Hair Co.**

Use: **Editorial poster**

Model: **Kate Lofts**

Art director: **Jo Vallender**

Camera: **Canon EOS 600**

Lens: **100mm**

Film: **Tmax 100**

Exposure: **f/11**

Lighting: **Available light and fill-in**

Props and set: **Mosquito net**

Plan View

▼

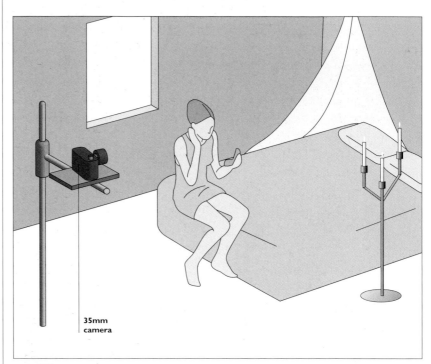

35mm
camera

"KATE LOFTS WAS A GREAT MODEL," SAYS JULIA MARTINEZ. "SHE HADN'T MODELLED BEFORE, BUT I KNEW HER PERSONALLY AND THAT HELPED. THE SHOT WAS TAKEN IN SOMEONE'S APARTMENT. THE OWNER RIPPED OUT HER LIVING ROOM TO ALLOW US TO CREATE THE SET. SHE ALREADY HAD PAPIER MÂCHÉ FINISH WALLS, AND HAD COLOURED THEM WITH STRONG COLD INSTANT COFFEE!"

A window behind the model is the main light source. The compact mirror held by the model is positioned to provide throw-back fill on the face. The chosen angle of the model in relation to the window is important in that it ensures a good even light across the "grain" of the hair, giving a highlight sheen but not losing the detail of the texture.

The overall styling and set-dressing is important too. The emphasis on texture throughout the image accentuates the smoothness of the coiffure: the "busy-ness" of the model's clothing, the mottled background and rippling mosquito net all provide contrast with the silky mound of hair.

► *Silver reflectors, in this case, the compact mirror, are much more directional than a plain white reflector would be*

► *Different films have different responses to wide lighting ratios*

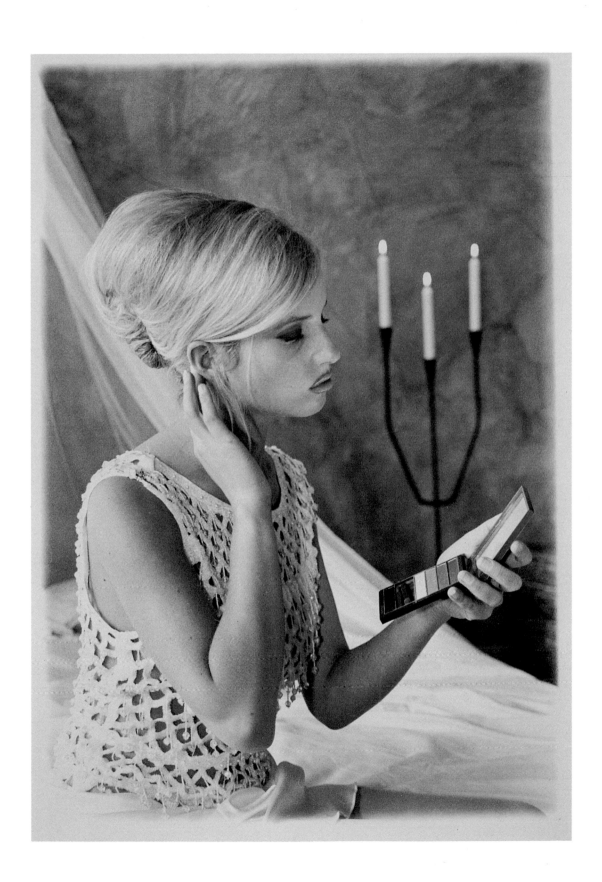

Photographer: **Benedict Campbell**

Client: **Rachael Skinner – Milliner**

Use: **Promotional**

Model: **Rachael Patrick**

Assistant: **Max**

Make-up: **Maria Comparetto**

Camera: **35mm**

Lens: **200mm with 1.5 anamorphic lens**

Film: **Fuji Velvia (cross-processed)**

Exposure: **1/30 second at f/16**

Lighting: **Electronic flash: Fish Fryer with modelling light on, daylight**

Props and set: **Rachael's hat, background white wall, foreground aluminium sheet**

Plan View

C U R L Y W U R L Y

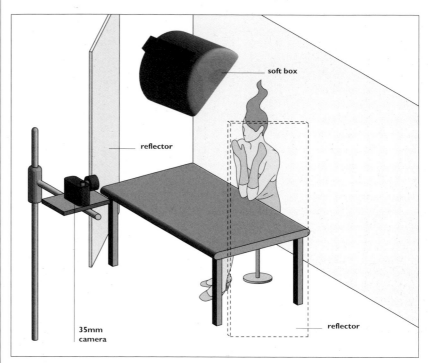

ALTHOUGH THIS COULD WELL BE A PHOTOGRAPH OF AN EXTREMELY ELABORATELY-DRESSED COIFFURE, IT IS IN FACT THE WORK OF A MILLINER AND NOT THAT OF A HAIR STYLIST. THIS SPLENDID HAT IS FULL OF MOVEMENT AND FUN AND IS INCLUDED IN THIS "HAIR" CHAPTER AS A "VARIATION ON THE THEME" OF HEAD-DRESSING AT ITS MOST THEATRICAL.

The intrinsic drama of the subject is exaggerated by the use of the additional anamorphic lens attached to the 200mm lens, which elongates the image and accentuates the towering height and shape of the hat. The pose is carefully directed to correspond with this effect, with strong bold uprights (the throat and dark gloved hands and arms) contributing to the impression of height.

The top lighting provided by the very large soft box helps to give the flat, graphic shapes that are reminiscent of the high fashion icons that Benedict had in mind, flattening the skin tones in conjunction with the two large white vertical polyboards at the sides. The room has a glass ceiling so although there is no specific lighting on the background, the white wall behind is lit to register as grey, which takes on a blue coloration in the final image because of the cross-processing.

► *It is possible to introduce distortions to an image at the printing stage*

► *The form of a distinctive central prop or product can inspire the whole concept for a shot*

Photographer's comment:

The shot tries to encapsulate the qualities of 1950's Chanel/Dior shots. The anamorphic lens gives the elongated effect – a cinematographic lens used for wide-screen pictures.

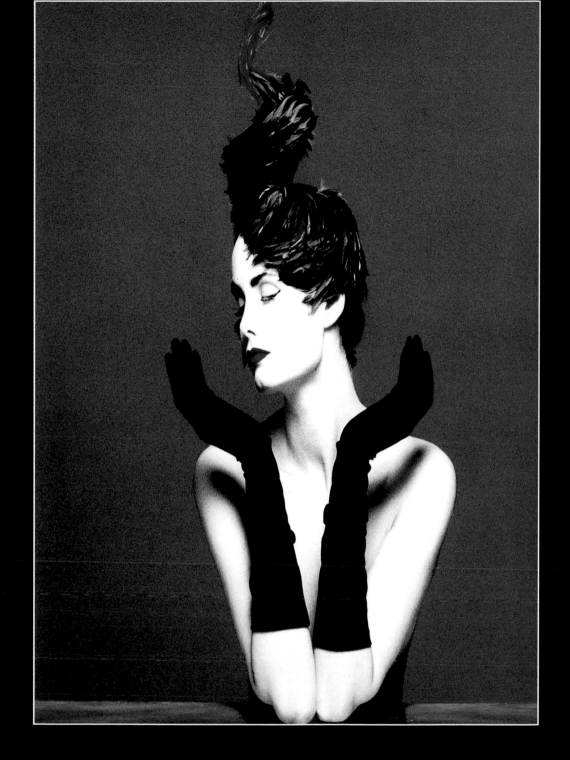

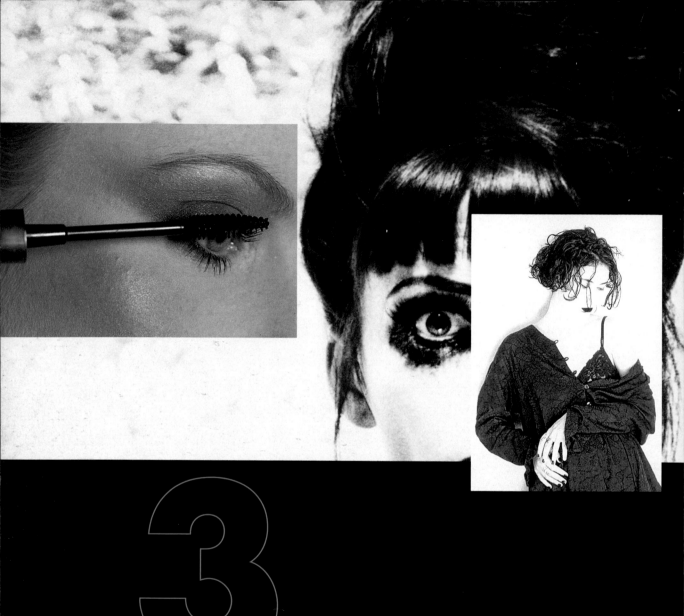

3

make-up

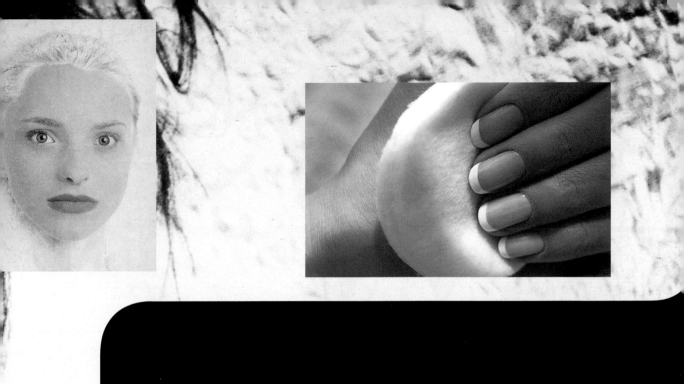

For beauty shots, the photographer's most important colleague is arguably the make-up artist, an essential member of the team with a highly skilled task to perform. The purpose of the shoot might be to advertise the product, or the model, or the ease of use of individual items of make-up, or the overall results that can be achieved with a particular brand of make-up … the possibilities are endless, but a successful result for the photographer will rest heavily on first-rate work by the make-up artist.

The images in this chapter represent a wide range of emphases on aspects of make-up, from a clear concentration on lipstick, for example, in Joseph Colucci's "Thought" on page 59, where most of the image is in graphic black and white, while the lips are in vivid and startling colour; to images that depict, as much as anything, the art of the make-up artist, such as in Günther Uttendorfer's "Susanne" shot on page 63, where the first question in the viewer's mind is to do with working out what, exactly, we are looking at: what has the make-up artist done? The answer in this case is that not only the model, but also the whole area around her head has been carefully "dressed" with powder.

The photographer has to know when to introduce a photographic "twist" to an image – and when to keep a low profile and take an almost documentary approach of simply recording what the model and make-up artist have to offer. When the make-up is already shouting for attention, for example in Benedict Campbell's "Red Rachael" (page 67), the photographer has to decide between an equally unconventional photographic approach (playing with composition, lighting, processing and finishing techniques) or a more restrained style, if the "creative" approach is felt to be in danger of undermining or detracting from the subject. Less is indeed sometimes more.

Photographer: **Joseph Colucci**

Use: **Self-promotion**

Design: **Joseph Colucci**

Camera: **4x5in**

Lens: **250mm**

Film: **Polaroid, Tmax 100 and Kodak EPP**

Exposure: **f/5.6**

Lighting: **Electronic flash: one head**

Props and set: **White seamless paper**

Plan View

THOUGHT

▼

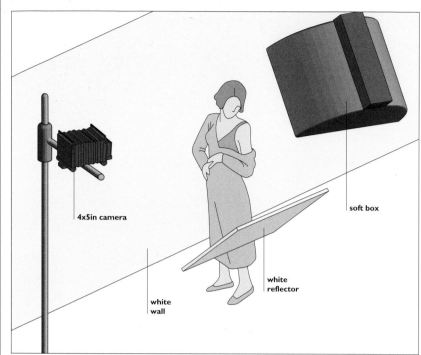

4x5in camera

white wall

white reflector

soft box

ALTHOUGH THERE WERE SEVERAL STAGES TO THE CREATION OF THIS PHOTOGRAPH, JOSEPH COLUCCI CLAIMS THAT, "THE IMAGE WAS CREATED SIMPLY", USING A FAIRLY STRAIGHTFORWARD SET OF PROCEDURES.

The subject was standing against a white wall with a square soft box to the right, and a white reflector between and below the camera and the soft box. A 4x5in Polaroid was taken and then mounted onto a piece of cardboard and re-photographed onto black and white stock to add contrast. A print was made from this, and the lips were painted red using a water-based paint. This whole image was then photographed once more on EPP transparency film. The result of putting the image through so many generations of photograph is an image of high contrast and deep detail in the shades of black, while the skin and background areas have almost completely burned out to a clear flat white, with just the bare minimum of necessary modelling visible, giving the classic "Gothic" look that Joseph had in mind.

► It might be tempting to tint the fingernails too in such a shot, but this would weaken the impact of the coloured lips and detract from the picture as a whole

Photographer's comment:

At the time of this shoot I was into the Gothic look because of the high contrast of the light skin and the dark hair and make-up.

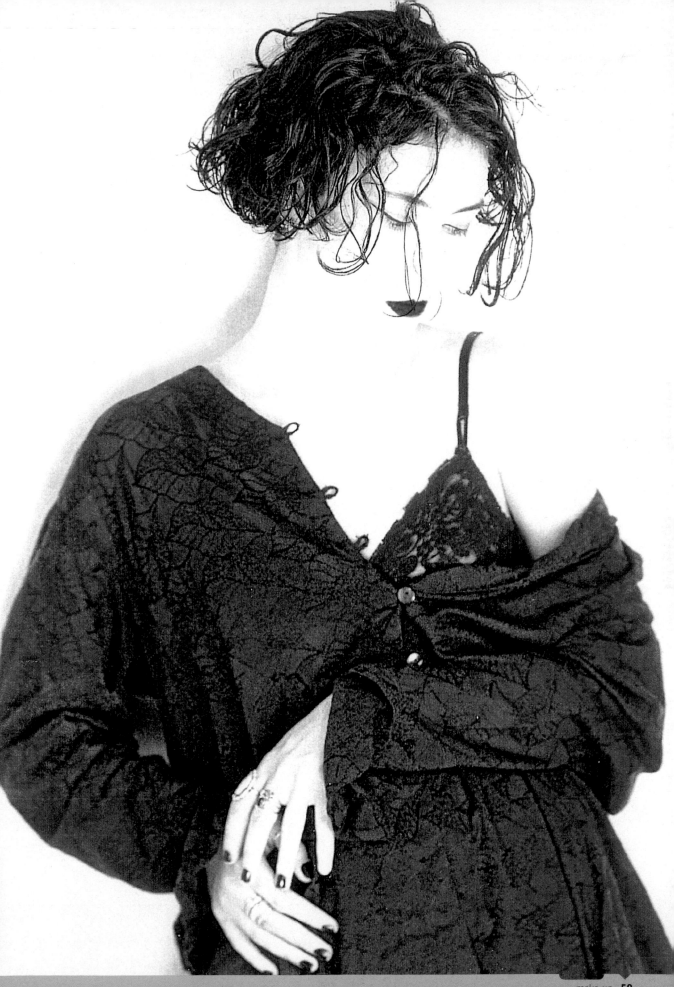

MASCARA

▼

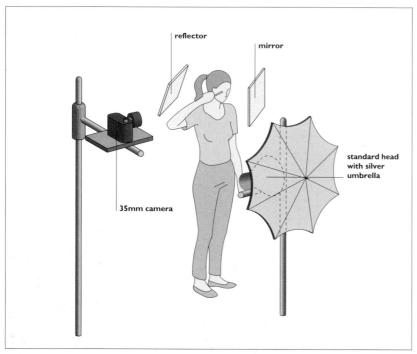

Photographer: **Claude Guillaumin**
Client: **Madame Figaro**
Use: **Editorial**
Art director: **Martin Schmollgruber**
Stylist: **D. Eveque**
Camera: **Contax RTS 35mm**
Lens: **Zeiss 60mm macro**
Film: **Kodak EPR 64**
Exposure: **1/60 second at f/16**
Lighting: **Electronic flash**

Diagram labels: reflector, mirror, 35mm camera, standard head with silver umbrella

A 60MM LENS IS AN UNUSUALLY SHORT MACRO LENS TO CHOOSE FOR THIS KIND OF SHOT. IT REQUIRES THE CAMERA TO BE IN VERY CLOSE PROXIMITY TO THE MODEL, WHICH CAN BE A DIFFICULT ARRANGEMENT TO WORK IN AND TO LIGHT, AND IT TAKES AN EXPERIENCED PROFESSIONAL TO MAKE THE SHOT WORK SO EFFECTIVELY.

A strong, but not harsh, intensity of light is needed here in order to retain a relatively large depth of field. The silver umbrella diffuses the flash since a direct flash would be too harsh and uncomplimentary and would give a harder, sharp shadow of the brush and barrel on the face.

The mirror picks up the details of the lower lashes and eye and the reflector to the left gives smooth, even highlight along the barrel of the brush itself, giving it shape and modelling, as well as providing even light across the whole of the subject.

Photographer's comment:

You should use a small reflector to fit between the model and the photographer. In this close-up the photographer is very close to the model (30-45cm).

► A longer macro lens would make it possible to achieve the same frame size from further away, alleviating some of the practical difficulties of lighting the subject at close quarters

► It is sensible to check beforehand whether a model is left-handed or right-handed as this will affect the set-up of the shoot

Plan View

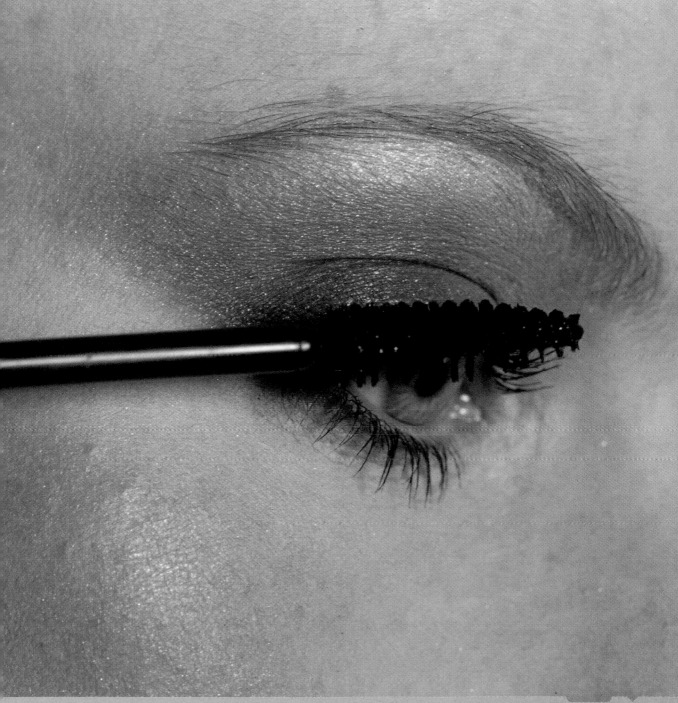

Photographer: **Günther Uttendorfer**

Client: **Hair and beauty exhibition**

Use: **Poster**

Model: **Susanne/Rothchild Agency**

Assistant: **Jurgen Weber**

Make-up: **Genevieve**

Camera: **35mm**

Lens: **50mm f/1.8**

Film: **Polachrome**

Exposure: **f/8**

Lighting: **Electronic flash: 1 head**

Props and set: **The model is lying in white powder**

Plan View

► *Sometimes the lighting is the least troublesome aspect of getting the picture*

► *It is important to make sure that the model is not allergic to any props such as powders, liquids or body paint*

S U S A N N E

▼

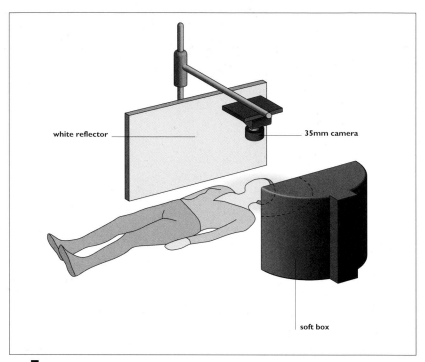

white reflector — 35mm camera

soft box

For the "Props and set" listed in the technical information for this shot, Günther Uttendorfer mentions that "the model is lying in white powder". A moment's thought shows that logistical problems of such a setting are bound to arise. "Sometimes it takes a lot of patience from the model to get a good shot," comments Günther, wryly.

It emerges that for this picture the model was not allowed to breathe for about half a minute so that the fine white powder would not be disturbed. Even the gentle turbulence of breath would have blown the powder away, leaving a gap around the model's head.

After the elaborate care taken to produce the setting and arrange powder and make-up, the lighting itself is from a technical point of view, very straightforward. A 75cm square soft box to the right is almost face-on to a white reflector on the opposite side of the

model, and the camera was positioned directly above and square-on to the face. The resulting even sweep of light across the face gives only a slight amount of modelling. For example, the shadow below the chin on the left is gentle penumbra rather than full deep shade, giving only marginally more separation than there is on the key light side. The resulting relative "flatness", suggesting a detached face hovering out of an indefinable background, ensures the surreal quality of the image.

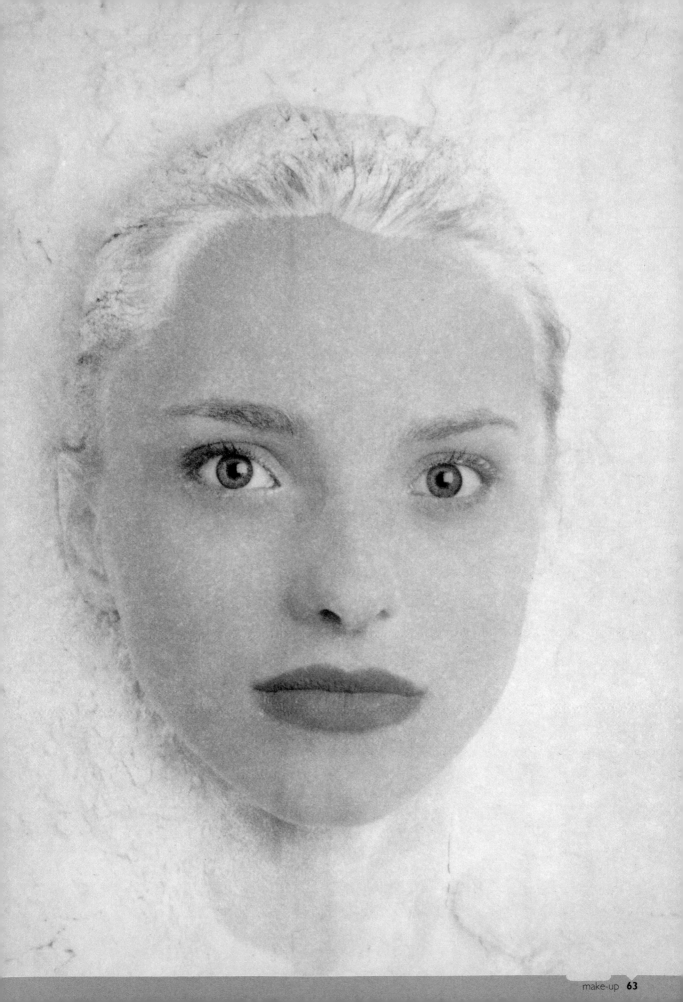

Photographer: **André Maier**

Client: **Capelli Punto Salon**

Use: **Advertising**

Camera: **35mm**

Lens: **100mm macro**

Film: **Kodak Tmax 100**

Exposure: **f/2.8**

Lighting: **Available light**

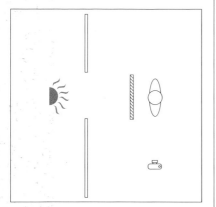

Plan View

▼

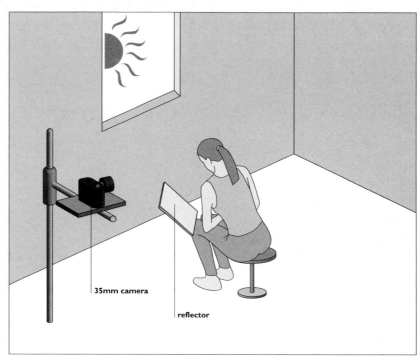

35mm camera

reflector

Sometimes a spontaneous shot taken outside the main shoot can be the success story of the day. André Maier says, "This photo was taken during the set-up of the actual shoot. It wasn't planned but turned out to be the final selection."

It is easy to see why this glamorous image caught the eye of the client. The pensive expression and haunting Judy Garland-like innocence of the shot is accentuated by the classic silver screen Hollywood look created by the make-up and choice of black and white film stock. Extremes of tone remove all detail from the complexion, leaving the emphasis on the exquisitely made-up eye and lips and finely sculpted eyebrow.

The eye is the most important feature of the image, and its expression is punctuated by a large, bold reflection of the window behind the camera. The texture of the lashes is enhanced with mascara and eye shadow to give a deep velvety look in the midst of the smooth, white area of skin. The window is the only source of available light, and use of a reflector tight into the model's face evens out the light further.

The negative was printed one stop over-exposed, bleached with Farmer's Reducer, and selenium toned — the bleaching reduces the light mid-tones but keeps the blacks of the background and the eyes.

Photographer's comment:

Seize the opportunities and be flexible.

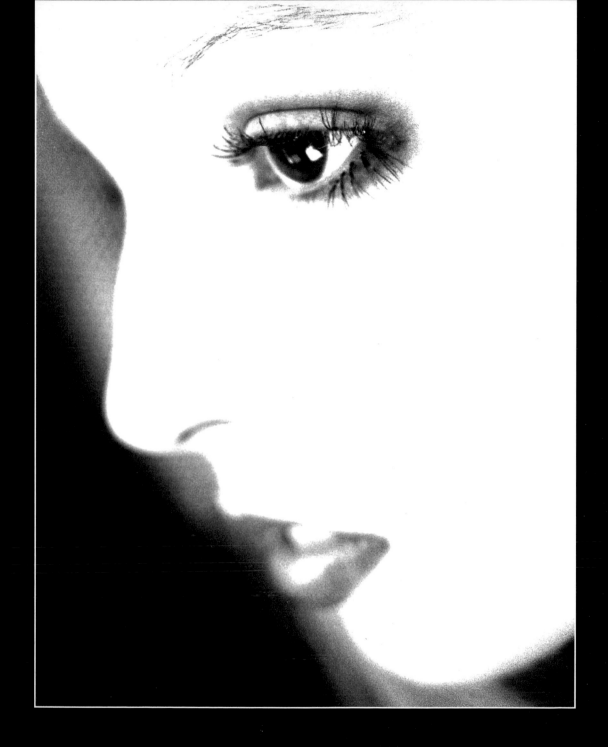

Photographer: **Benedict Campbell**

Client: **Vernon Oakley**

Use: **Calendar**

Model: **Rachael**

Assistant: **Lee Rex Atherton**

Make-up: **James McMahon**

Camera: **6x6cm**

Lens: **80mm**

Film: **Fuji Velvia rated at 100 ISO**

Exposure: **f/11.5**

Lighting: **Electronic flash and tungsten**

Props and set: **Room set using tin foil and cling film and suspended light bulbs above the model.**

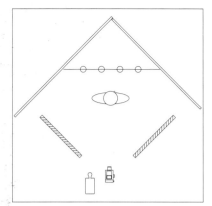

Plan View

▼

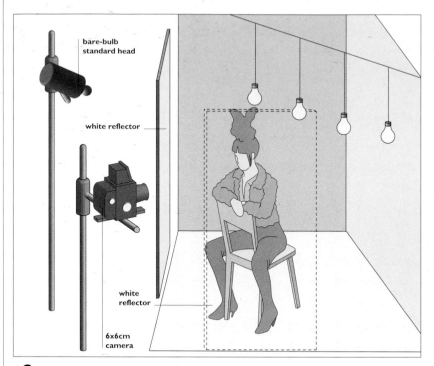

bare-bulb standard head

white reflector

white reflector

6x6cm camera

COLOURS AND TEXTURES SING OUT FROM THIS IMAGE. THE STARTLING MAKE-UP, GLEAMING, PILED-UP HAIR AND VIVID CHOICE OF CLOTHING ARE PERFECTLY SET OFF BY THE SPACE-AGE SILVER BACKGROUND. ALMOST EVERYTHING SHINES, FROM THE LIPS, STRANDS OF HAIR, SATIN SHIRT AND METAL ZIPPER ON THE JACKET, TO THE SILVER FOIL COVERED CHAIR AND BACKGROUND AND, IF YOU LOOK CLOSELY, THE DETAIL OF THE GOLDEN FIXTURE OF A DOMESTIC LIGHT BULB AT THE TOP LEFT OF THE IMAGE. EVERYTHING COMBINES TO DAZZLE.

A bare-bulb standard head, just behind the camera and directed full on to the model, is reflected boldly by two large white panels to maximise the "in your face" impact. Four light bulbs suspended behind the model add further sparkle to the foil backdrop and, importantly, add to the all-round lighting on the model.

Notice the shadow area on the face and neck on the right, created by this arrangement. Of course, the whole of the background is a giant reflector in itself, and the uneven texture from the small creases in it has the effect of dipersing the flash in many directions.

► *Domestic light bulbs have a colour temperature of around 2800 degrees Kelvin, which is lower than the photofloods which operate at about 3400 degrees Kelvin*

► *The brightness and colour temperature can be adjusted by varying the wattage of light bulbs*

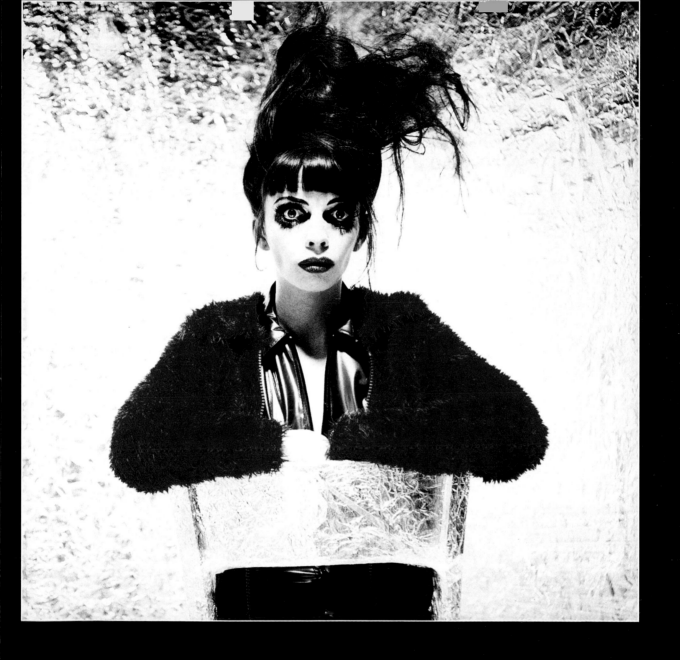

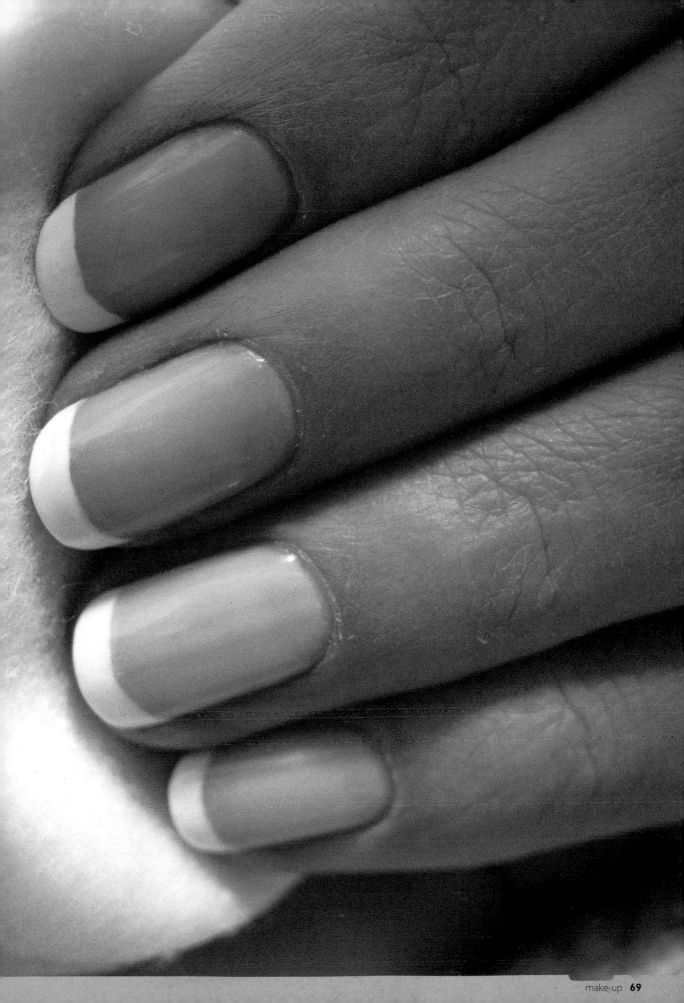

Photographer: **Claude Guillaumin**

Client: **Votre Beaute**

Use: **Editorial**

Art director: **Philippe Van Den Plas**

Stylist: **D. Eveque**

Camera: **Contax RTS 35mm**

Lens: **Zeiss 60mm macro**

Film: **Fuji Provia 100**

Exposure: **1/60 second at f/16**

Lighting: **Electronic flash**

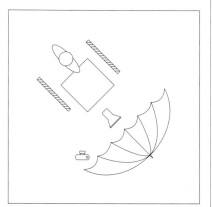

Plan View

F R E N C H M A N I C U R E

▼

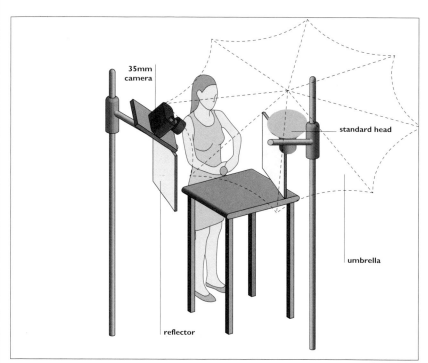

WHEN AN INTRINSICALLY SHINY SUBJECT, SUCH AS A HIGHLY POLISHED SET OF FINGERNAILS, IS TO BE SHOT AT CLOSE RANGE, REFLECTIONS ARE AN IMPORTANT CONSIDERATION FOR THE PHOTOGRAPHER. IN THIS CASE CLAUDE GUILLAUMIN WANTED TO CONVEY THE GLOSS OF THE NAILS WITHOUT HAVING LARGE WHITE AREAS OF HIGHLIGHTS OR OBVIOUS REFLECTIONS OF THE LIGHTING KIT.

The use of a standard head shooting into a large umbrella positioned above at about 45 degrees gives dispersed even light across the subject. The camera is very close to the subject, only about 30-45cm away. The position of the photographer, standing within the curvature of the umbrella, creates an area of slight shade across the cotton wool pad. A gold reflector to the left of camera adds a warm glow to the skin tones along the upper edge of the wrist and arm, while a white reflector to the right lifts the shadows on the fingers.

► *Sometimes a large umbrella is more appropriate for a job than a soft box*

► *Gold reflectors are more directional than white ones*

Photographer's comment:

As I am shooting very close, I have to stand inside the umbrella and use two reflectors held by two assistants.

Photographer: **Ben Lagunas and Alex Kuri**

Client: **Vogue**

Use: **Editorial**

Model: **Zarina**

Assistant: **Luis, Natasha, Suzanne**

Stylist: **Charle**

Art director: **Van Dament**

Camera: **Nikon F4**

Lens: **300mm**

Film: **Kodak EPP**

Exposure: **1/125 second at f/5.6**

Lighting: **Available light**

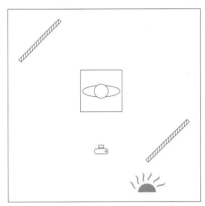

Plan View

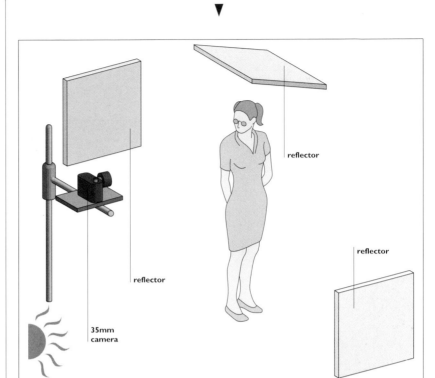

ALTHOUGH ONLY AVAILABLE LIGHT WAS USED FOR THIS SHOT, THERE IS STILL A MULTITUDE OF TECHNICAL FACTORS TO CONSIDER. THE SIDE OF THE FACE TILTED AWAY FROM THE INTENSELY BRIGHT SUNLIGHT IS IN SHADE, AND SO TO "LIFT" THIS AREA A SILVER REFLECTOR IS USED TO BOUNCE LIGHT IN. THE FIERCE FRONTAL LIGHTING, SUPPLEMENTED BY A WHITE REFLECTOR PANEL TO THE FRONT AND ANOTHER ONE ABOVE, IS SO STRONG THAT IT EVENS OUT MUCH OF THE DETAIL OF THE SKIN, ALLOWING THE EYES AND LIPS TO DOMINATE.

► *Catch-lights in the eyes can be the perfect finishing touch*

► *Lenses of sunglasses can be painted with matt paint to avoid unwanted reflections*

► *It is worth bracketing a lot when using cross-processing as the results are fairly unpredictable*

The sunglasses themselves also require consideration. Reflections in lenses can be difficult to control, but here the lenses appear for the most part as matt black, and only the slight reflection on the lens to the right is tolerated in order to pick up on the colour elsewhere.

The highly-contrasty effect exaggerates the bright sunlight and this is achieved by cross-processing the film. This technique also emphasises the hypnotically bright colours of the eyes and lips, which are, again, picked up by the peripheral details of the clothing and deep red hair. It is not accidental that there is no hint of background; the tight crop deliberately concentrates all the viewer's attention on the compelling face.

Photographer's comment:

She had an enigmatic glance, a sensual innocence that captures the viewer and makes them stop at the eyes and the lips.

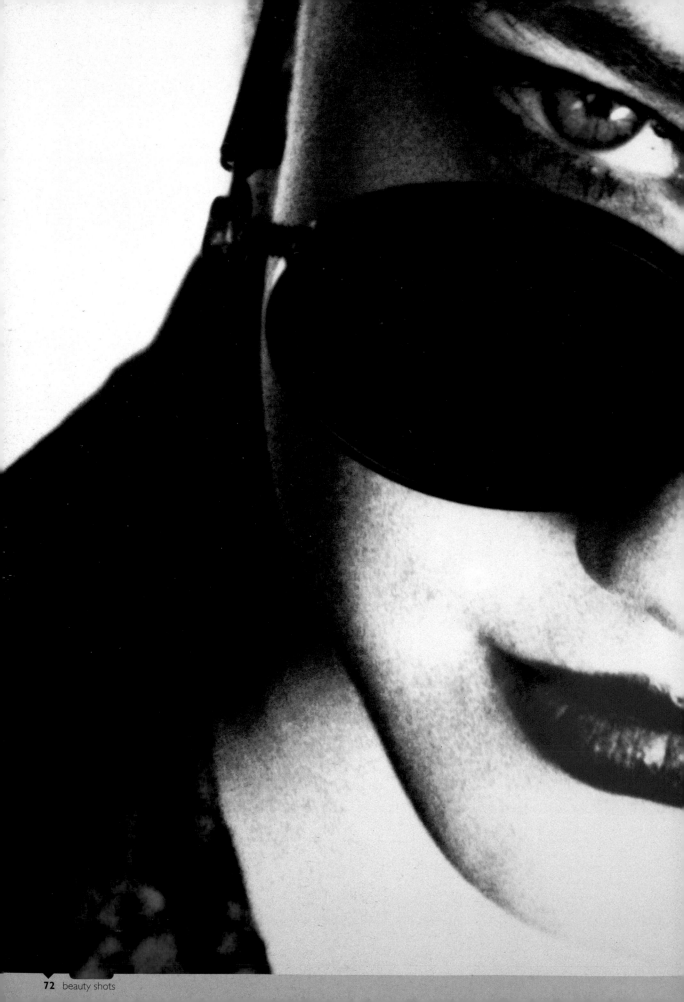

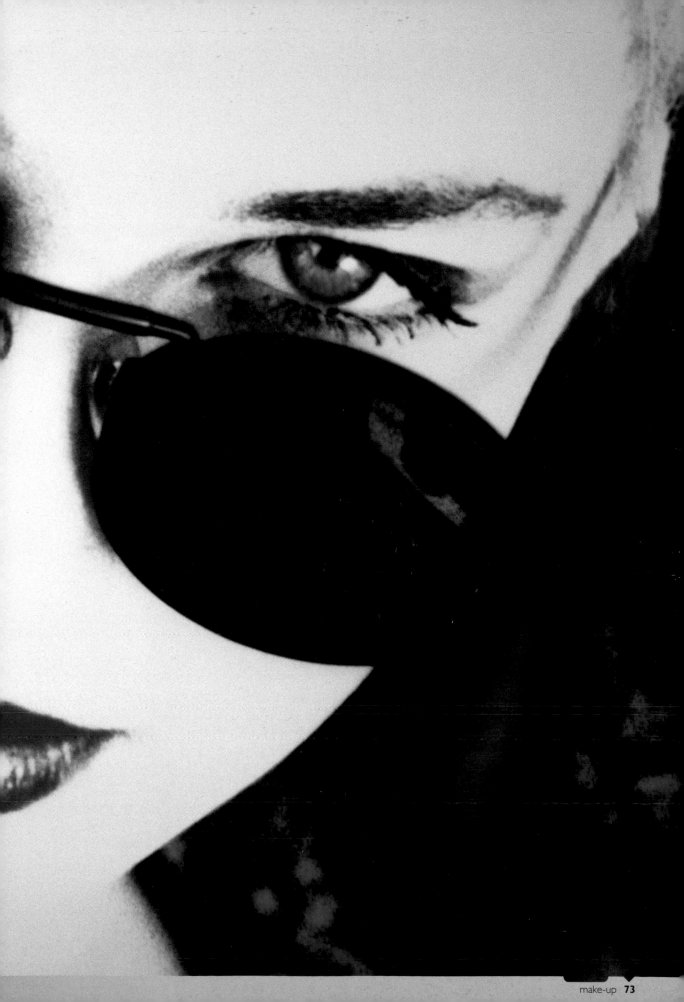

Client: **Super Nails of London**

Use: **Editorial, promotion**

Model: **Natalie Underwood**

Cat model: **Barfi**

Camera: **35mm**

Lens: **105mm**

Film: **Fuji RDP**

Exposure: **Not recorded**

Lighting: **Electronic flash: 1 head**

Plan View

CAT AND NAILS

▼

standard head

35mm camera

reflector

JUST A STANDARD HEAD ON THE LEFT, A REFLECTOR ON THE RIGHT, AN ENORMOUS CAT AND A SET OF INCREDIBLE FINGERNAILS. IT IS POSSIBLE TO MAKE A STUNNING, ASTONISHING AND EYE-CATCHING FEATURE WITH A VERY SIMPLE LIGHTING SET-UP, IF THE MODEL AND PROPS ARE RIGHT.

The fingernails are varnished and polished to perfection, giving a series of glistening highlights. The cat's coat absorbs a large amount of light but the position of the reflector allows a good amount of texture to record. The contrast between the softness of the fur and the sharp, hard texture of the nails contributes to the overall impact of the composition.

Equally important is the arresting gaze of the cat, who has been persuaded to look directly into the camera for the crucial moment of the shot.

► *It is good to make sure an animal is used to and not bothered by flash lights before the shoot – a lot of time can be wasted if the creature responds badly*

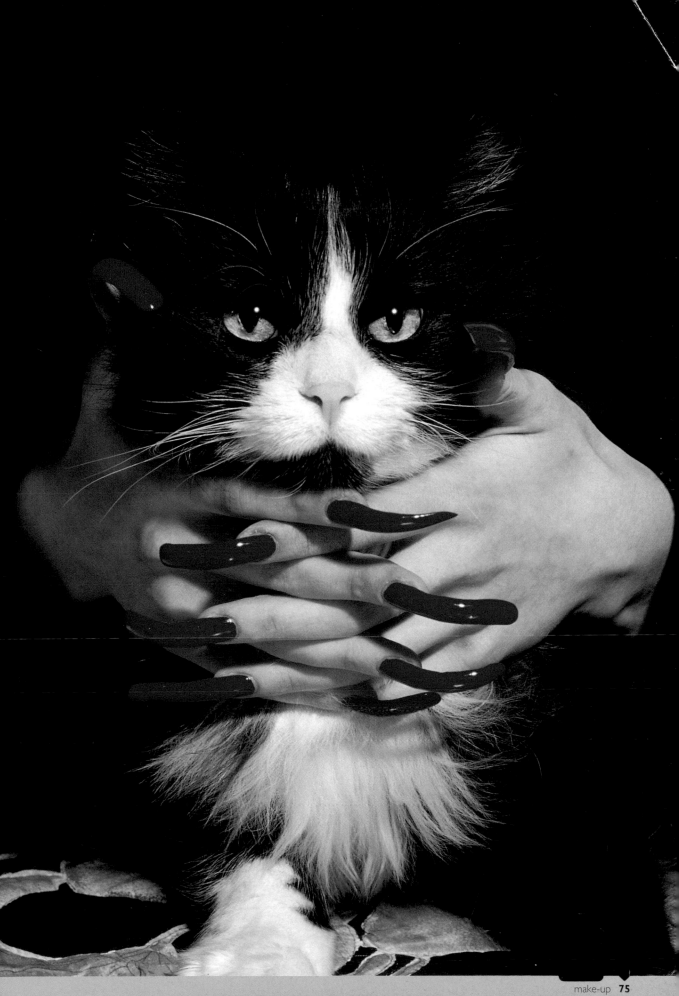

4
products

Product shots are of great importance in advertising, and interesting products can make fascinating art photography still lifes from an artistic point of view. The task of the creative professional photographers featured in this chapter is generally to turn what might threaten to be a dull, straightforward product shot into an effective still life. As might be expected in a collection of product shots, the majority of the photographs in this chapter feature only the products themselves, and only in one case is a model also included in the shot. It is relevant that this latter shot concerns jewellery, a product that benefits from a context and from being viewed in situ, as it were: a necklace being worn by a model.

Most beauty products are understandably designed to be intrinsically beautiful, to promote the promise of beauty, attractiveness and allure that is essential to their commercial success. This attention to design is a gift for the photographer. Many of the products define their own style and imagery with an eye to the potential impact of advertising and shop displays. An actual fragrance, for example, cannot be photographed: we cannot see a smell. But packaging and presentation of a perfume can convey its mood, to give intimations of how the perfume might make the consumer feel, of a lifestyle, of all the desired associations. The challenge for the photographer is to work with these aspects of the product, whether deciding to work with the physical object as a still-life subject, or trying to convey the nature of the fragrance by emphasising particular features that will conjure up the right associations. By contrast, shots of, for example, lipstick, offer a quite different task. Here the colour is primarily what is being sold, as well as texture, ease of use, visual appeal, and so on. This primary concern with

Photographer: **Erik Russell**

Client: **Harpers and Queen**

Use: **Editorial**

Camera: **Mamiya RZ67**

Lens: **90mm with no. 1 extension tube**

Film: **Fuji Velvia**

Exposure: **1/125 second at f/16**

Lighting: **Electronic flash: 2 heads**

Props and set: **Light table**

Plan View

► *Tungsten light is hot and may melt some cosmetic substances*

► *Heat-absorbent filters are available (consuming up to 80% of the heat) but they are very expensive. Electronic flash is the obvious alternative*

L I P S T I C K A R M Y

▼

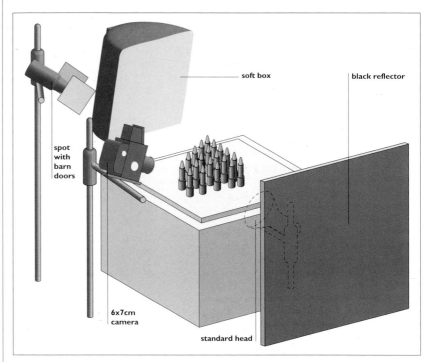

soft box

black reflector

spot with barn doors

6x7cm camera

standard head

THIS APPARENTLY STRAIGHTFORWARD COMPOSITION GIVES LITTLE INDICATION OF THE MANY CONSIDERATIONS THAT GO INTO THE PREPARATION. FINDING PERFECT, SMOOTH LIPSTICK COLOUR STICKS, SCRATCH-FREE, BLEMISH-FREE AND FINGERPRINT-FREE BARRELS, ARRANGING THE COLOURS IN EFFECTIVE COMBINATIONS, EVEN POSITIONING THE MULTITUDE OF TUBES WITHOUT KNOCKING THEM ALL OVER LIKE DOMINOES . . . THE LIST GOES ON.

The highly experienced photographer takes all in his or her stride, and armed with little more than a steady hand, a polishing cloth and a generous supply of lipsticks, the composition is set and the shoot can begin.

The lipsticks were carefully placed on an opal perspex light table with a standard head underneath the table on the line of sight of the camera, flagged by the lipsticks themselves, and acting as a back light. The key light is another head higher than – and to the left of – the camera modified by gated barn doors to snoot the light. A swimming-pool light goes along the edge of the table slightly set back to provide fill. Parallel with this is the black reflector on the opposite side of the table, providing a very small amount of light from the right-hand side to give shape to the lipsticks without introducing too much light (which would have a flattening effect).

Photographer's comment:

We were looking for a regimented form to illustrate the range of available colours.

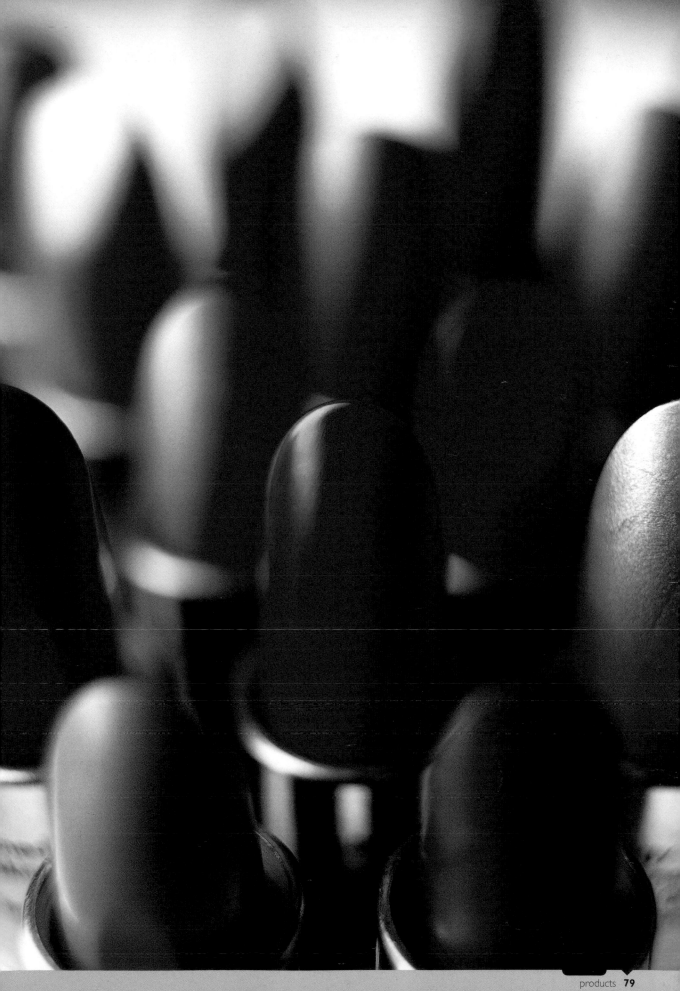

Photographer: **John Paul Arlington**

Client: **Portfolio**

Use: **Self-promotion**

Assistant: **Chris Smith**

Camera: **Mamiya RZ67**

Lens: **110mm**

Film: **Fuji Velvia 50**

Exposure: **1/30 second at f/11**

Lighting: **Electronic flash**

Props and set: **Draped black velvet**

Plan View

► *If there is a danger of getting unwanted reflections of the photographer in the set, a black velvet curtain between the subject and the photographer will help, with a hole just large enough for the camera lens to protrude*

► *One can never be too careful about checking for fingerprints and smears on reflective surfaces*

V O L D E N U I T

▼

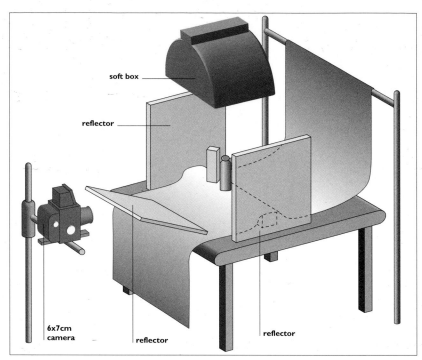

"AS THE NAME OF THE EAU DE TOILETTE IS 'VOL DE NUIT', WHICH IN ENGLISH MEANS 'NIGHT FLIGHT', MY INTERPRETATION WAS TO GIVE THE DARK EFFECT OF THE NIGHT USING THE BLACK VELVET AS BACKGROUND AND THE UV FILTER SMEARED WITH PETROLEUM JELLY TO PRODUCE THE MOTION EFFECT OF THE FLIGHT," SAYS JOHN PAUL ARLINGTON.

Black velvet is a superb dark background, ideal for situations where the product needs to look as though it is suspended in mid-air, and is the perfect choice of backdrop for the "flying in space" illusion that the photographer wanted here. A little extra "something" was needed to complete the impression of flight: in this case, a touch of that versatile substance, petroleum jelly. A small dab of the jelly smeared onto a UV filter gives the required shimmering softness and sense of movement to the bottom of the picture.

A soft box directly over the subject reflected by bounces on almost all sides makes the most of the intricate criss-crossing metallic framework of the bottle, and picks out the embossed finish of the box.

EAU DE TOILETTE

VOL DE NUIT

GUERLAIN

PARIS

Photographer: **Claude Guillaumin**

Client: **Cosmopolitan**

Use: **Editorial**

Art director: **Christian Gamby**

Stylist: **Rosine Vidart**

Camera: **35mm Nikon**

Lens: **180mm f/2.8**

Film: **Fuji Provia 100**

Exposure: **1/125 at f/8 1/2**

Lighting: **Available light**

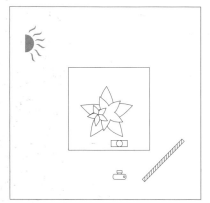

Plan View

► *The photographer has more control over a subject and set-up in the studio, but sometimes the exact effect of natural sunlight is difficult to emulate precisely and an outdoor shoot is more appropriate*

EAU PARFUMÉE

▼

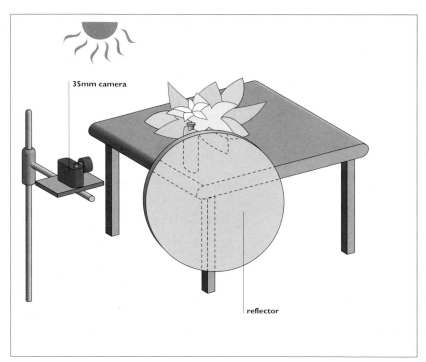

35mm camera

reflector

PRODUCT SHOTS TEND GENERALLY TO BE SHOT IN THE STUDIO UNDER CONTROLLED LIGHTING CONDITIONS, AND IT IS UNUSUAL (AS THE SELECTION OF PICTURES IN THIS CHAPTER INDICATES) FOR A STILL-LIFE PRODUCT SHOT TO BE SET AND SHOT IN AN OUTDOOR DAYLIGHT LOCATION, ESPECIALLY IF THE LANDSCAPE BACKGROUND OF THE SITE IS NOT TO BE WITHIN FRAME.

For this shot, natural outdoor sunlight is the only light source, bounced in with a reflector. The sun is three-quarters on and behind the bottle, shining through the glass and giving some diffraction of the yellow daffodil petals to add interest to the form. The position of the sun brings out the translucent qualities of the green leaves to echo the translucence of the green, perfumed water and the bounce reflects back just enough light to ensure that the all-important trade name on the label is clearly legible, and to highlight the chrome detail of the bottle.

The white almost-triangle of light to the left of the bottle is an important area of space and light in terms of the composition of the whole image. It balances the white highlights in the upper part of the shot as well as balancing the similar grey space created by the gaps in the foliage on the upper right edge of the frame. The yellow edge to one of the leaves has a similar function in relation to the dazzling yellow of the flower and the gentler sunny yellow gleam in the bottle, adding to the harmony of the whole.

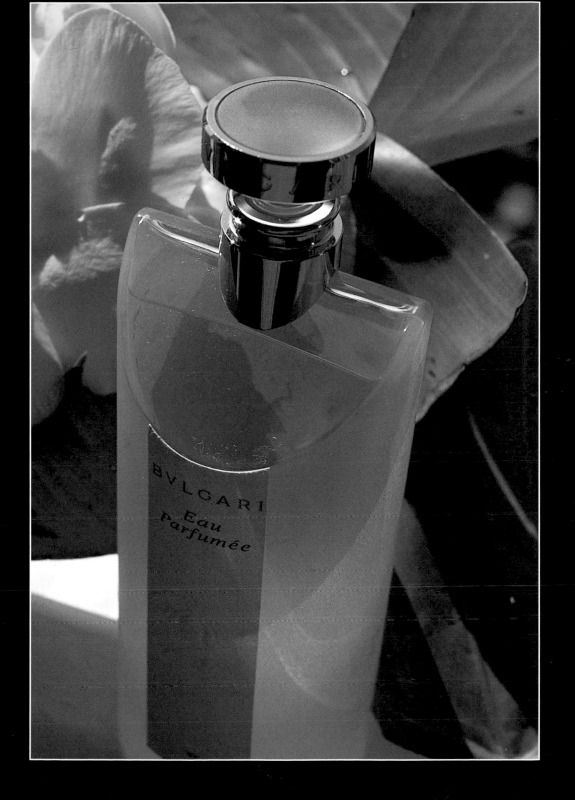

Photographer: **Salvio Parisi**

Use: **Personal research**

Assistant: **Chicca Fusco**

Art director: **Ezio Manciucca**

Camera: **4x5in**

Lens: **150mm**

Film: **Tmax 100**

Exposure: **1/8 second at f/16 1/2**

Lighting: **Tungsten**

Plan View

► *Hand-tinting is a skill in itself*

► *Using tungsten light with a black and white stock has no problems of colour balance*

► *Logistically, a set-up like this has to be planned carefully in advance, with the lamp below the bottle ready, in position and tested, before the actual shooting begins*

VERSACE PERFUME FOR MEN

▼

4x5in camera

soft box

THE SLIDE IS A REPRODUCTION OF A BLACK AND WHITE PRINT IN WHICH THE BOTTLE HAS BEEN COLOURED SEPARATELY. TWO EXPOSURES WERE USED, WITH THE CAMERA DIRECTLY ABOVE THE SUBJECT.

For the first exposure a soft box was placed diagonally at one side, giving a slight fall-off in light from the right side to the left side of frame and thus providing some modelling and a naturalistic feel.

For the second exposure, a small lamp, which was already in position underneath the bottle, was turned on to light the product from below and pick out and emphasise the product. The third stage in the production of the final image was the hand-tinting of the bottle on the black and white print.

The choice of props is important. Visually, the fabrics and wood grain provide a huge variety of interesting graphic patterns and textures in contrast with the smooth, coloured bottle of perfume. Contextually the choice of items must emphasise the masculinity of the product as well as establish the setting of the shot.

Photographer's comment:

The singularity of this image is that it simulates a point of view from above the inside of a man's drawer, with the bottle of perfume coloured on a black and white picture.

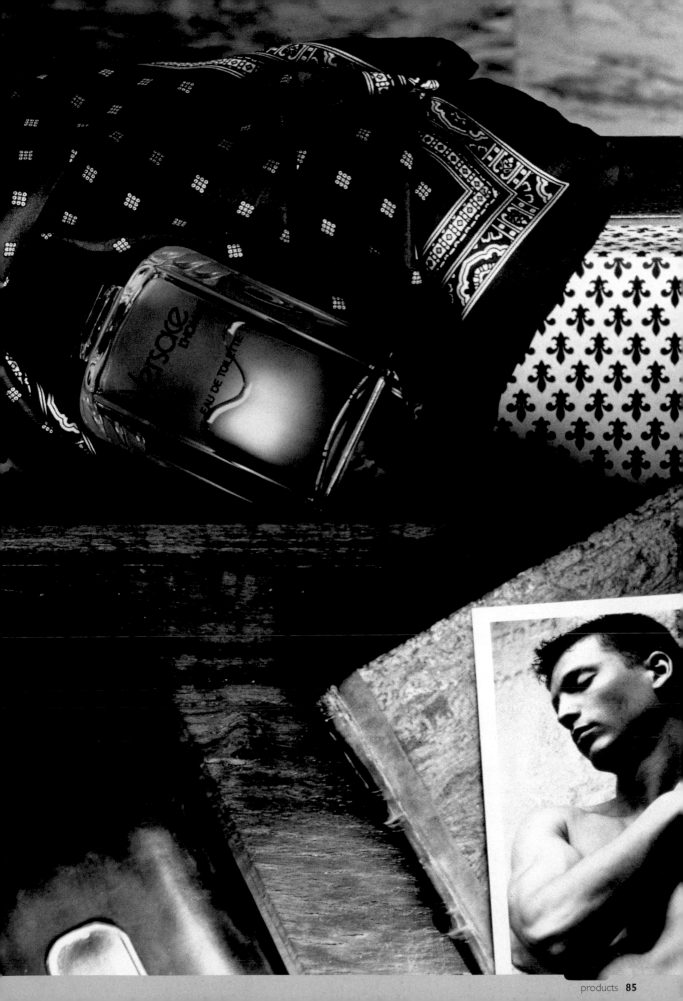

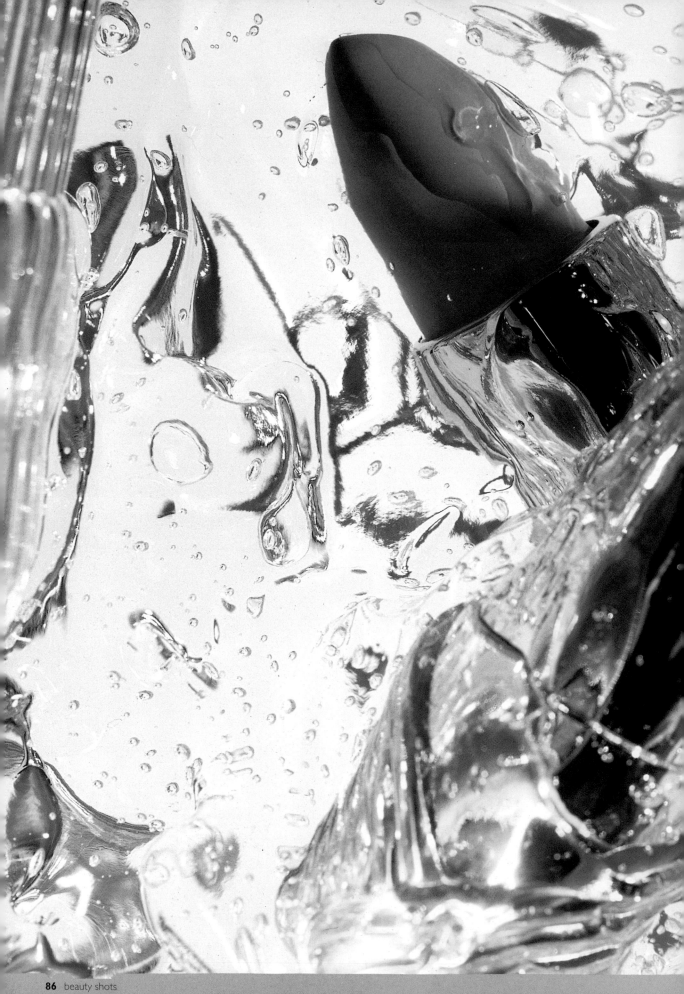

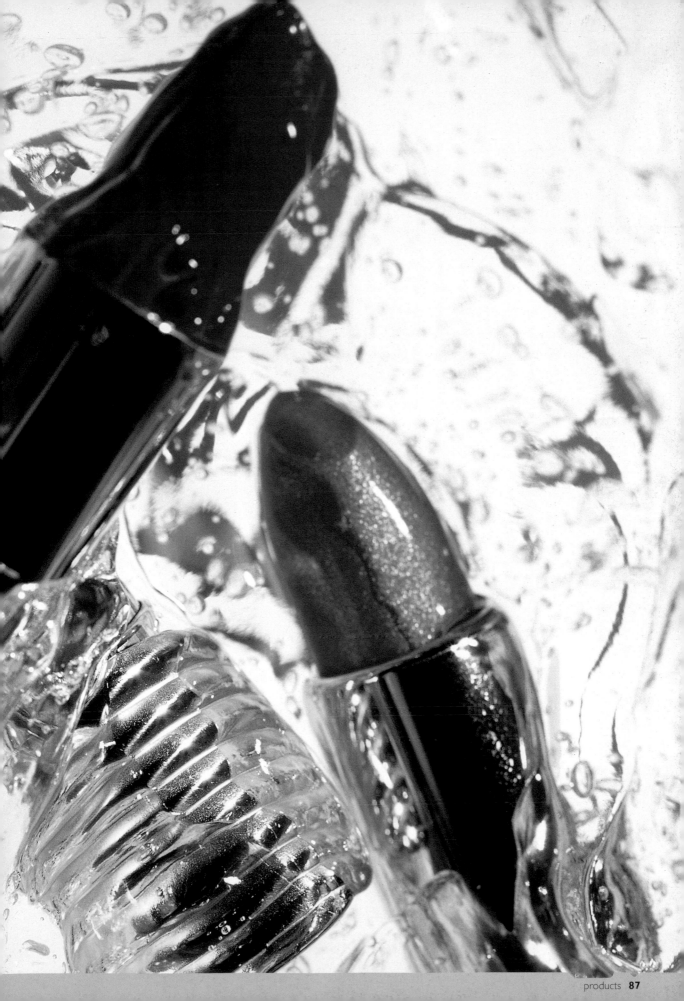

Photographer: **Erik Russell**

Client: **Harpers and Queen**

Use: **Editorial**

Assistant: **Kate Price**

Art director: **Robin Harvey**

Camera: **Mamiya RZ67**

Lens: **140mm with no. 1 extension tube**

Film: **Kodak Ektachrome EPX**

Exposure: **1/125 second at f/32**

Lighting: **Flash**

Props and set: **Glycerine and glass tray on light table**

Plan View

LIPSTICK CASCADE

▼

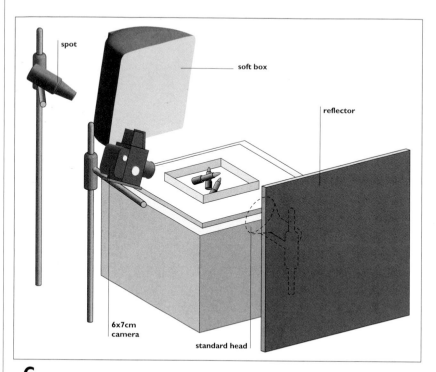

spot

soft box

reflector

6x7cm camera

standard head

GLYCERINE IS ONE OF THOSE ALL-PURPOSE USEFUL PRODUCTS TO HAVE TO HAND FOR ALL MANNER OF UNEXPECTED PURPOSES. IT MIXES WELL WITH SOAP TO GIVE PROLONGED LIFE AND DURABILITY TO BUBBLES AND TO ENHANCE THE COLOURS PRODUCED, HAS A SPARKLING APPEARANCE OF ITS OWN, AND IS A THICKER, MORE VISCOUS AND THEREFORE MORE CONTROLLABLE SUBSTITUTE FOR WATER WHEN AN IMPRESSION OF MOVING LIQUID IS REQUIRED.

Erik Russell's lipsticks are presented here on a glass tray of glycerine, which provides the splashing "movement". The lighting set-up is very similar to that used for the same photographer's "Lipstick Army" (page 79), with a light table giving bottom light, a key light placed to the left of the camera, a swimming-pool light providing fill and a black reflector in position on the opposite side. The difference is that the key light here is a focusing spot rather than a barn-doored head. Whereas the "Lipstick Army" required a relatively smooth, even light, here the desired effect is for as much sparkle and small pinpoint reflections as possible, and the tight focusing spot is a more appropriate choice.

► *The Kodak film stock used for this image has now been discontinued. Ektachrome 100 Plus (EPP) is a possible alternative*

► *The light table must be solid and heavy to avoid any movement during the shoot*

Photographer's comment:

Achieving spatial relationship and interest whilst keeping afloat.

Photographer: **Jay Myrdal**

Client: **Rosy Lambkin**

Use: **Model portfolio**

Model: **Rosy Lambkin**

Assistant: **Marcus Lima**

Camera: **Sinar P2 4x5in**

Lens: **300mm**

Film: **Ektachrome Plus**

Exposure: **1/60 second at f/32 1/4**

Lighting: **Electronic flash: 3 heads**

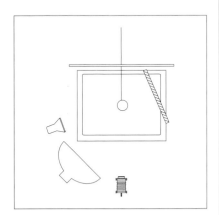

Plan View

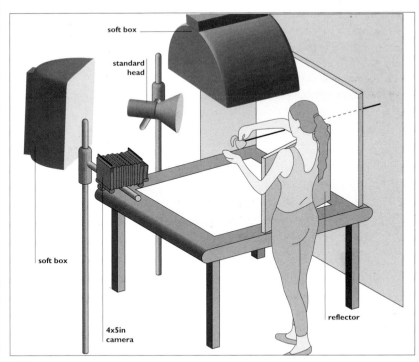

▼

THIS IS AN UNUSUAL CHOICE OF SUBJECT FOR JAY MYRDAL, WHO IS BETTER KNOWN FOR HIS SPECIAL EFFECTS SHOTS. "I DON'T OFTEN DO BEAUTY SHOTS," HE SAYS, "BUT I DO LIKE SHOOTING HANDS."

Jay says: "The most important thing to get right, it seems to me, is the hand itself. No amount of superb lighting will fix an ugly hand. Attention to detail is also very important because, this close in, everything shows. The camera original was fine but I could not resist the temptation to scan it into my computer system and clean it up a bit, primarily removing the slight shadow cast by the supporting armature."

The "supporting armature" is a rod that supports the bottle, projecting away from the camera and through the silver card. The background is lit by a standard flash head, aimed to give some graduation, and some of this light spills onto the fingertips and bottle. The top light is a 100x80cm Lucifero soft box supplemented by a 50x50cm Broncolor soft box at the front left. White reflectors are placed to the right and low down in front. The simple purity of the final image belies the elaborate set-up and physical mechanics that were required; the hallmark, perhaps, of an accomplished special effects practitioner.

► *Supportive armatures, such as "magic arms", are useful tools for stabilising this kind of subject, or, indeed for holding small light sources in precise positions*

► *Large soft boxes are essential when lighting glass bottles. Small soft boxes will be clearly visible in their entirety in the reflections*

Photographer's comment:

I have recently acquired a Dicomed computer platform to retouch and manipulate images in-house.

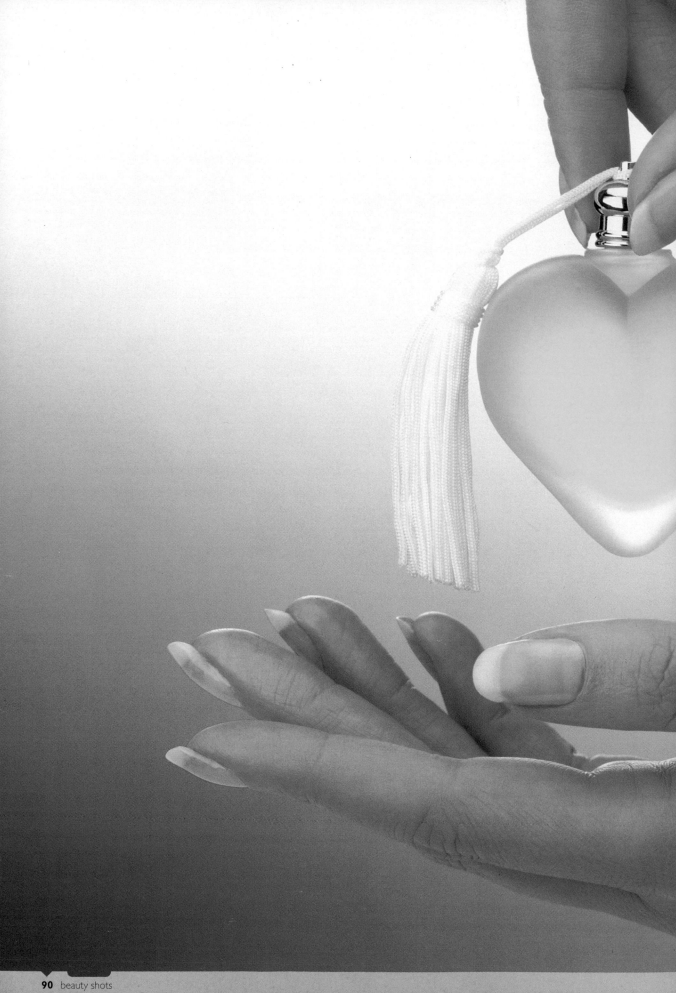

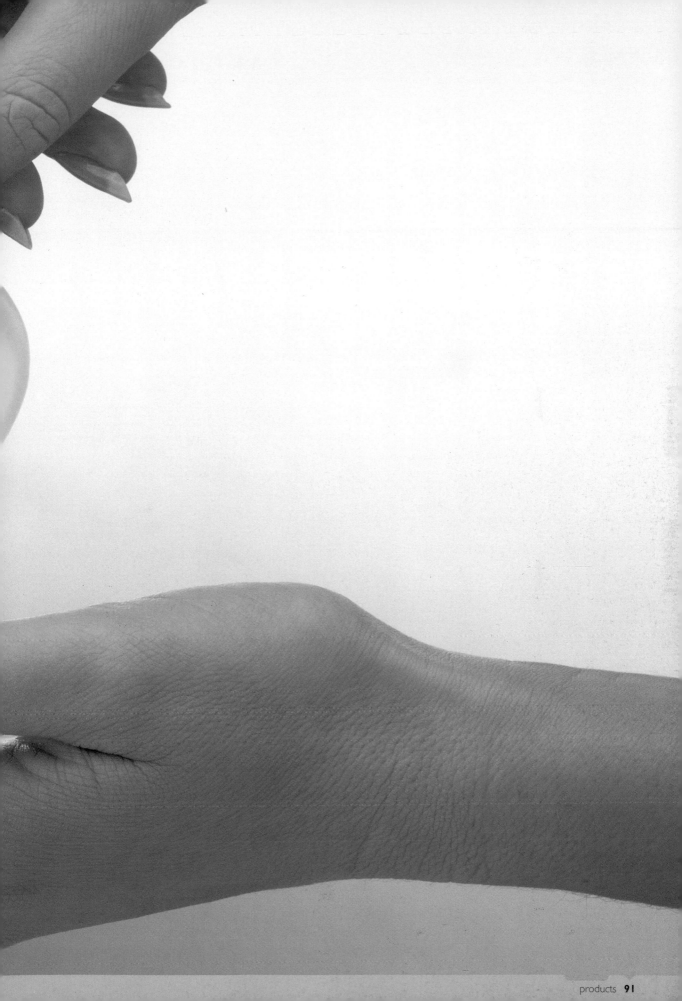

Photographer: **Guido Paterno Castello**

Use: **Self-promotion**

Assistant: **Fernando Ribeiro**

Camera: **4x5in**

Lens: **210mm**

Film: **EPR 64**

Exposure: **f/45**

Lighting: **Electronic flash: 2 heads**

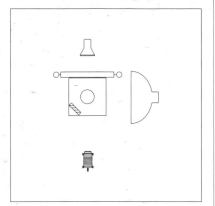

Plan View

▼

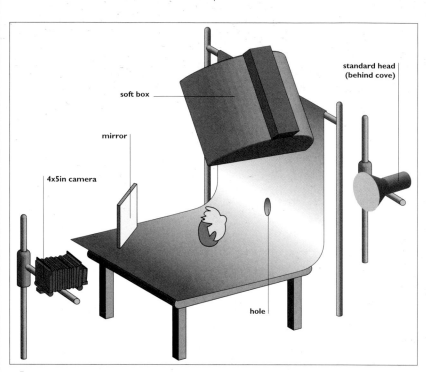

standard head (behind cove)

soft box

mirror

4x5in camera

hole

A SINGLE PERFUME BOTTLE ON A PLAIN BACKGROUND: IT LOOKS STRAIGHTFORWARD BUT IS ANYTHING BUT A SIMPLE TASK TO LIGHT. THIS SUBJECT COULD HAVE BEEN APPROACHED IN MANY DIFFERENT WAYS BUT GUIDO PATERNO CASTELLO CHOSE TO TREAT IT AS THREE SEPARATE SUBJECTS, EACH WITH ITS OWN CHALLENGES: FIRST, THE OPAQUE GLASS SCULPTURE ON THE LID; SECOND, THE TRANSPARENT BOTTLE WITH COLOURED PERFUME WITHIN; AND FINALLY, THE DARK, TEXTURED BACKGROUND.

The difficulty with a pearly-white sculpture like this frosted glass bird is that the detail and shape of the form could easily be lost if not lit sympathetically so the photographer has placed diffusing paper under the wing of the bird to give it, as he puts it, "more volume". The perfume is lit from behind: a spot comes through a carefully positioned hole in the background, giving a very narrow-beamed light source on the body of the bottle only. The haze light to the left provides soft over-all light and finally a mirror reflector sends back some light to give sparkling highlights.

The background is graduated to show off the detail of the bird while the weave of the fabric provides a textured screen for the pool of colour produced by the haze light shining through the liquid perfume, which effectively acts as an amber filter.

► *A relatively reflective black background is necessary to achieve this glowing pool of light since a more absorbent one would "deaden" the effect*

► *Unwanted reflections can sometimes be controlled by the use of a polarising filter*

Photographer's comment:

The importance of correct lighting is fundamental for a successful photograph.

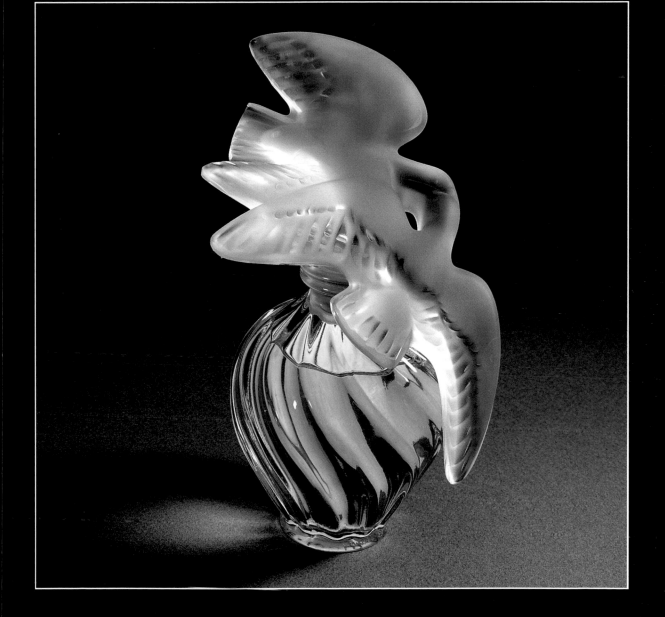

Photographer: **Michèle Francken**

Client: **Siegfried de Buck (jewellery designer)**

Use: **Publicity**

Model: **Tania**

Make-up: **Paul Hillerocere**

Camera: **Hasselblad**

Lens: **150mm**

Film: **VPS160 colour negative**

Exposure: **1/125 second at f/8**

Lighting: **Electronic flash**

Props and set: **Black background**

Plan View

JEWEL IN MOUTH

▼

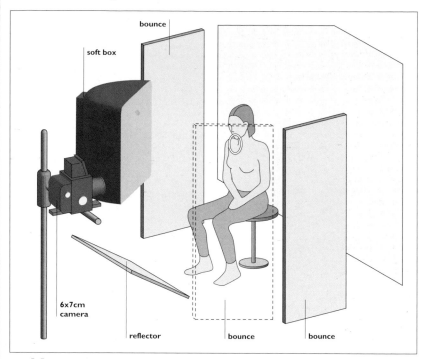

MICHÈLE FRANCKEN USED JUST ONE SOFT BOX BUT MADE THE MOST OF THE LIGHT IT PROVIDED BY BRINGING IN A PLETHORA OF BOUNCES.

Four white panels produce an almost continuous semi-circle of reflective surfaces around the model, the only gap being the point where the soft box light source itself is positioned. The result is a directional but very gentle light on the model, supplemented by softly bounced "fill" all round.

The skilfully applied make-up ensures a smooth evenness to the skin to echo the sensual sleekness of the construction of the piece of jewellery. Each of the metal sections of the necklace is at a different angle and catches the light in a different way, showing off the texture and finish of the piece in all its aspects.

► *Colour negative film has far more latitude than colour transparency film*

► *If one light is enough, just use one light*

Photographer's comment:

A fine natural make-up was necessary on a beautiful smooth skin.

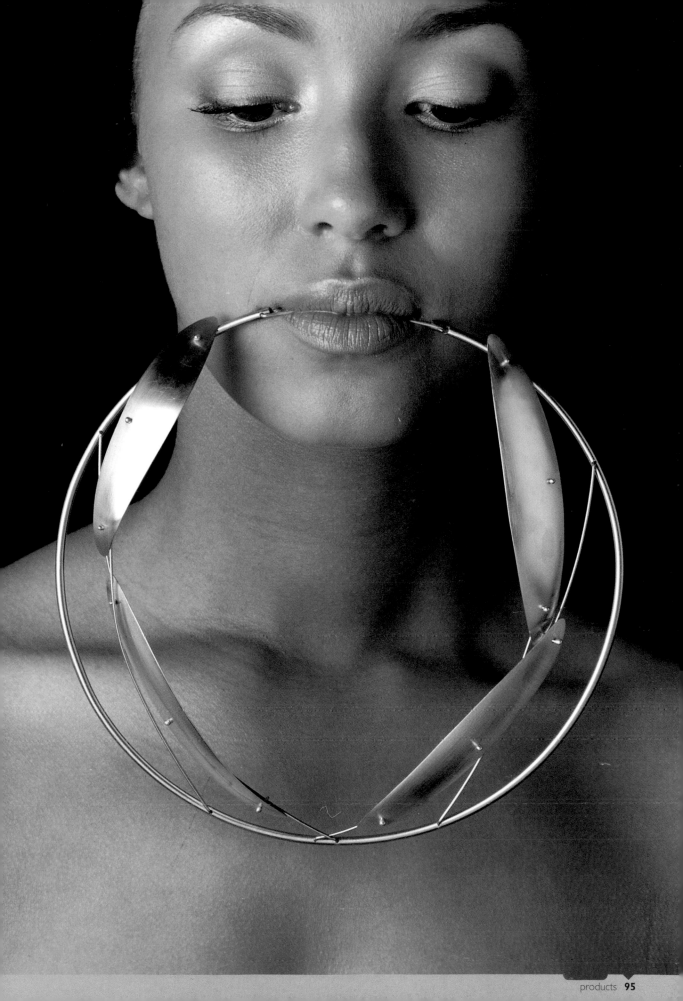

Photographer: **Tom Epperson**

Use: **Personal work**

Assistant: **Reiniell Cestina and Jenny Jacolbe**

Camera: **Mamiya 6x7cm**

Lens: **90mm**

Film: **Kodak EPP**

Exposure: **1/8 second at f/11**

Lighting: **Available light**

Props and set: **Background of white paper**

Plan View

▼

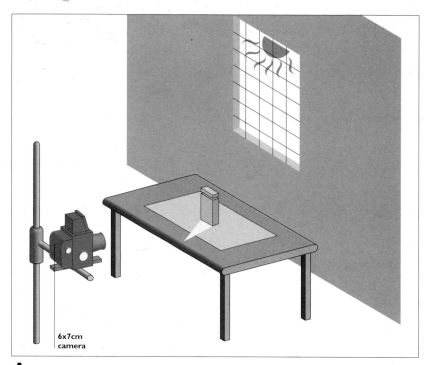

6x7cm camera

A CLEAN WHITE PIECE OF PAPER WAS USED AS A BACKGROUND AND SIMPLY LAID ON TOP OF A KITCHEN WORKTOP NEXT TO A WINDOW, LATE IN THE AFTERNOON AS THE SUN STREAMED IN. TOM EPPERSON WAS DEMONSTRATING TO HIS ASSISTANTS THAT EFFECTIVE PHOTOGRAPHS CAN BE PRODUCED WITH VERY LITTLE EQUIPMENT.

The lighting provides not only illumination but also context, and the window shadow is important for establishing what lies beyond our view. Although this set-up is, essentially, an opportunistic one, taking advantage of naturally-occurring surroundings, it could equally have been set up in a studio with a mocked-up window, for instance using a simply constructed wooden frame with strips of gaffer tape to emulate the pattern of mullions and window panes, and with a strong direct key light to imitate the sun.

The use of an 81A filter gives a mired shift of +18, warming up and enhancing the golden perfume in the golden sunlight.

► *When shooting a sun-lit image, the position and movement of the sun must be taken into account before the actual shoot; time will be limited*

► *The colour temperature of a sun-lit shot also needs to be taken into consideration and compensated for if necessary using a suitable warm-up filter*

Photographer's comment:

The whole object of the shot was to show the use of daylight and its simplicity. It was also done as a test for further reference.

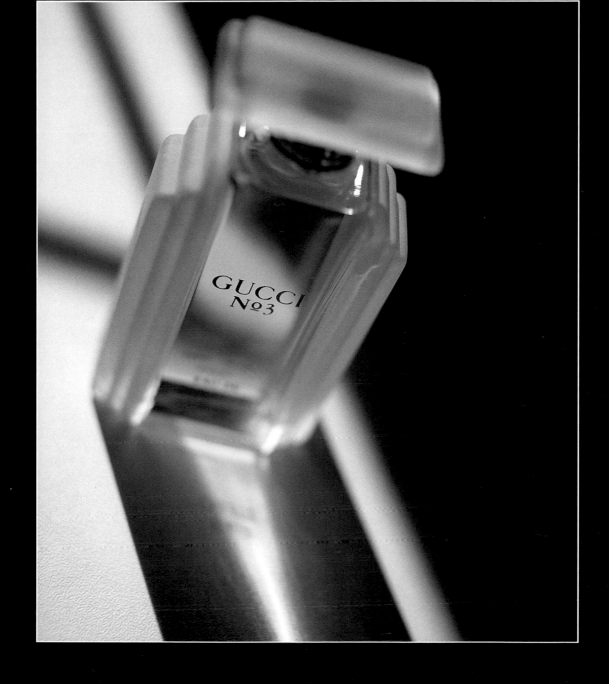

Photographer: **Kiyoshi Togashi**

Use: **Self-promotion**

Art director: **Kiyoshi Togashi**

Stylist: **Kiyoshi Togashi**

Camera: **4x5in**

Lens: **90mm**

Film: **Fuji RTP 64T**

Exposure: **f/8**

Lighting: **Electronic flash and tungsten**

Props and set: **Lipstick and nautilus shell on glass block**

Plan View

LIPSTICK WITH NAUTILUS SHELL

▼

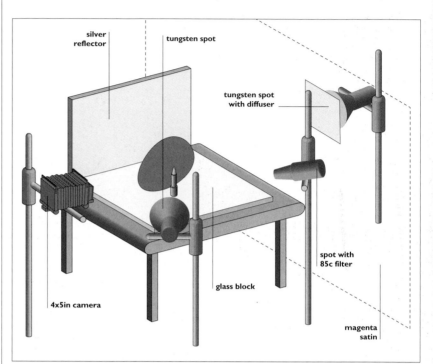

WHAT WE HAVE HERE IS A MULTIPLE EXPOSURE OF A LIPSTICK AND A SHELL ON A BLOCK OF GLASS. WHAT IS NOT VISIBLE IS A PIECE OF WIRE HOT-GLUED TO THE REAR OF THE LIPSTICK BARREL, WHICH ALLOWED KIYOSHI TOGASHI TO MANIPULATE THE POSITION OF THE COSMETIC.

For the first exposure, a magenta satin backdrop has a tungsten spot with diffuser projected through it from the rear to provide a graduated warm pink glow, with additional diffusion occurring because the fabric disperses the light further. The tungsten spot provides front light showing the grain of the shell and giving the main image of the lipstick, while the silver reflector provides fill.

For the three subsequent exposures the tungsten lights were turned off, the lipstick was rotated to new positions and a flash for each position produced the ghosted multiple images of the stick visible to the right of the photograph. An 85C filter was used to modify the flash because the overall lighting was tungsten and a tungsten-balanced film was being used for the shot.

► *Forward planning is essential; rigs need to be tested comprehensively before shooting commences*

Photographer's comment:

I set out to create a sensuous look for my cosmetic shot. The tungsten lighting provided the mood I desired while the flash lighting captured the sense of motion and life. I love the result.

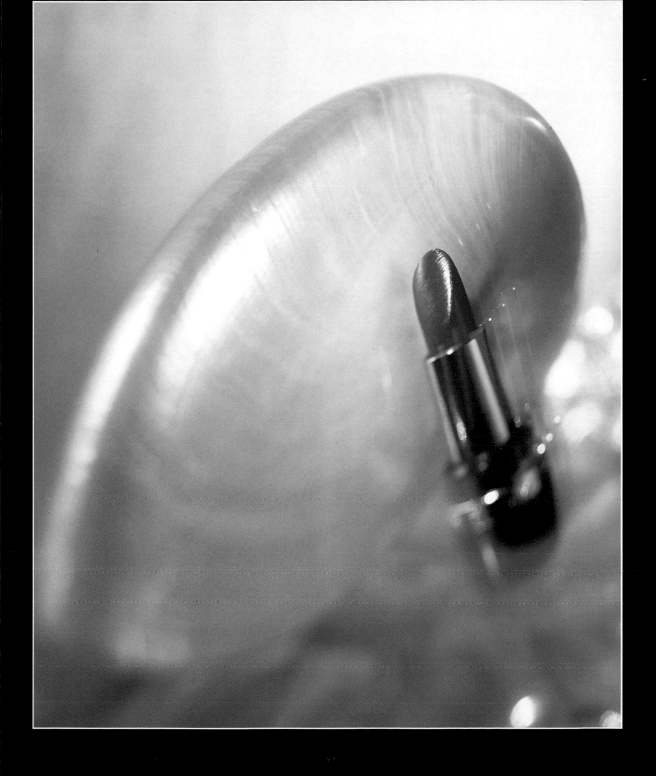

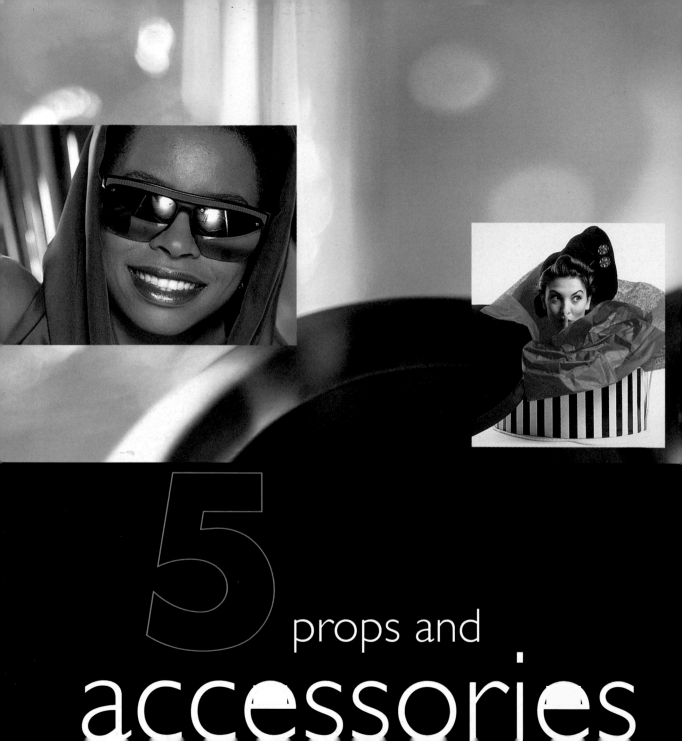

5 props and accessories

There are few photographs in this book without a human being in there somewhere,

but it does happen more than once in this chapter where various items of

paraphernalia related to the pursuit of a beautiful appearance — such as stylish

sunglasses, toothpaste and toothbrushes — are featured alone. These images merit

Photographer: **Julia Martinez**

Camera: **Canon EOS 600**

Lens: **300mm**

Film: **Tmax 100**

Exposure: **f/11**

Lighting: **Available light**

Props and set: **Chipped paint on wall**

Plan View

▼

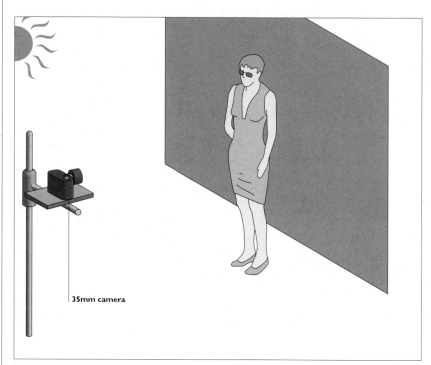

35mm camera

THE HARSH SHADOWS ON THE MODEL'S FACE AND HAIR INDICATE THE ANGLE OF THE SUN: IT IS NOT AT ITS HIGHEST, AND ALTHOUGH BRIGHT AND STRONG IT IS NOT AT ITS MOST EXCESSIVE EXTREME BRILLIANCE. HENCE, ALTHOUGH THE WHITE CLOTHING GIVES AN IMMEDIATE IMPRESSION OF DAZZLING SUNLIGHT, THE SKIN TONES DO HAVE GRADATION AND TEXTURE AND ARE NOT WASHED OUT BY OVER-BRIGHT DAYLIGHT.

► It is always worth carrying a notebook even when you are not working to make notes about interesting textures and backgrounds that you spot. It is very frustrating to know what you want but not be able to remember where you have seen it. Don't forget a pencil or a pen also!

► With the ever-growing world of digital imaging, it is worth collating a library of backgrounds to call upon

Interestingly, the shadow of the model's head on the wall to the right of the image is not as sharp or dark as one might expect, when compared with the sharper shadows on the face. Although no bounce was used, some fill is obviously occurring here from the surrounding location, perhaps a wall at right angles to the one facing the camera.

The chipped paint of the wall gives a good foil to set the clean lines of the model against, with areas of texture and gradation in stark contrast with the smoothness of the model's skin and clothing. The detail of colour hand-tinted on the frame of the impenetrably dark sunglasses gives interest and punctuation to the composition.

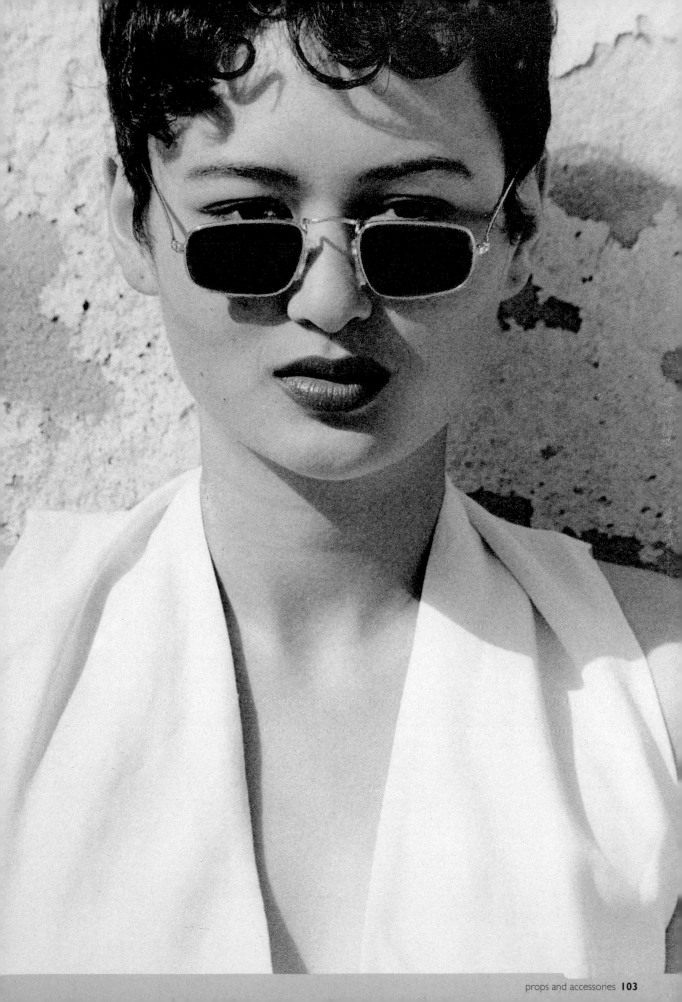

Photographer: **Holly Stewart**

Client: **Self-promotion**

Use: **Book**

Make-up: **Dawn Sutti**

Styling and hair: **Victor Hutching**

Camera: **6x6cm**

Lens: **180mm**

Film: **EPZ**

Exposure: **1/125 second at f/16**

Lighting: **Electronic flash: 3 heads**

Props and set: **White seamless background**

Plan View

H A T B O X

▼

A WHITE SEAMLESS BACKGROUND HAS BEEN PLACED ON A RIG AND A LARGE HOLE MADE IN IT, WITH THE MODEL STANDING THROUGH THE HOLE. A HOLE IN THE BOTTOM OF THE HATBOX ALLOWS IT TO BE PLACED OVER HER HEAD AND SHOULDERS AND THEN DRESSED AND STYLED IN SITU.

The soft box gives side-lighting, with a piece of 8x4in card on the opposite side of the subject providing some fill to the shadow side of the face.

The careful set-dressing uses the light in various ways to add to the composition. The graphic design of the box gives bold areas of black and white contrast. The crumpled red tissue paper in and around the box captures the light at lots of different angles and adds textured interest. Finally, the lid has been positioned in such a way that it is tilted away from the light to provide an even area of blackness to give balance and add contrast with the hat itself.

► *When the camera view needs to appear to be at floor level, it is worth considering building a raised set to alleviate difficulties when lighting the shot*

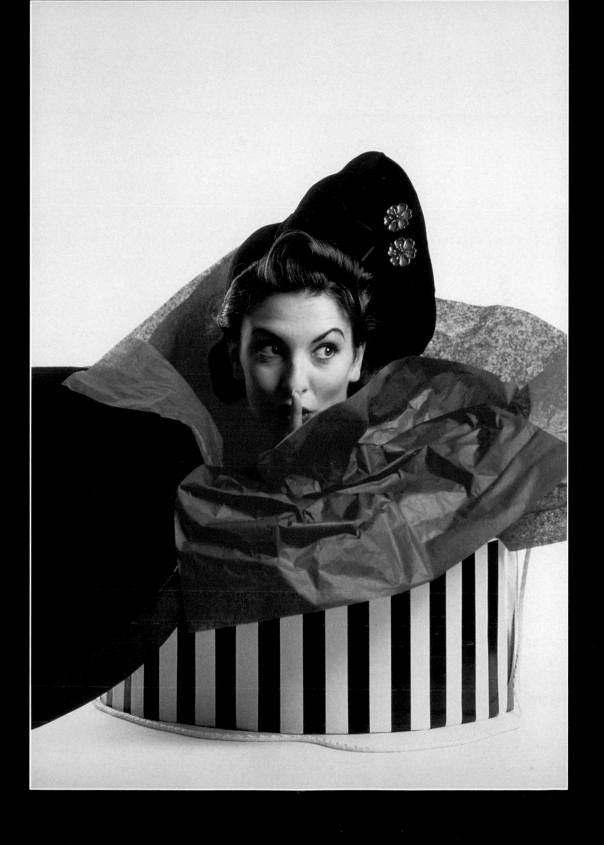

S H A D E S O F B R O W N

Photographer: **Lewis Lang**

Use: **Model test**

Camera: **35mm**

Lens: **75–150mm zoom**

Film: **Ektachrome 64**

Exposure: **1/80 second at f/11**

Lighting: **Electronic flash**

Props and background: **Mylar sheet, small stage off the ground**

▼

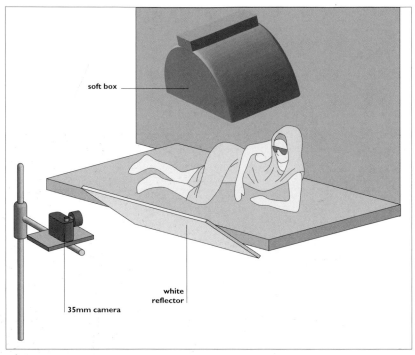

soft box

white reflector

35mm camera

HOWEVER WELL PLANNED A SHOOT MAY BE, UNFORESEEN ELEMENTS CAN ALWAYS OCCUR AND THE PROFESSIONAL PHOTOGRAPHER NEEDS TO THINK ON HIS OR HER FEET AND IMPROVISE, AMEND AND EXPERIMENT IMAGINATIVELY TO MAKE THE MOST OF THE SITUATION. LEWIS LANG DESCRIBES WHAT HAPPENED WHEN HE FOUND HIMSELF FACED WITH A STUDIO SHOOT AND A MODEL WITH A SUDDEN, UNEXPECTED EYE COMPLAINT.

''The model's eyes became watery during the shoot, possibly due to an allergy or cold, so I turned a minus into a plus by using the sunglasses both to cover her eyes and add an exciting graphic element. Despite the eye situation the model was a real trouper and we got some excellent shots. The Mylar in the background picked up whatever light there was in the studio but its distortions added a glitzy hi-tech look. Moving around got me the best light/dark patterns in the background.''

Lewis describes this as ''technically a very simple shot.'' The soft box was in a full frontal position just above the model's head and a silver reflector bounced light back up under her chin.

► *A good model is a real asset. Experience counts for a lot, but professionalism is far more important*

Plan View

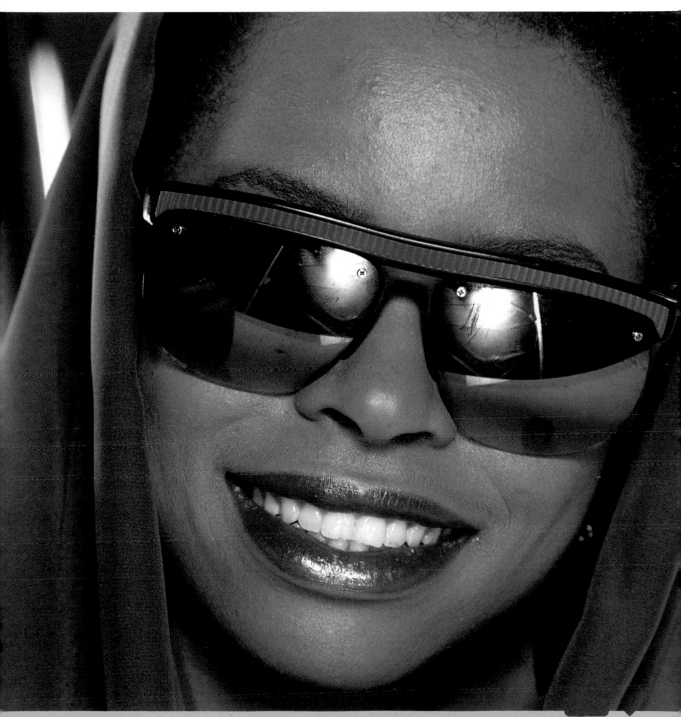

Photographer: **Salvio Parisi**

Client: **Silhouette Model Agency**

Use: **Calendar**

Model: **Marta**

Assistant: **Chicca Fusco**

Hair and make-up: **Robert Vetica**

Art director: **Charles Politte**

Camera: **4x4in with 6x7cm back**

Lens: **210mm**

Film: **Kodak VHC / 120 developed in E6**

Exposure: **1/125 second at f/16**

Lighting: **Electronic flash**

Props and set: **White paper background**

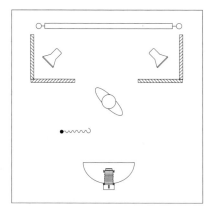

Plan View

► *The green tinge on the upper edge of the ironwork is an effect of being slightly out of focus*

► *It's good to experiment with combinations of films and processes but do instruct your lab specifically of your requirements to avoid confusion*

► *Kodachrome can only be processed in its own chemistry*

M A R T A

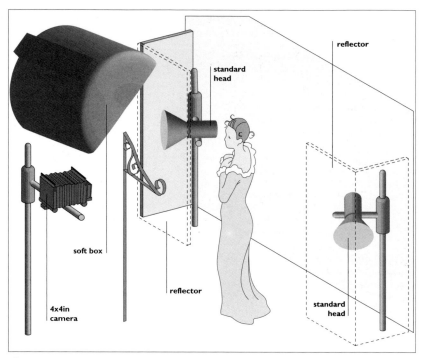

ALTHOUGH THERE ARE TWO MAIN SUBJECTS TO THIS SHOT, THE IRONWORK AND THE MODEL, ONLY THE MODEL IS LIT, AND ONLY VERY SIMPLY AT THAT.

A large soft box above the camera lights the model square on, giving a complimentary, even complexion. Two flash heads reflected by panels light the white background, giving a bright, even backdrop. Against so much brightness the ironwork stands out in slightly out of focus silhouette, the shape echoing the stray locks of hair, and the darkness of the silhouette picking up on the darkness of the model's hair and eyes.

Pale skin and large, dark eyes with dramatic make-up combine to give the old-fashioned feel that Salvio Parisi was looking for; the mood of a silent movie star or a period star of stage or ballet. To add to the theatrical mood, Salvio Parisi used CC20Y and CC20R (yellow and red) filters and over-developed the negative film in an E6 process.

Photographer's comment:

The idea of the picture is a kind of old style woman: the hair style, the partial focus, the old yellow colour of the slide (the negative film developed in E6) and the piece of iron in front of the model.

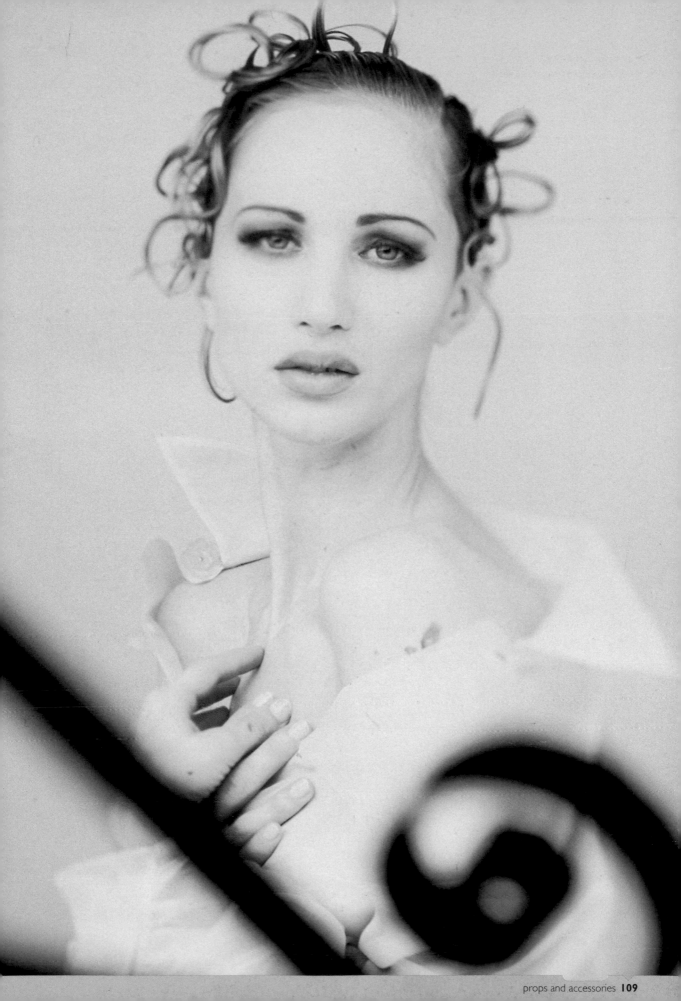

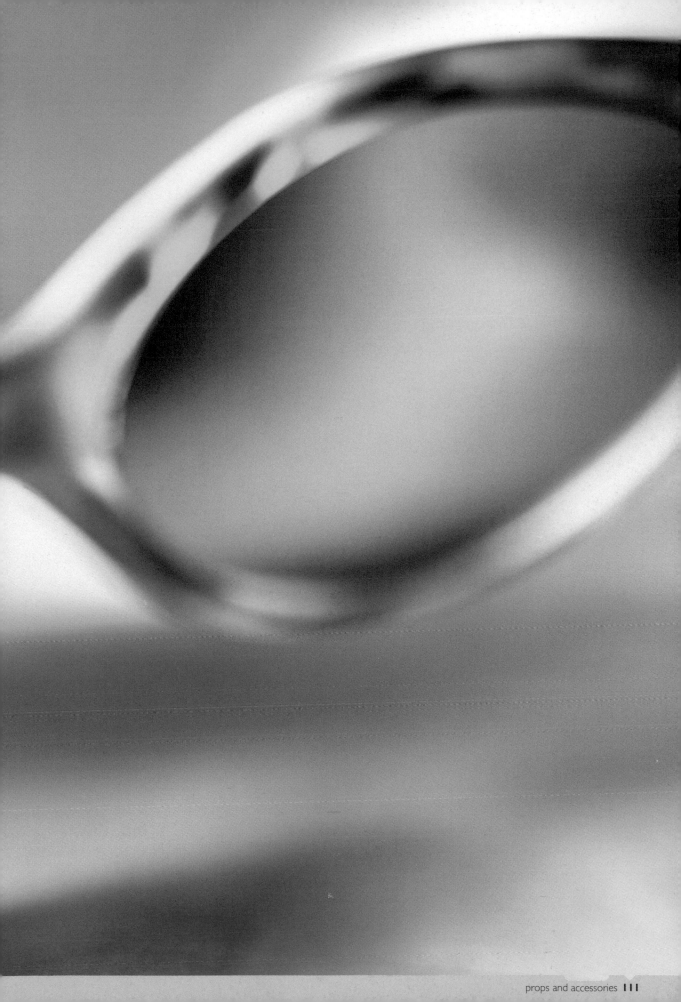

Photographer: Ernie Friedlander

Use: Self-promotion

Camera: 8x10 inch

Lens: 200mm wide angle

Film: Fuji RDP II 100 ISO

Exposure: 1 second at f/8

Lighting: Tungsten and light painting with light wand

Props and set: Sunglasses on blue textured art paper

Plan View

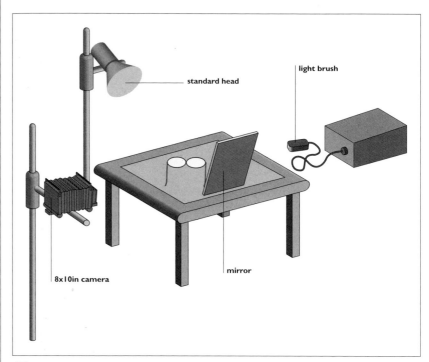

standard head

light brush

8x10in camera

mirror

THIS SHOT WAS PUT TOGETHER IN TWO STAGES. FIRST, ERNIE FRIEDLANDER MADE AN INITIAL EXPOSURE USING A 1 KILOWATT TUNGSTEN LIGHT, AND SECONDLY HE USED A LIGHT BRUSH TO 'PAINT' WITH LIGHT AND CREATE HIGHLIGHTS AND 'FILL' JUST WHERE HE WANTED THEM.

The tungsten light has a 3/4 colour temperature blue (CTB) gel which, used with the daylight balanced film, gives a slightly warm look and complements the colour of the sunglasses themselves. A mirror placed to camera right reflects back a little light onto the glasses to add some highlights (since they are transparent and the tungsten keylight positioned as it is, to the back left, shines through them).

In the second exposure each part of the composition received its own

treatment with the light wand, as follows: left side of glasses – 30 seconds; right side of glasses – 10 seconds; bridge – 10 seconds; right lens of glasses – 10 seconds; background behind glasses to give colour in lenses – 15 seconds. Using a base tungsten exposure plus a light brush to 'paint' different parts of the subject with light for various lengths of time typically gives this mottled, sunny result and an impression of dappled light streaming through a window.

► *Getting just the effect you want from a lightbrush is a fine art and takes practise*

► *The wide lens used on an 8x10 camera at close range here gives a shallow depth of field and a flatter, more graphic result. Focus in this example is not a prime consideration; form, colour and light are more important*

Photographer: **Enric Monte**

Client: **Sonimac**

Use: **Cartel**

Assistant: **Carles Guinot**

Stylist: **Miguel Garigliano**

Art director: **Enric Parellada**

Camera: **6x7cm**

Lens: **180mm**

Film: **Ektachrome 64**

Exposure: **1 second at f/22**

Lighting: **Electronic flash and tungsten**

Props and set: **Painted backdrop**

Plan View

FOTOGRAFIANDO AL FOTOGRAFO

▼

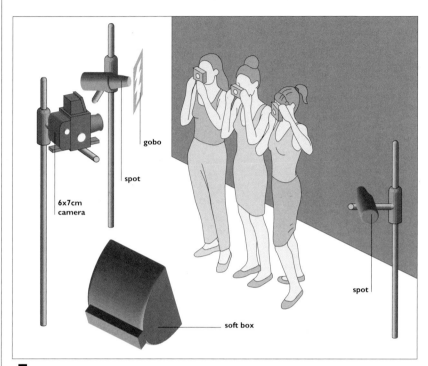

Eⁿᴿᴵᶜ Mᴼᴺᵀᴱ ᴴᴬˢ ᵁˢᴱᴰ ᵀᴴᴱ ᵀᵁᴺᴳˢᵀᴱᴺ ˢᴾᴼᵀ (ᶜᴬᴹᴱᴿᴬ ᴿᴵᴳᴴᵀ) ᵀᴼ ˢᴱᴺᴰ ᴬ ˢᴴᴬᶠᵀ ᴼᶠ ᴸᴵᴳᴴᵀ ᴼᴺᵀᴼ ᵀᴴᴱ ᴾᴬᴵᴺᵀᴱᴰ ᴮᴬᶜᴷᶜᴸᴼᵀᴴ ᶠᴼᴿ ᴬ ᵛᴬᴿᴵᴱᵀᵞ ᴼᶠ ᴿᴱᴬˢᴼᴺˢ. Bᴱᶜᴬᵁˢᴱ ᵀᴴᴱ ᴮᴬᶜᴷᴳᴿᴼᵁᴺᴰ ᴵˢ ᴸᴵᵀ ᴮᵞ ᵀᴴᴵˢ ᶜᴼᴺᵀᴵᴺᵁᴼᵁˢ ᵀᵁᴺᴳˢᵀᴱᴺ, ᴵᵀ ᴿᴱ�Qᵁᴵᴿᴱˢ ᴬ ᴸᴼᴺᴳᴱᴿ ᴱˣᴾᴼˢᵁᴿᴱ ᵀᴴᴬᴺ ᴰᴼ ᵀᴴᴱ ᴹᴼᴰᴱᴸˢ ᴵᴺ ᵀᴴᴱ ᶠᴼᴿᴱᴳᴿᴼᵁᴺᴰ, ᴵᴺ ᵀᴴᴵˢ ᴵᴺˢᵀᴬᴺᶜᴱ 1 ˢᴱᶜᴼᴺᴰ.

This length of shutter speed in turn brings with it softly silhouetted outlines of the periphery of the models (soft because a small amount of movement is inevitable during such a long exposure). Most important of all, it also allows enough time for the photographer to throw the focus of the lens after the flash has finished, giving the required impression of zooming movement on the background.

The models' faces are lit by the flash to camera left, directed through a gobo that allows light only onto the selected areas of the faces. The soft box in front lifts the shadows and gives a little detail lower down.

► *When you rack the focus on a long lens there is a considerable focus shift*

► *Modelling lights in flash heads are tungsten balanced*

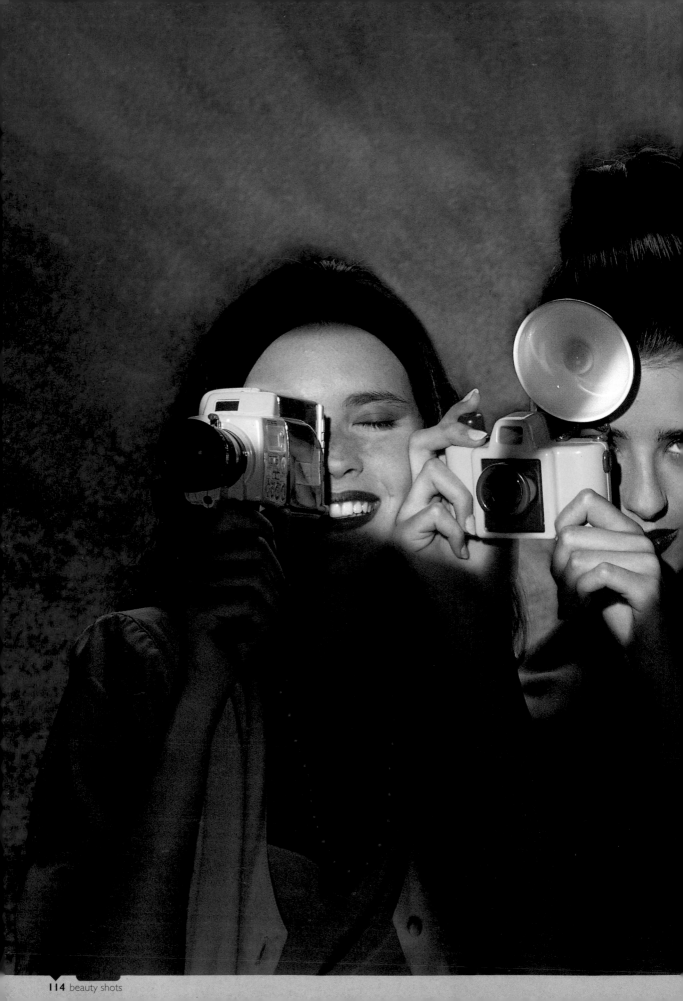

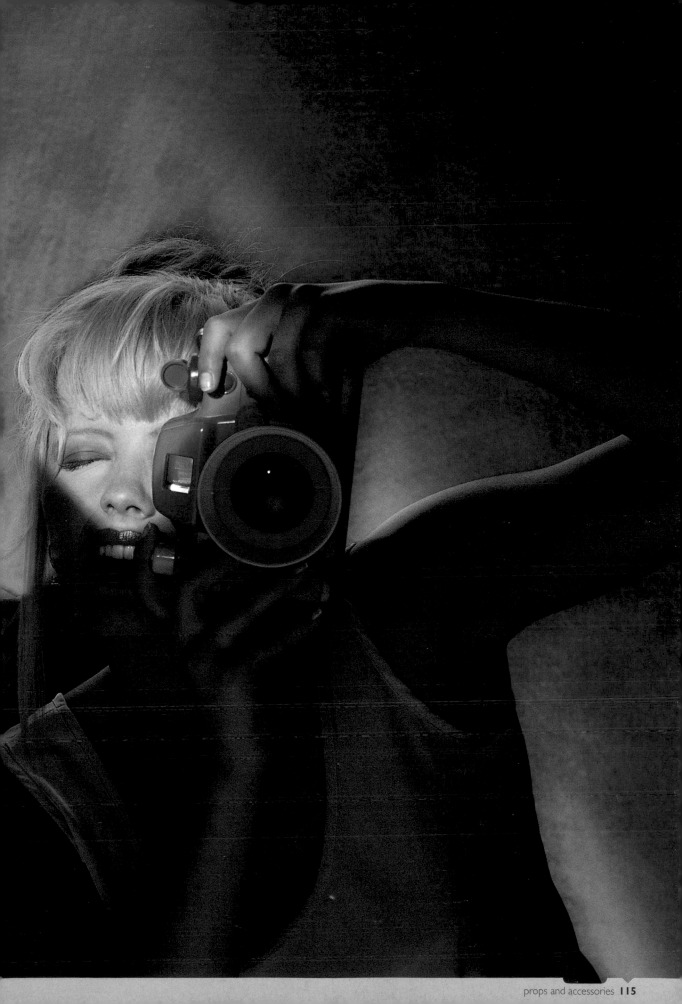

Photographer: **Guido Paterno Castello**

Use: **Self-promotion**

Model: **Dhana Dannah**

Assistant: **Fernando Ribeiro**

Camera: **6x6in**

Lens: **80mm**

Film: **EPR 64**

Exposure: **f/16**

Lighting: **Electronic flash**

Plan View

J O I A

▼

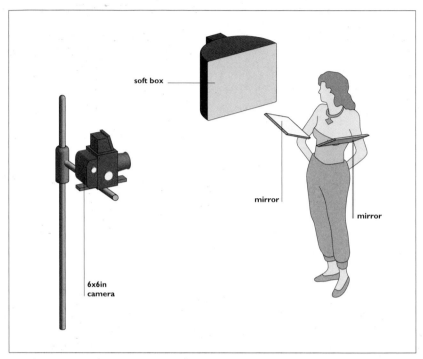

soft box

mirror

mirror

6x6in
camera

"**T**HIS PHOTOGRAPH WAS EXTREMELY DIFFICULT TO LIGHT SINCE THE LIGHTING ON THE MODEL AND ON THE JEWELLERY IS TOTALLY DIFFERENT," SAYS GUIDO PATERNO CASTELLO.

There is actually only one light source, which is where you would expect it to be: at the side and slightly to the front, with the model's face inclined towards it. For the lighting on the jewellery itself, Guido directed his assistant to hand-hold two mirrors below and in front of the necklace, just out of shot, to bounce back some of the light and achieve the exact reflections that he wanted. The result is exquisite evenness of light along the full length of the necklace, providing highlights even where it lies against the dark skin in full shadow.

Finally, digital manipulation was used to darken the side and back of the head so that the face appears to hover, mask-like, in the darkness.

► *You can improvise with commonplace items to use as reflectors. Everything from silver-backed plasterboard to kitchen foil is available for experimentation*

► *Digital manipulation is ever-changing. If you are considering buying a system, make sure you know what you want it to do, and are not just led by software sales patter*

Photographer's comment:

The blending of correct lighting on the model and the jewellery combined with digital manipulation achieved a good overall result.

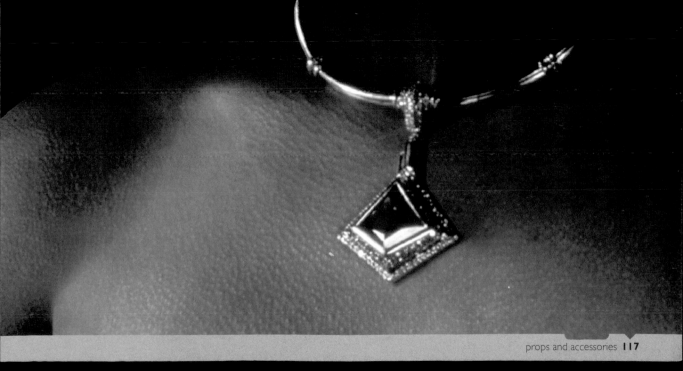

Photographer: Michel Cloutier

Use: Personal work

Camera: 35mm Contax RTS II

Lens: 100mm f/2

Film: Fuji RDP

Exposure: 1/125 second at f/8.5

Lighting: Electronic flash: 2 heads

Plan View

▼

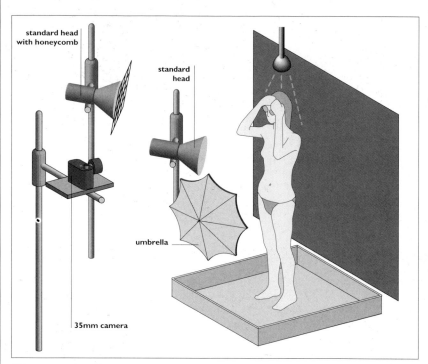

THE BLUENESS OF THE IMAGE COMES FROM A COLOURED GEL OVER THE STANDARD HEAD WITH HONEYCOMB TO CAMERA LEFT. OTHERWISE THE SET-UP IS FAIRLY STRAIGHTFORWARD. THERE IS A STANDARD HEAD WITH 11 INCH REFLECTOR ON THE BACKGROUND AND AN UMBRELLA REFLECTOR USED TO PROVIDE FILL ON THE CAMERA RIGHT SIDE OF THE MODEL'S FACE.

The shutter speed of 1/125 does not completely 'freeze' the movement of the showering water, but allows a sense of motion to come through.

The water from the shower falls into a small paddling pool in which the model is standing: the practicalities of shooting with water must be considered carefully when planning a shoot of this kind.

► When working with electricity and water, safety must be a priority concern and needs to be taken account of throughout the shoot

► Waterproof make-up is essential if the model is going to get at all wet

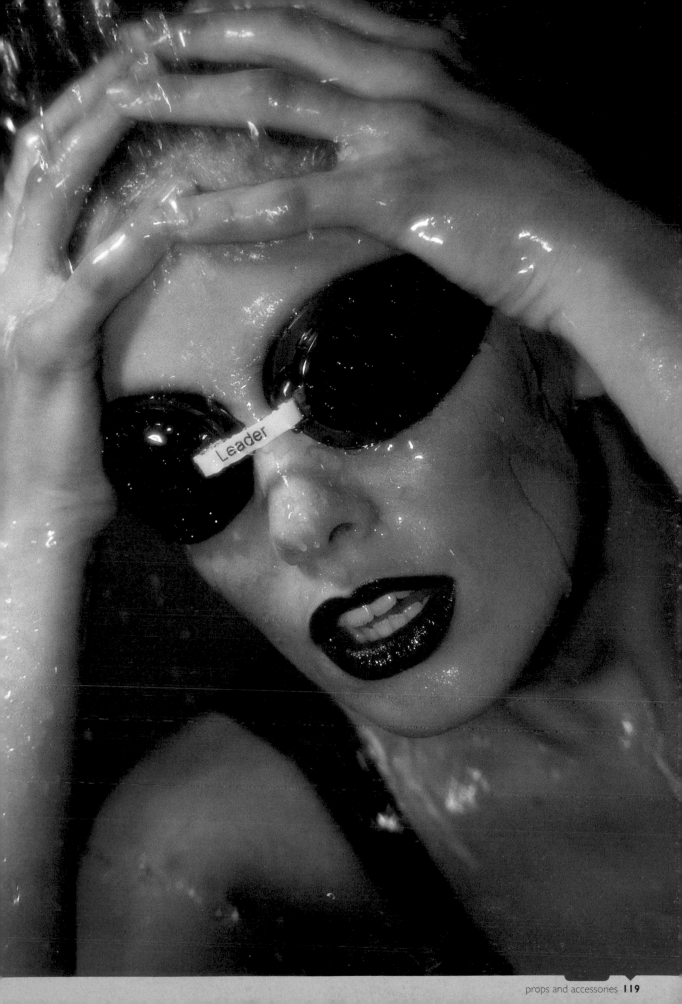

6 special

effects

Special effects are used for all kinds of shots, not just beauty. The images included in this chapter demonstrate wonderful special effects that deserve inclusion.

In current advertising, sometimes it is not even necessary to show the product itself, since the overall style of the shot can be strong enough to identify the branding. Often these powerful indirect branding images are achieved with special effects, which can be tailored to be so very individual that they become the trigger for reminding the viewer of the association between the image and the product.

Many types of special effects have traditionally been achieved using physical means: hand-tinting, solarisation, posterisation, filtration, to name a few. Now the computer is widely used and can offer an enormous range of possibilities electronically, from simple retouching to fantastically elaborate manipulation of basic images. It might be argued that so widespread is computer manipulation becoming, that it can hardly be classified as a special effect because it is almost a commonplace "norm" for people to want to retouch their work. But as with all technology, it is not a question of whether the means is commonly available, but whether the tool is used to good effect, rather than the effect being dictated by the capability of the tool. This is as true of computer technology as it has always been of traditional methods special effects. The temptation for many people is to overdo things, just because they can; but there is no substitute for imagination and expert realisation of the idea in the mind, as these shots show.

Photographer: **Kazuo Sakai**

Client: **Syueshya**

Use: **Novel cover**

Assistant: **Tomohara**

Make-up: **Nakagawa**

Art director: **Kazuo Sakai**

Camera: **Nikon F4 35mm**

Lens: **85mm**

Film: **RDP II 100**

Exposure: **1/125 second at f/8**

Lighting: **Electronic flash**

Props and set: **White paper**

Plan View

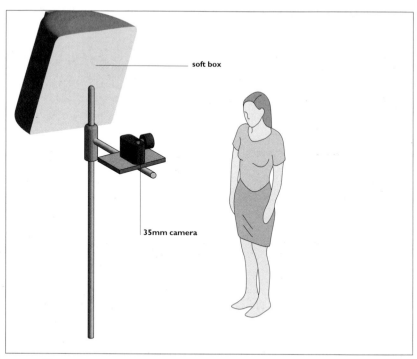

M A S K

▼

soft box

35mm camera

THIS HAUNTING IMAGE SHOWS DIGITAL MANIPULATION AT ITS BEST. IT IS NOT OVER-ELABORATE; THERE IS NO SENSE OF GILDING THE LILY HERE. INSTEAD, SOMETHING THAT WOULD NOT BE FEASIBLE TO REALISE IN ACTUALITY HAS BEEN CREATED WITH RESTRAINT, WITH THE AID OF THE SOFTWARE.

The starting point is of course suitable base photographs. Consistency of lighting on the various components of the final image is very important, as with any collage or montage work of this kind, since obviously varying light sources will destroy any harmony between the constituent elements. The model, background and fragments of newspaper were therefore lit simply with the same set-up, a single soft box to camera left, ensuring continuity and compatibility of directional light. The three resulting photographs were then scanned and manipulated using Photoshop on a Mac.

► *More and more bureaus are offering slide scanning services but the process still isn't cheap*

► *To get reasonable image quality, very large file sizes are necessary, so 1.44MB floppy disks are not adequate*

Photographer's comment:

From original lighting, 1060 DPI, the final output was onto Kodak LVT2 film recorder, on Kodachrome 64T.

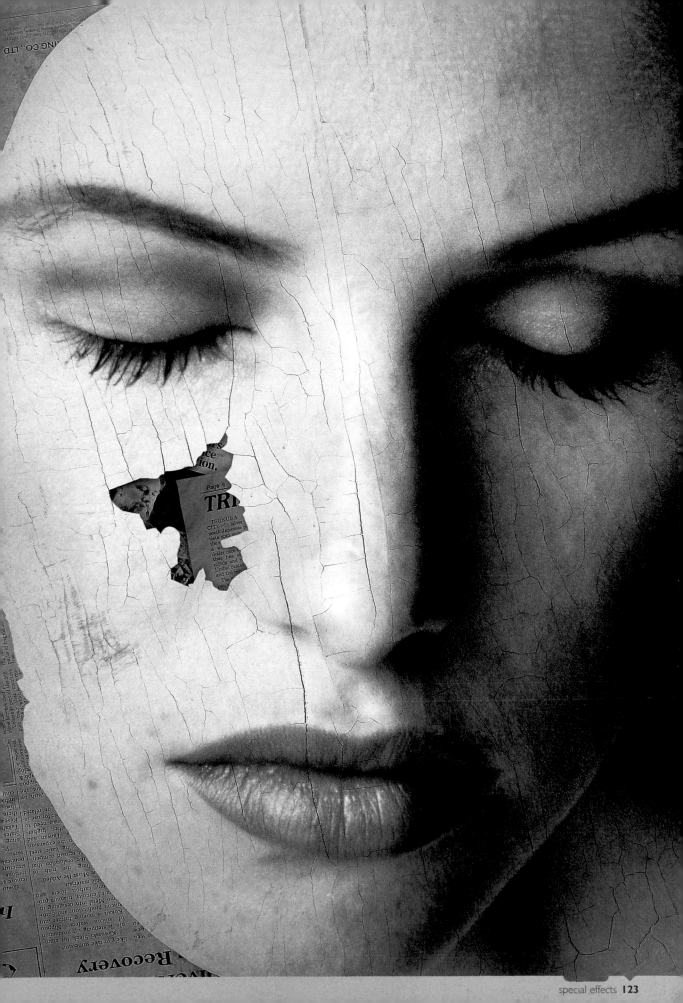

T O O T H P A S T E

Photographer: **Bob Coates**

Use: **Stock**

Camera: **35mm**

Lens: **35–135mm at 130mm**

Film: **Fuji Velvia**

Exposure: **12 seconds at f/4**

Lighting: **Black light (ultra-violet)**

Props and set: **Black velvet background, glass with black poster board underneath**

▼

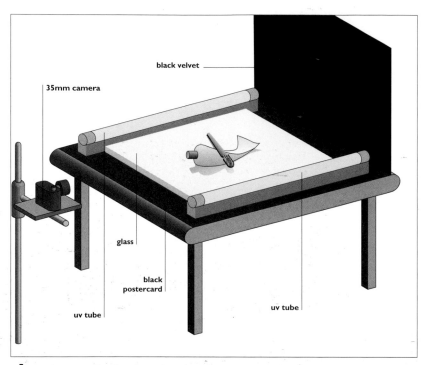

AT FIRST GLANCE, THIS MIGHT LOOK LIKE A COMPUTER-GENERATED IMAGE. BUT IN FACT IT IS SIMPLY A STRAIGHTFORWARD STILL LIFE OF A REAL TOOTHBRUSH AND TUBE OF TOOTHPASTE, CLEVERLY TREATED FOR THIS SURREAL EFFECT.

Bob Coates first painted the items white, then gave them several layers of the three colours of fluorescent spray paint. He then laid the objects on a sheet of glass with black poster board underneath, and set up the background with black velvet fabric.

Two 2-foot 18 watt fluorescent tubes (that is, ultra-violet black light, rather than everyday domestic fluorescent strip lights) were laid on the table, one either side of the still life, parallel with each other and perpendicular to the film plane of the camera. This form of light is visible to the naked eye as a deep violet glow, but far more fascinating than the light source itself is the gleam of fluorescence that it produces on the objects that it lights.

Bob used his spot meter just as he would for any other (non ultra-violet) shot and tried out various combinations of exposure and aperture before arriving at an aperture of f/4 which gave him a length of exposure that he was satisfied with at 12 seconds.

Photographer's comment:

I used many thin fluorescent layers so that the paint didn't run or crack. Don't forget to bracket exposure time and f-stop for many different "looks".

- ► Black (UV) light is wavelengths shorter than about 400nm. Shots in the near ultra-violet are possible with most standard lenses down to about 320nm and most films are sensitive to this. They will record it as a very deep violet

- ► Beyond 320nm UV light is absorbed by glass, and quartz lenses are required

- ► Reflections in glass can look less intense than the actual object and this can be compensated for (where the composition is suitable) by using a split neutral density filter

Plan View

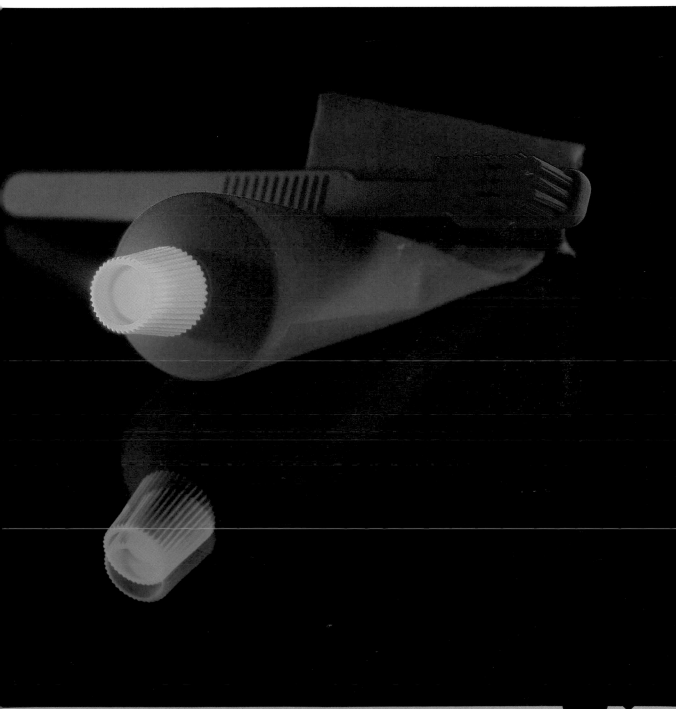

Photographer: **Marc Joye**

Use: **Portfolio**

Model: **Justine**

Camera: **6x6cm**

Lens: **80mm**

Film: **Tmax 100**

Exposure: **1/100 second at f/11**

Lighting: **Electronic flash: 2 heads**

Plan View

► *Be careful of lens flare with lamps pointing in the direction of the camera. Either set flags or use the model to alleviate the problem*

► *Flare can be used creatively to add to the mood of a shot. It occurs in different forms such as a milkyness over the whole or part of an image, or can be points of coloured light blooming across the surface of the lens*

D A N C E R

▼

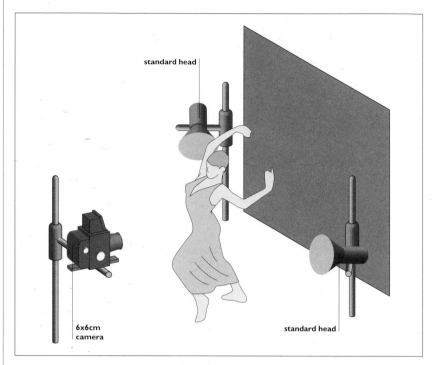

standard head

6x6cm camera

standard head

THE TWO STANDARD HEADS USED FOR THIS SHOT ARE POSITIONED ON EITHER SIDE AND BACK FROM THE MODEL TO GIVE OBLIQUE BACK LIGHTING. THE LIGHT THUS GLANCES OFF THE FOLDS OF THE MODEL'S DRESS AND HIGHLIGHTS THE OUTLINE OF HER LIMBS, COMPLEMENTING THE SENSE OF FLOWING DANCE INDICATED BY BOTH HER POSE, THE EVIDENT MOVEMENT OF THE FOOT, WHICH IS SLIGHTLY SOFT, AND THE SWIRL OF THE CLOTHING.

There is no key light as such. The two identical lights positioned symmetrically about the axis of the lens give a sense of balance and add to the non-naturalistic, theatrical mood. More naturalistic lighting with an obvious front key light would have given quite a different feel, emphasising visibility of the front view rather than the overriding attention to form that this arrangement has produced. On the other hand, using just one key light behind would have gone too far the other way, producing an image that would be all silhouette and no detail.

The almost geometric form of the model is beautifully enhanced by the physical finishing, texture and presentation of the final image. The negative was printed on designer paper made sensitive with Fuji Art Emulsion, the dress hand-painted with Kodak dye, and finally the curve was drawn in with a designer's pencil.

Photographer's comment:

Justine was dancing in her fine cotton summer dress.

Jan.96 EA

Photographer: **Paco Macias**

Use: **Self-promotion**

Model: **Erika Alvarado**

Assistant: **Gabriela Hernandez and Jose Luis Hernandez**

Camera: **6x6cm**

Lens: **150mm**

Film: **Fuji RDP II 100 ISO**

Exposure: **1/125 second at f/11**

Lighting: **Electronic flash: 3 heads**

Props and set: **Humidifier and orchids**

Plan View

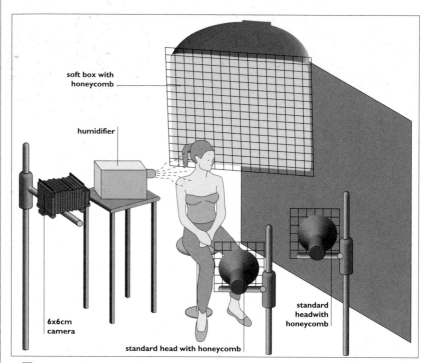

soft box with honeycomb

humidifier

6x6cm camera

standard head with honeycomb

standard head with honeycomb

THE KEY TO THIS IMAGE IS ONE OF THE PROPS IDENTIFIED IN THE TECHNICAL BREAKDOWN, WHICH REVEALS THAT THIS APPARENTLY "SPECIAL EFFECTS" PHOTOGRAPH IS IN FACT THE MAGICAL RESULT OF A HUMIDIFIER UPON THE HUMAN FACE, IN CONJUNCTION WITH MODIFIED DIRECT SIDE-LIGHT.

Paco Macias explains the inspiration for the shot: "The first time I saw the effect caused by a humidifier over the face with thousands of drops hanging on the fine hair – click! The idea of the photo was simple: to capture droplets on a beautiful face, with amazing results."

This chance observation of an unusual effect has been well utilised here. Paco Macias has found the ideal lighting set-up to pick up every drop of moisture on the model, transforming what might be described prosaically as damp hair into seemingly extraordinary fibre-optic lashes. Nothing more complicated than three electronic flashes and a couple of honeycombs in a side-lit arrangement give a dramatic directional light, and - "click!" – the original inspiring moment is recreated and captured on film.

Photographer's comment:

To materialise photographic ideas is pure magic!

► *Most pieces of equipment, be they camera, lighting, or other ancillary devices, are generally available for rental*

► *Often, if you are considering buying a piece of equipment, it is worth renting it first to check that it is the right thing for you*

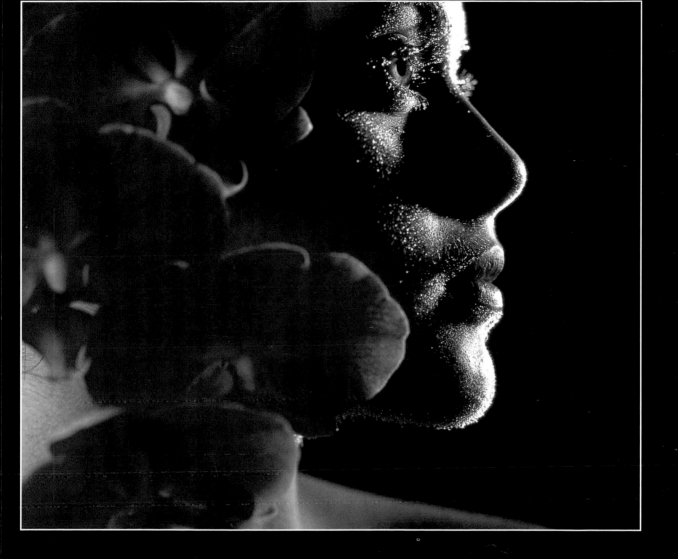

Photographer: **Salvio Parisi**

Client: **La Griffe/Coiffure Magazine**

Use: **Editorial**

Model: **Angie**

Assistant: **Chicca Fusco**

Hair and make-up: **Chen Ho**

Camera: **4x5in**

Lens: **210mm**

Film: **Polaroid T-59**

Exposure: **f/22**

Lighting: **Electronic flash**

Props and set: **White background**

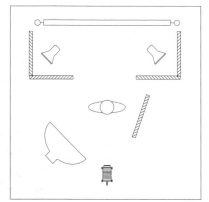

Plan View

A N G I E

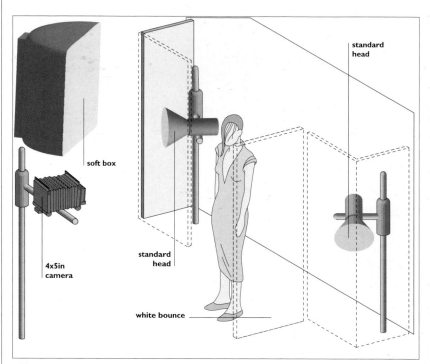

SOMETIMES, EVEN POSING THE MODEL WITH CAREFUL DIRECTION CAN ADD TO THE "SPECIAL EFFECTS" LOOK OF AN IMAGE. THE MODEL HERE APPEARS TO HAVE AN UNNATURALLY LONG NECKLINE, AND THE INITIAL IMPRESSION IS THAT MANIPULATION OF SOME KIND MUST HAVE BEEN USED TO DISTORT AND ELONGATE HER SHAPE. IN FACT, NO SUCH DISTORTION WAS USED.

The model is not straight on to the camera but has her shoulders at 45 degrees and what is apparently a long swan-like neck is actually the throat plus the upper part of the torso with the shoulder turned out of sight, smoothly extending in a curve to complete the back-to-front S-shape defined by the right side outline of the model.

The lighting is important to complete this illusion. The throat and upper body/shoulder areas must admit of no variation in tone or modelling, and evenness across this area is ensured by the large bounce to the right which disperses the light from the soft box to the left.

The choice of Polaroid T59 film is one of the Polaroid stocks that produces a negative, and Salvio Parisi has taken advantage of this by making a transfer version of the shot, at which stage the mottled sepia effect crossing from the background onto the throat is introduced.

Photographer's comment:

I was experimenting with Polaroids on a fashion/hair shoot; this is a "transfer" version.

Photographer: **Myk Semenytsh**

Use: **Pharmaceutical calendar**

Agency: **Opus Advertising**

Model: **Sophie McDonnell at Boss Agencies, Manchester**

Art director: **Paul Thompson**

Camera: **RB67**

Lens: **250mm**

Film: **Fuji RDP**

Exposure: **2 seconds at f/11**

Lighting: **Electronic flash and projectors**

Props and set: **Dark brown mottled background**

Plan View

► *Projector bulbs are normally 250 watts*

► *When using slide projectors with daylight balanced film, a colour correction filter can be used in front of the projector lens if required. However this will reduce the light output of the projector by up to 2 stops*

▼

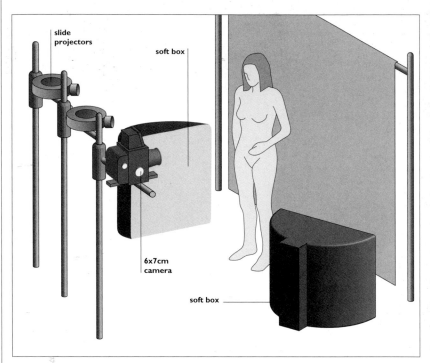

slide projectors

soft box

6x7cm camera

soft box

THE CONCEPT FOR THIS CALENDAR SHOOT WAS BASED ON THE IDEA THAT THE PHARMACEUTICAL COMPANY'S (THAT IS, THE CLIENT'S) PRODUCTS ARE MADE TO GO INTO THE BODY, HENCE THE PICTURES PROJECTED ONTO THE MODEL'S BODY FEATURE MEDICINAL IMAGES.

The first stage was to prepare the 35mm slides of the pharmaceutical products. Two slides were then simultaneously projected onto the model's torso. The studio needs to be dark for the projected images to show up well on the model's skin, but even so, the projections are of relatively low light, and a 2-second exposure was required for them to record on film in the final image. The yellow tinge and warmth of the projections on the body is a result of the projector light bulbs, which are tungsten.

The edge of the model's body and the background were each illuminated by their own individual soft box, each with the modelling light turned off and set to a predetermined power setting.

Photographer's comment:

Shot as part of a series of body parts with projections onto them. The concept is that the company produces drugs that go into the body. Both male and female were shot.

Photographer: **Joseph Colucci**

Use: **Portfolio**

Design: **Joseph Colucci**

Camera: **Nikon and Hasselblad**

Lenses: **80mm and 180mm**

Exposure: **f/5.6 and f/8**

Lighting: **Electronic flash**

Props and set: **White and green seamless paper**

Plan View

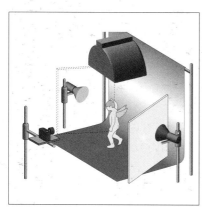

Alternative View

▶ *Classical genres are a good source of ideas for new interpretations*

▶ *A lot can be learned from the discipline of trying to reproduce the compositions and lighting arrangements depicted by the great masters of art and photography*

DREAMER

▼

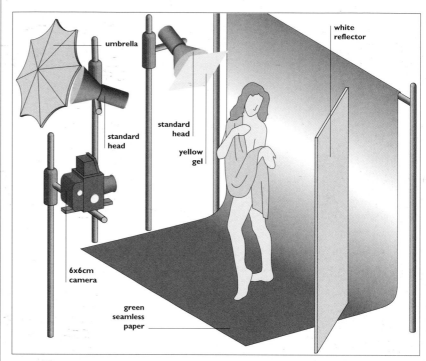

Eᴌᴇᴄᴛʀᴏɴɪᴄ ᴍᴀɴɪᴘᴜʟᴀᴛɪᴏɴ ᴄᴀɴ ʙᴇ ɢʀᴇᴀᴛ ғᴜɴ. Tʜɪѕ ɪᴍᴀɢᴇ ᴡᴀѕ ᴄᴏᴍᴘᴏѕᴇᴅ ɪɴ Pʜᴏᴛᴏѕʜᴏᴘ ᴀɴᴅ ᴛʜᴇʀᴇ ᴡᴇʀᴇ ғɪᴠᴇ ѕᴛᴇᴘѕ ᴛᴏ ᴛʜᴇ ᴘʀᴏᴄᴇᴅᴜʀᴇ. Iɴ ᴛʜᴇ ᴡᴏʀᴅѕ ᴏғ ᴛʜᴇ ᴘʜᴏᴛᴏɢʀᴀᴘʜᴇʀ:

"**1** A child was placed on white seamless paper and allowed to walk freely. A soft box was placed overhead and two lights diffused by material stood on both sides. A 35mm Nikon camera was used.

"**2** A model on green seamless paper was fashioned to look like a mythical character with the help of a make-up artist. The image was lit with a 32in umbrella over the camera, a hard light from the back left side and a diffused light from the right side. For this image I used a Hasselblad.

"**3** I photographed a section of my backyard to use for the background with available light.

"**4** Four different views of the dove were created from one image. The same image was also the source of the cherub's wings.

"**5** All images were scanned onto a photo CD, transported into Photoshop and finally composed."

Photographer's comment:

I was inspired by painters of the Renaissance.

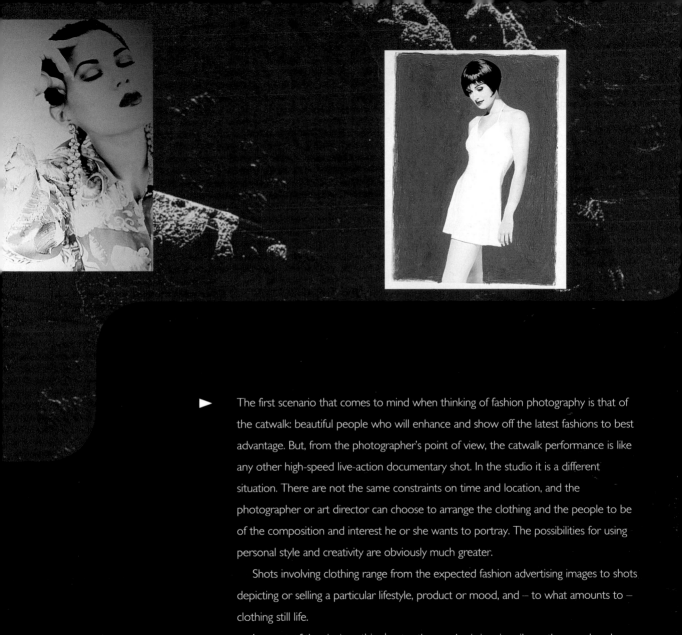

The first scenario that comes to mind when thinking of fashion photography is that of the catwalk: beautiful people who will enhance and show off the latest fashions to best advantage. But, from the photographer's point of view, the catwalk performance is like any other high-speed live-action documentary shot. In the studio it is a different situation. There are not the same constraints on time and location, and the photographer or art director can choose to arrange the clothing and the people to be of the composition and interest he or she wants to portray. The possibilities for using personal style and creativity are obviously much greater.

Shots involving clothing range from the expected fashion advertising images to shots depicting or selling a particular lifestyle, product or mood, and – to what amounts to – clothing still life.

In some of the shots in this chapter the emphasis is primarily on the people, who are dressed in some particularly distinctive or effective way; in others the attention is on the clothes themselves, displayed as beauty accessories in their own right. The connecting factor is the notion that fine feathers do make fine birds: clothing and fashion contribute an enormous amount to the overall impact of a person and, for many people, fashion is inseparable from the world of beauty.

Photographer: **Kazuo Sakai**

Use: **Test shot**

Model: **Sara**

Camera: **35mm Canon F1**

Lens: **85mm**

Film: **Fuji RDPII**

Exposure: **1/125 second at f/2**

Lighting: **Electronic flash**

Props and background: **White paper**

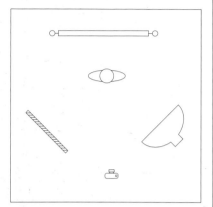

Plan View

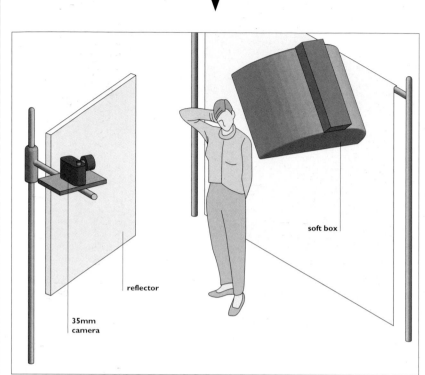

soft box

reflector

35mm
camera

KAZUO SAKAI IS A MULTI-TALENTED PHOTOGRAPHER WHO HAS A RANGE OF RESOURCES TO CHOOSE FROM: PHOTOGRAPHY, DIGITAL IMAGING, THE TRADITIONAL PAINTBRUSH. ALTHOUGH HE COULD HAVE CREATED THIS FINAL IMAGE ELECTRONICALLY, HE TURNED TO TRADITIONAL METHODS, USING A TRADITIONAL RATHER THAN A DIGITAL PALETTE.

For the initial shot he chose to light the model very simply and then went on to enhance the result with hand-painting.

The choice of rich fabric for the model's clothes is a challenging one - just enough detail of the texture is picked out by the careful positioning of the reflector in terms of proximity. Too close in and it could well have looked over-fussy and ostentatious. Too far away and it would have been too dark with no detail visible.

► *Restraint is often an important element in the success of the most sophisticated images. It is all too easy to go 'over the top' just because you can*

► *It is very important to choose the correct style of lighting to complement the end result*

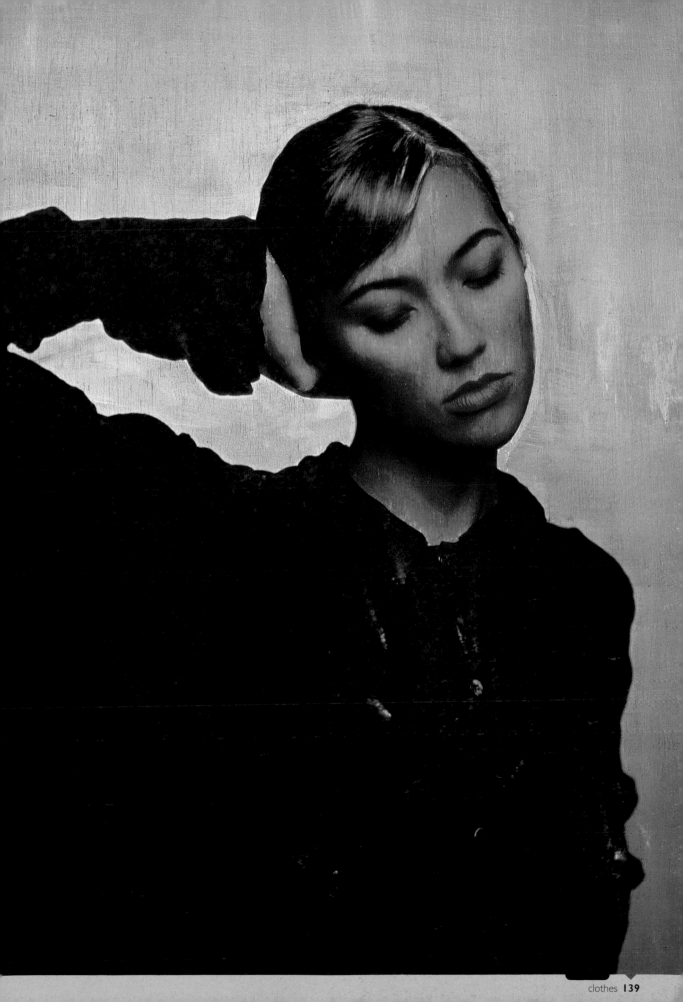

Photographer: **Benedict Campbell**

Client: **Japanese fashion client**

Use: **Editorial**

Model: **Tomoko**

Assistant: **David Knight/Max**

Stylist: **Stuart Crotch**

Camera: **35mm**

Lens: **200mm**

Film: **Fuji Velvia (cross-processed)**

Exposure: **Not recorded**

Lighting: **Ring flash, 2 soft boxes**

Props and set: **Clothes and painted background**

Plan View

ORANGE TOP

▼

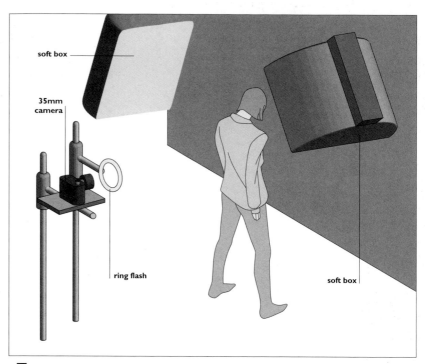

THIS IS ONE OF THE FEW PICTURES IN THIS BOOK THAT DEMONSTRATES THE USE OF A RING FLASH. THE RESULT IS OBVIOUSLY VERY EYE-CATCHING.

Benedict Campbell used the ring flash in conjunction with two soft boxes which are lighting the blue background. "The soft boxes are set one stop under the ring flash, therefore giving the metallic look to the shirt," he explains. Notice the slight shadow around the edge of the model, also resulting from the use of the ring flash. This not only gives some separation from the background, but slightly tones down what would otherwise be a rather painful clash

between the vivid orange and blue of the shirt and background. While the startling and effective overall colour contrast between the two remains intact, the "fighting" that could occur where the two colours meet is thus cleverly side-stepped by the gentle, even shadow.

The texture and colours are the two most important aspects of this shot, and the cross-processing is used to heighten the intensity of the shades and to keep contrast at a high level.

► *This picture demonstrates the very versatile nature of "magic arms"; in this case an Arri arm holding the ring flash*

► *If the subject is strong enough in itself, the pose can be very simple, allowing the eye to settle on the texture and colour above all else*

► *Ring flashes can give very unusual catch-lights in eyes*

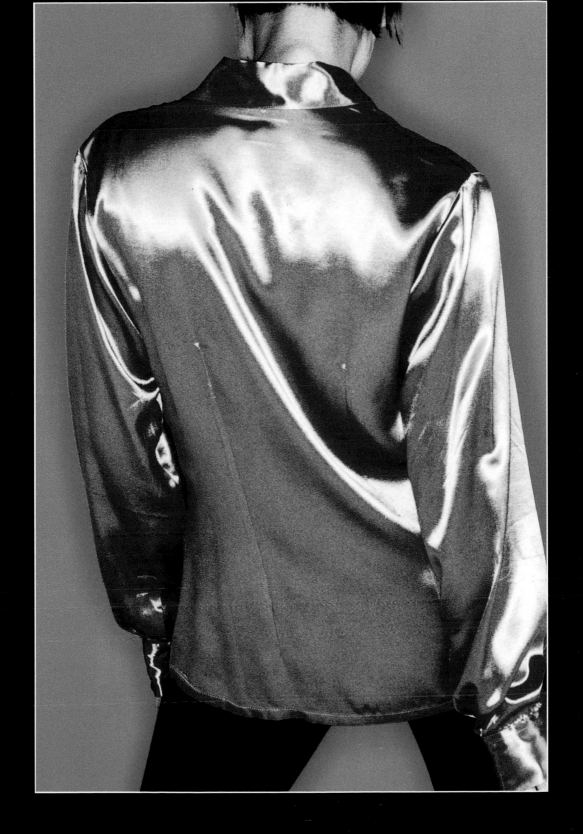

Photographer: **Julia Martinez**

Client: **Jo Vallender Hair Company**

Use: **Editorial poster**

Model: **Kate Lofts**

Art director: **Jo Vallender**

Camera: **Canon EOS 5**

Lens: **50mm**

Film: **Tmax 100**

Exposure: **f/11**

Lighting: **Available light**

Props and set: **Black cloth, on location**

Plan View

► *On a sunny, cloudless day, it is difficult (and dangerous) for a model to look in the direction of the sun for any length of time and the photographer will have to work around this limitation*

► *Take care not to look at the sun through a lens accidentally*

▼

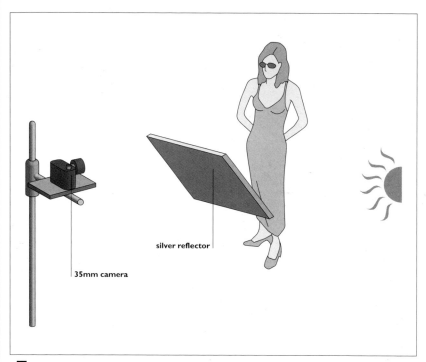

silver reflector

35mm camera

THE FASCINATING DETAIL TO THIS PHOTOGRAPH IS THE SUBTLE IMAGE THAT APPEARS IN THE LENSES OF THE SUNGLASSES — NOT SOMETHING THAT IS IMMEDIATELY APPARENT, BUT AN INTRIGUING FINISHING TOUCH ONCE IT HAS BEEN NOTICED.

The shoot took place in bright daylight on location, with the model facing almost directly into the sun. Julia Martinez was using a silver reflector close in front of the model and, noticing the reflections sent back into the lenses of the sunglasses, decided to take this phenomenon one stage further and floated the idea of placing similar images deliberately in the sunglasses. The client liked the idea, so the idea was executed using computer manipulation.

Of course, judicious and cunning use of mirror reflectors could, in the right circumstances, give a similar result, returning the model's own image onto the surface of the sunglasses without recourse to computer technology.

Photographer's comment:

The computer work was an afterthought: we suggested it to the client and the client liked it.

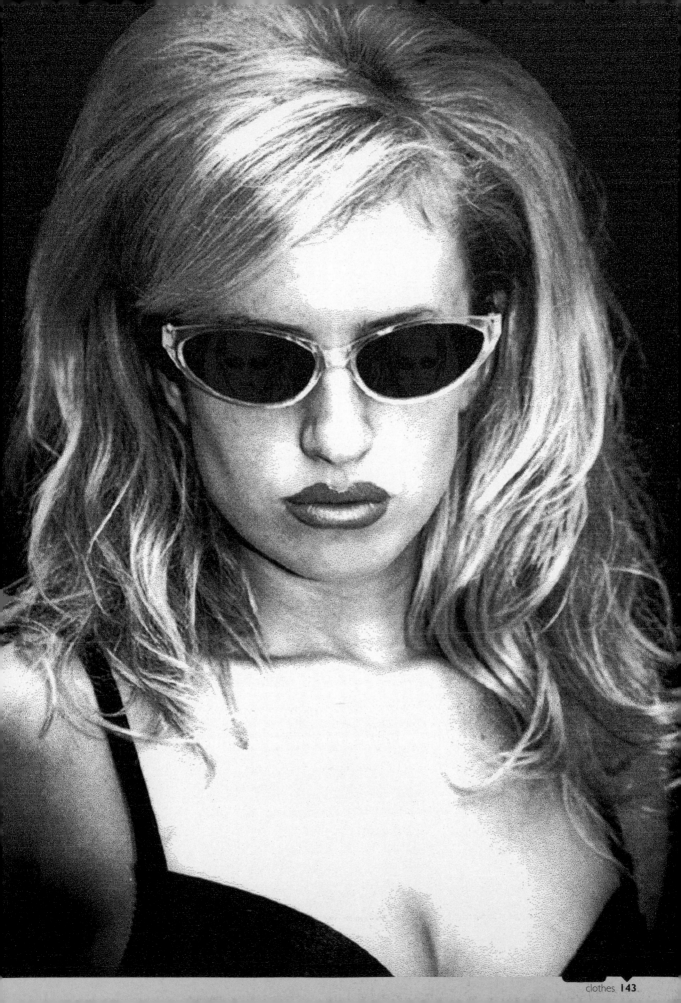

Photographer: **Joseph Colucci**

Use: **Self-promotion**

Design: **Joseph Colucci**

Camera: **4x5in**

Lens: **250mm**

Exposure: **f/11**

Lighting: **Tungsten**

Props and set: **Plexiglass, shoes and white paint**

Plan View

S H O E S

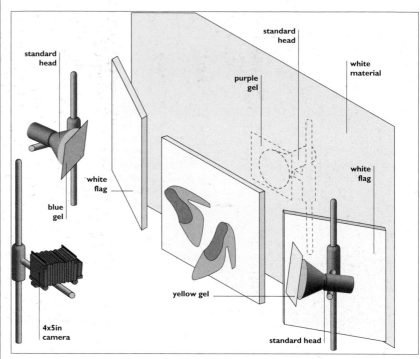

Sᴏᴍᴇ ɪᴍᴀɢᴇs ᴊᴜsᴛ sᴛᴏᴘ ᴛʜᴇ ᴠɪᴇᴡᴇʀ ɪɴ ᴛʜᴇɪʀ ᴛʀᴀᴄᴋs: "Hᴏᴡ ᴅɪᴅ ᴛʜᴇʏ ᴅᴏ ᴛʜᴀᴛ?" Jᴏsᴇᴘʜ Cᴏʟᴜᴄᴄɪ ᴡᴏʀᴋs ᴇxᴛᴇɴsɪᴠᴇʟʏ ᴀɴᴅ ᴇxᴘᴇʀᴛʟʏ ᴡɪᴛʜ sᴛᴀᴛᴇ-ᴏғ-ᴛʜᴇ-ᴀʀᴛ ᴄᴏᴍᴘᴜᴛᴇʀ ᴍᴀɴɪᴘᴜʟᴀᴛɪᴏɴ ᴀɴᴅ ᴛʜᴇ ɪɴɪᴛɪᴀʟ ɪᴍᴘʀᴇssɪᴏɴ ᴡɪᴛʜ ᴛʜɪs sʜᴏᴛ ɪs ᴛʜᴀᴛ ᴛᴇᴄʜɴᴏʟᴏɢʏ ʜᴀs ʙᴇᴇɴ ʙʀᴏᴜɢʜᴛ ᴛᴏ ʙᴇᴀʀ ᴛᴏ ᴀᴄʜɪᴇᴠᴇ ᴛʜɪs ᴇʏᴇ-ᴄᴀᴛᴄʜɪɴɢ ɪᴍᴀɢᴇ.

It comes as a surprise, then, to discover that only traditional techniques and purely physical means were used for this shot. A sheet of perspex, three gels, a pot of paint and a pair of shoes are as sophisticated as it gets.

A pair of black shoes were glued to a sheet of Plexiglass and then splattered with white paint and set upright before the camera. A sheet of white material was hung a short distance behind the Plexiglass and a 750 watt tungsten light with a purple gel was placed directly behind that, pointing straight towards the camera. Two further 750 watt tungsten lights, one either side, each with a coloured gel, one yellow, one blue, were placed so that the light just skimmed across the near edges of the shoes. Finally, two white cards were used to flag the side-lights to prevent any light spilling onto the white material background.

► *Special effects technology is not always needed for a special effects look*

► *Glue helps you to get what you want, exactly where you want it*

Photographer's comment:

The Italian in me loves bright colours.

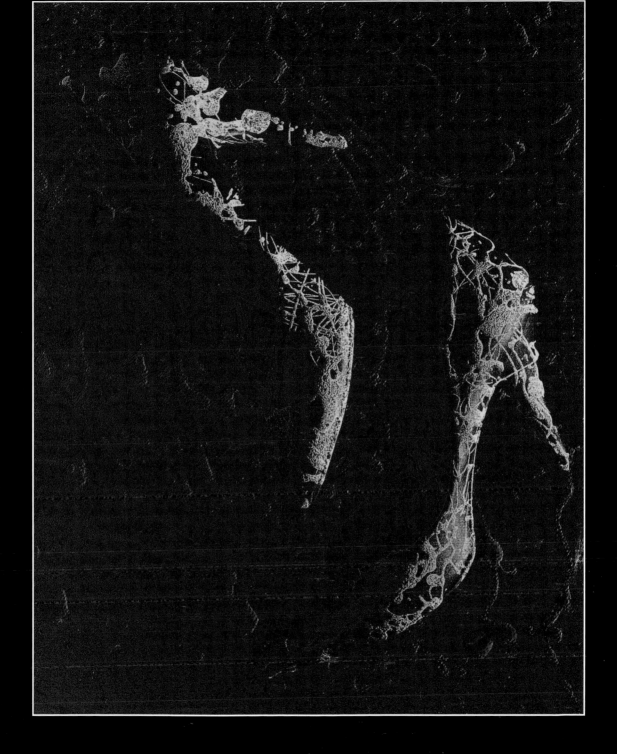

Photographer: **Benedict Campbell**

Client: **Spanish Vogue**

Use: **Editorial**

Model: **Patricia**

Assistant: **David Knight**

Stylist: **Jeffery Buckland**

Camera: **35mm**

Lens: **200mm**

Film: **Fuji Velvia (cross-processed in C41)**

Exposure: **1/125 second at f/2.8**

Lighting: **Available light, reflector**

Props and set: **Tourists!**

Plan View

PATRICIA

▼

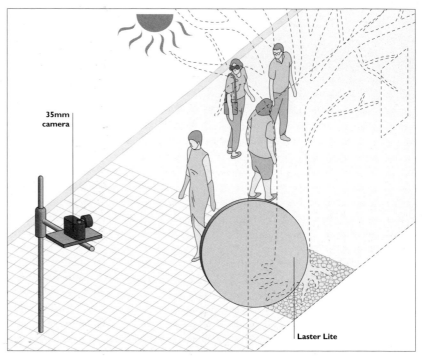

BENEDICT CAMPBELL DELIBERATELY SET OUT TO CREATE A VERY STARK, CONTRASTY IMAGE, HENCE THE USE OF CROSS-PROCESS. NOTICE THE TELL-TALE CYAN CAST IN THE SHADOW DETAIL.

Very often photographers choose to have the sun behind the subject, as in this instance, and use a reflector to bounce light back, a Laster Lite being held by the assistant, walking alongside the model here. This positioning avoids the problem of having the photographer's own shadow in frame.

This type of semi-candid semi-contrived shot is an example of a shoot where the photographer will never know what the result will be until the day: the spontaneity of shooting in public, with random passers-by is something that brings unpredictable results.

► It is always possible to rent-a-crowd if you are not confident of cooperatively placed members of the public meandering into shot at the right moment!

► Copyright and personal privacy laws vary around the world and it is important to be sure of your ground before taking candid shots for commercial gain

► Elements such as high contrast can become a trademark style of a photographer. In the work of Bill Brandt, for example, it is virtually a signature

Photographer's comment:

Exposed for shadow detail. Model in shade under tree – Laster Lite used to fill in lighting.

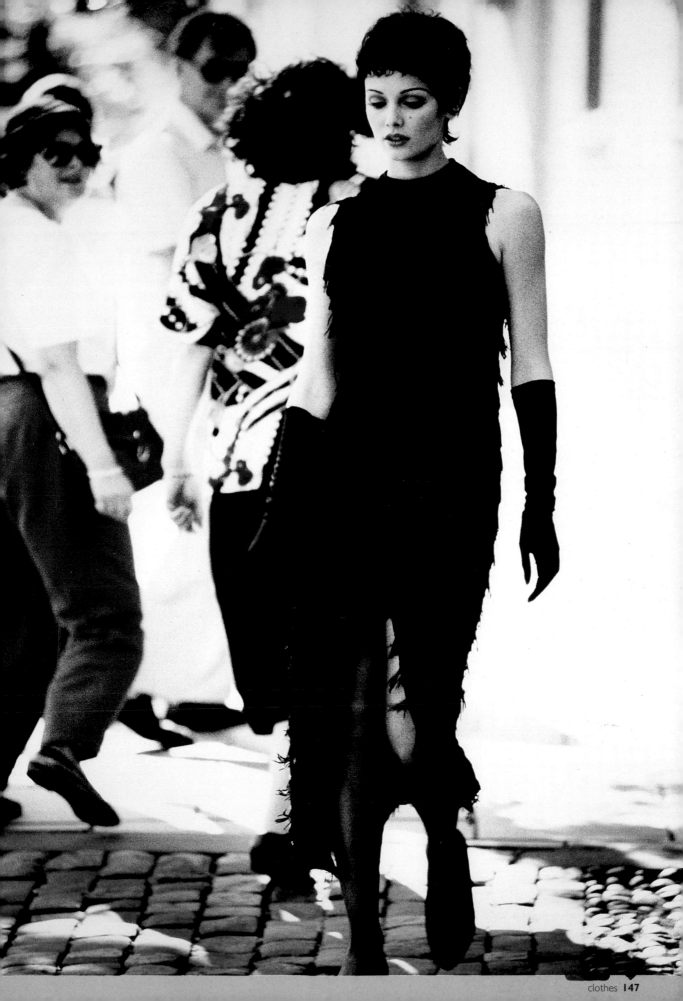

Photographer: **Julia Martinez**

Client: **Hazel Scott Knitwear Company**

Use: **Editorial poster**

Model: **Ann Taylor**

Art director: **Hazel Taylor**

Make-up: **Armin Weisheit**

Camera: **Canon EOS 5**

Lens: **50mm**

Film: **Tmax 100**

Exposure: **f/22**

Lighting: **Available light**

Props and set: **Location**

Plan View

▼

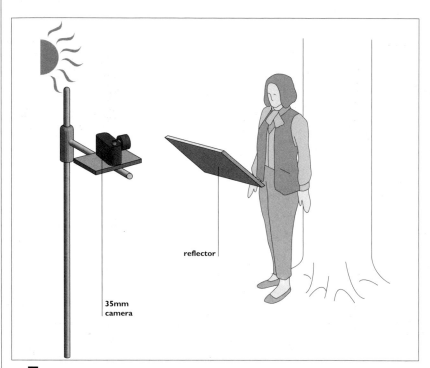

reflector

35mm camera

THE OUTDOOR GLOUCESTERSHIRE COUNTRYSIDE LOCATION IS JUST VISIBLE ENOUGH TO ESTABLISH A SENSE OF CONTEXT THAT IS COMPATIBLE WITH THE STYLING OF THE MODEL. SHE WEARS SIMPLE, NATURAL MAKE-UP, A PRACTICAL YET STYLISH OUTDOOR SWEATER AND HAS WIND-TOUSLED HAIR. AT THE CENTRE OF THE IMAGE (AND OF THE PROMOTION) IS THE GLEAMING SILKY SCARF, LUXURIOUSLY YET CASUALLY ARRANGED TO CATCH THE SUNLIGHT AND SHOW OFF ITS BEAUTIFUL TEXTURE AND QUALITY.

The effective portrayal of rippling fabric owes its success to the contrast between areas of shade, light, and above all, the glowing highlights. This was achieved by exposing primarily for the shadows on the model's face and allowing the highlights to register as they will. The result is perfect exposure of the face, while the scarf registers as relatively high-key and takes on an almost unreal quality, "zinging" out above the tones of the model's face.

► To retain a good tonal range it is important to choose the correct film stock

► A spot meter is essential to know how different parts of a scene will record

Photographer's comment:

The client arranged the make-up artist. He came from London and was brilliant.

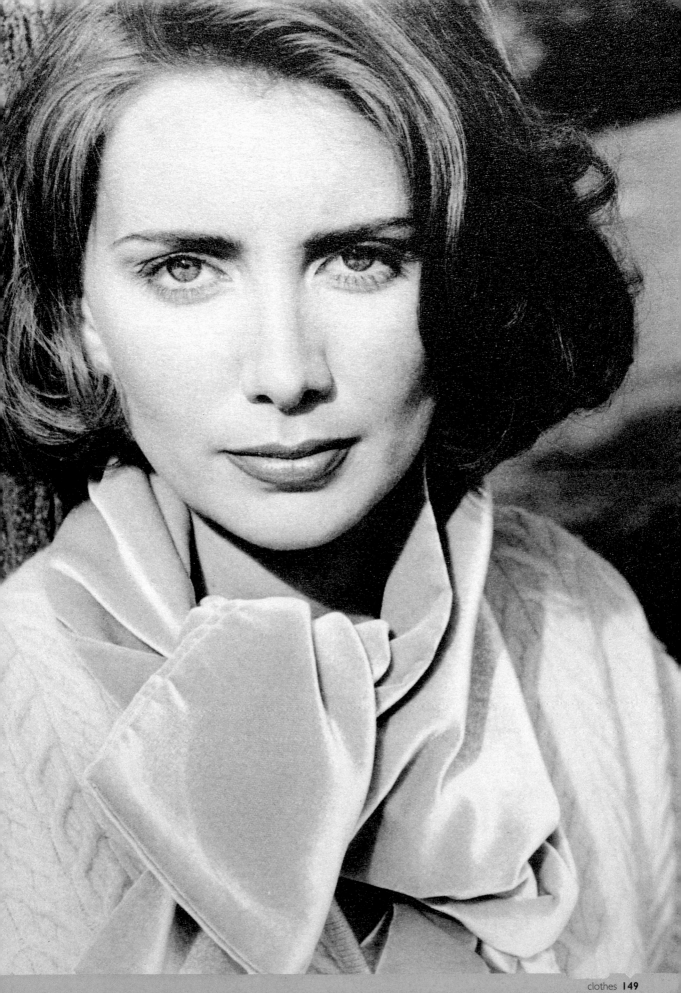

Photographer: **Ben Lagunas and Alex Kuri**

Client: **Bella**

Use: **Editorial**

Assistant: **Natasha, Victoria**

Stylist: **Charle**

Camera: **Nikon F4**

Lens: **300mm**

Film: **Kodak EPP**

Exposure: **1/30 second at f/5.6**

Lighting: **Electronic flash**

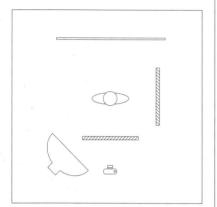

Plan View

MAKE-UP

▼

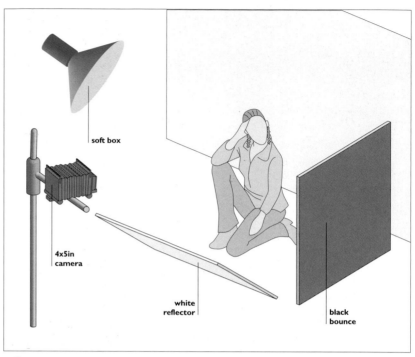

soft box

4x5in
camera

white
reflector

black
bounce

OPEN-AIR SHOOTS OFTEN USE JUST THE AVAILABLE SUNLIGHT WITH OCCASIONAL BOUNCES, BUT BEN LAGUNAS AND ALEX KURI CHOSE TO SHOOT THIS OUTDOORS, AND ENHANCED THE NATURAL SUNNY MEXICAN DAYLIGHT WITH A CIRCULAR SOFT BOX AND TWO LARGE PANEL REFLECTORS, ONE WHITE AND ONE BLACK.

The choice of clothing and colours is important to pick up on the eye-shadow make-up – that is, the product. The lipstick looks glorious, and the cross-process takes all the other colours (of the skin, the background, much of the clothing and hair) right down, so that the red lips can shine out. The reflective satin-finish clothing adds to the impression of gleaming shine.

It is all very bright and high-key. Everything is insignificant compared with the make-up; the whole set-up is a vehicle for showing off the cosmetics. The right model, right styling and right treatment are vital. The hand is almost entirely burnt out by the large circular flash which is the only additional light. The 35mm film with the 300mm lens, which is a long telephoto, gives a very shallow depth of field so that only the face displaying the make-up is in any detail or focus.

► *There is a big difference between over-exposure and allowing areas to burn out*

Photographer's comment:

We were concentrating on the make-up, that is the reason for the cross-process.

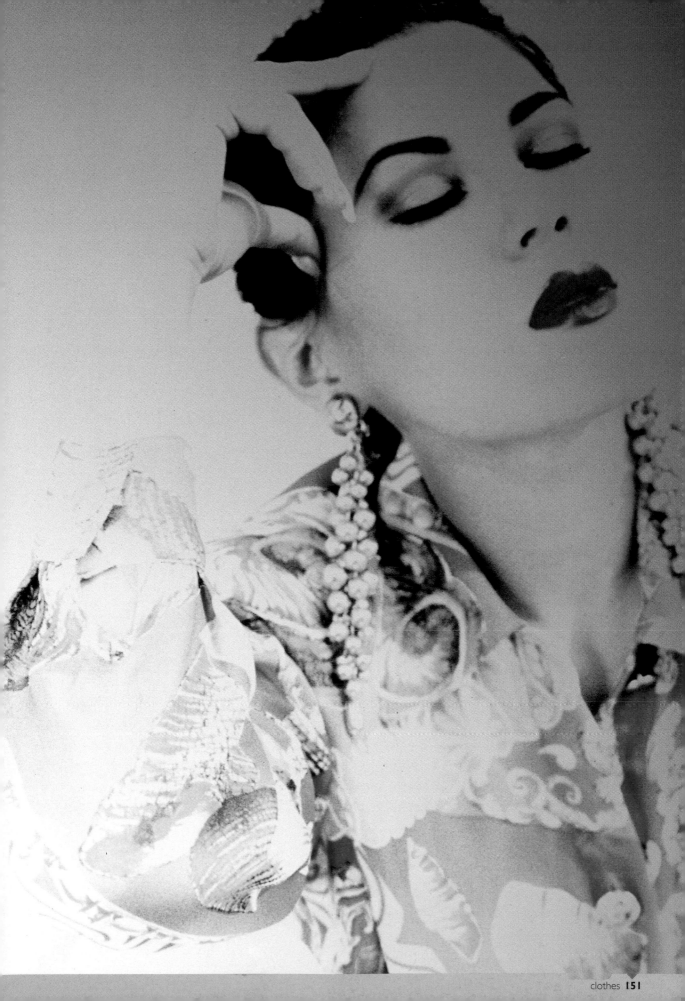

Photographer: **Benedict Campbell**

Client: **Insurance company**

Use: **Advertising**

Model: **Vicky Wiltshire**

Assistant: **Le Rex Atherton**

Stylist: **Pam Fraser**

Camera: **6x6in**

Lens: **150mm**

Film: **Fuji Velvia (cross-processed)**

Exposure: **Not recorded**

Lighting: **Electronic flash**

Props and set: **Shot in cove. Wig on model**

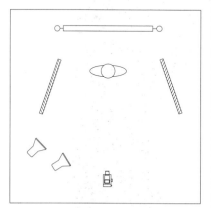

Plan View

VICKY

▼

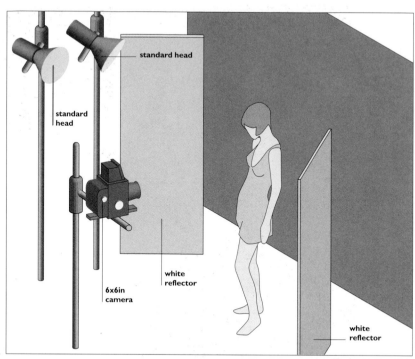

standard head

standard head

white reflector

6x6in camera

white reflector

THE LIGHTING FOR THIS SHOT IS RELATIVELY STRAIGHTFORWARD. THE MODEL IS STANDING BETWEEN TWO 8x4 FOOT VERTICAL POLYBOARDS. ONE STANDARD FLASH HEAD, WHICH IS THE KEY LIGHT, IS PLACED TO THE LEFT OF THE CAMERA AND POINTS DIRECTLY AT THE MODEL. A SECOND STANDARD HEAD BETWEEN THE CAMERA AND THE KEY LIGHT BOUNCES OFF THE POLYBOARD TO THE MODEL'S LEFT TO FILL IN LIGHT ON THE BODY.

The fun really begins with the post-production. Benedict Campbell cross-processed the Velvia transparency film in colour print film (C41) chemicals. He then made a colour print from the resulting negative.

The colour print was printed with a slightly green tinge (notice the colour on the back of the leg, the shine of the hair and in the slight folds of the fabric of the dress) to add to the unexpectedness of the colour range. Finally, the background was hand-painted using acrylic paint to give the bold sweeps of texture and colour in shades of purple and the whole work re-copied onto Velvia processed normally to produce a transparency of the final image.

► *The cyan cast in the shadows is a typical result of cross-processing colour transparency film in C41 chemicals*

► *It is harder using direct light than it is bouncing light and using soft boxes*

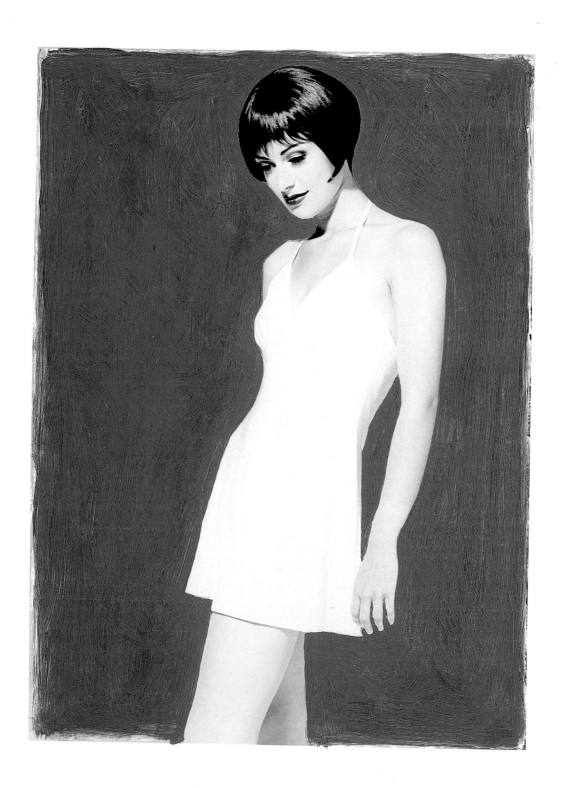

8
directory of
photographers

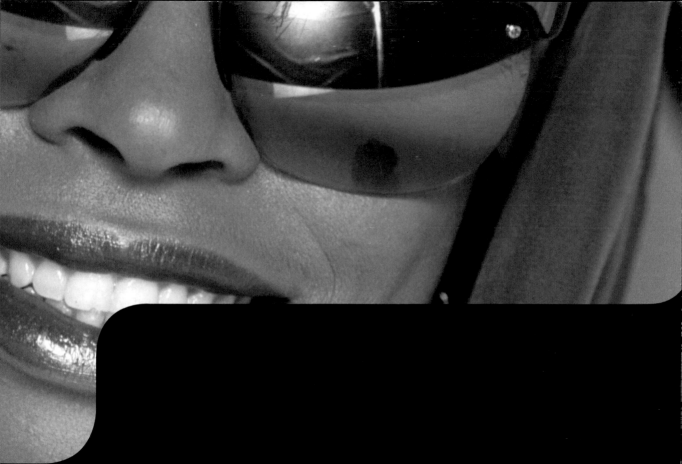

Photographer: **JOHN PAUL ARLINGTON**
Address: RUA SETE IRMAOS 798
ENCANTADO
95960 000 RS
BRAZIL
Telephone: +55 (0) 51 751 1257
Fax: +55 (0) 51 751 3001
E-mail: 101635.3002@compuserve.com
Biography: *Born in Montevideo, Uruguay to an English father and a Uruguayan mother, and brought up in Brazil, John Paul Arlington studied photography in England where he worked in a professional lab and as a photographer. He now lives in the south of Brazil where he has his own fully equipped studio. A young, bright, creative and resourceful professional, experienced in commercial, industrial and fashion photography, with excellent knowledge of all aspects of lab work, John Paul Arlington conveys his passion for photography into all his work producing top quality images with a fresh approach to an old art form. John Paul has produced images for Lloyds Bank, Avon Cosmetics, Barclays Bank, International Tool Corp, Allbyte Technology, Hilux and Robert Home, among others.*
Beauty: p81

Photographer: **BENEDICT CAMPBELL**
Address: THE FOUNDRY
WILSHAM ROAD
ABINGDON
OXFORD OX14 5HP
ENGLAND
Telephone: +44 (1235) 533288
Fax: +44 (1235) 533290
Biography: *I began my career in photography aged 17 years. I never went to college. Thirteen years on I still spend as much time as possible experimenting and for that reason my clients come to me for new looks. I am also a painter so I can look at photography from a different angle, that is, pure imagery. As clichéd as it might be, light is truly magical and has been my inspiration from the beginning.*
Beauty: pp 55, 67, 141, 147, 153

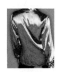

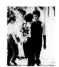

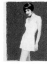

Photographer: **GUIDO PATERNO CASTELLO**
Studio: GPS STUDIA LTDA
Address 1: AVENIDA HENRIQUE DODSWORTH
83/1005
COPACABANA
RIO DE JANEIRO
BRAZIL
Address 2: AVENIDA HENRIQUE DUMONT 53/30
COB.
IPAMENA
RIO DE JANEIRO
BRAZIL
Telephone: +55 (21) 287 0789
Fax: +55 (21) 521 8064
Biography: *Born in New York, March 1958, Associate Arts degree at the American College in Paris, June 1979. BA in Industrial and Scientific Photographic Technology at Brooks Institute of Photographic Arts and Science, June 1984. Castello's clients are all major agencies based in Rio de Janeiro. He has won various awards including a silver medal in 1992, gold medal in 1993, bronze medals in 1994 and 1995 from ABRACOM (Brazilian Association of Marketing and Advertising).*
Beauty: pp 93, 117

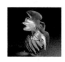

Photographer: **MICHEL CLOUTIER**
Studio: MICHEL CLOUTIER PHOTOGRAPHE INC.
Address: 4030 ST-AMBROISE
SUITE 344
MONTREAL
QUEBEC
CANADA H4C 2C7
Telephone: +1 (514) 939 9974 (Montreal)
+1 (416) 778 6940 (Toronto)
Fax: +1 (514) 939 2567
Biography: *"Facial expressions, the strength of flexed muscle, the story behind the furrowed brow. The human body is language, desire, passion . . . I love to explore the mysteries of this magnificent machine, how its subtle movements can create infinite combinations of shape, form and light. Photography allows us to capture the power and beauty of the human form in a way few other art forms can." From initial concept to finished product, Michel Cloutier has both the means and the expertise to ensure fast and professional results. Working easily with characters and fashion models he never fails to capture the chemistry of the moment. Self-employed for the last ten years, Michel is also the creator of Vertigo magazine, a publication which has served as a showcase for his unique and diverse creative talents.*
Beauty: pp119

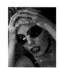

Photographer: **BOB COATES**
Studio: BOB COATES PHOTOGRAPHY
Address: 6501 RED HOOK PLAZA SUITE 201
ST THOMAS USVI 00802 1306
Telephone: +1 (809) 777 8426
e-mail: bcphoto@islands.vi
URL: http://www.usvi.net/cobex/people/bob
Biography: *St Thomas-based Caribbean photographer Bob Coates is available for assignments from location to studio productions. In addition to having his own business, he also shoots for the local newspapers, is a stringer for the Associated Press and illustrates articles for the magazine writer Joan Amerling. Bob was selected by the Virgin Islands Council on the Arts to photograph the work of territory artists. His photography is exhibited regularly in more than half-a-dozen restaurants on St Thomas and his images are frequently seen in many of the island-related publications and tourism brochures. He is represented by Index Stock Photography.*
Beauty: pp124

Photographer: **JOSEPH COLUCCI**
Studio: COLUCCI'S STUDIO
Address: 264 LACKAWANNA AVENUE
WEST PATERSON,
NEW JERSEY, 07424 USA
PO Box 2069
Telephone: +1 (201) 890 5770
Fax: +1 (201) 890 7160
e-mail: joe@coluccis.com
URL: http://www.coluccis.com
Joseph Colucci was born in Italy in 1953. He now resides in New Jersey where he successfully owns and operates Colucci's Studio. Intrigued by all facets of lighting, he loves to create beauty out of the ordinary. He is involved in digital imaging and enjoys exploring all new aspects of it. Photography buyers around the world have appreciated his current web site at http://www.coluccis.com
Beauty: pp 59, 135, 145

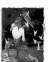

Photographer: **TOM EPPERSON**
Studio: TGE PHOTOGRAPHY
Address: 4898 DURBAN ST
MAKATI CITY
MANILA

	PHILIPPINES
Telephone:	+63 (2) 890 4229
Fax:	+63 (2) 890 4229
Biography:	*An American who has been living abroad for the past 20 years. "I have been in the Philippines now for ten years." Born in Cleveland, Ohio, 1955. Mostly corporate work but also specialising in interiors and food. Clients include Shangri-La Hotel, Manila, Intercontinental Hotel, Manila, Jardine-Davies, Philippine Airlines, Hong Kong Bank, American Express, Tabacalera Cigars, San Miguel.*

Beauty: p97

Photographer:	**MICHÈLE FRANCKEN**
Studio:	NV FRANCKEN CPM
Address:	VLAANDERENSTRAAT 51
	9000 GHENT
	BELGIUM
Telephone:	+32 (9) 225 4308
Fax:	+32 (9) 224 2132
Biography:	*I've worked since 1977 in the family business with my two brothers and four others. N.V. Francken C.P.M. has its own colour laboratory and specialises in fashion catalogues and fabrics. I experiment with personal work alongside my commercial work and I've had several exhibitions.*

Beauty: p95

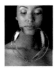

Photographer:	**ERNIE FRIEDLANDER**
Address:	275 SIXTH STREET
	SAN FRANCISCO
	94103 USA
Telephone:	+1 (415) 777 3373
Fax:	+1 (415) 777 3293
Biography:	*Commercial photographer working in advertising, specialising in still life and table top photography. Represented in the West and East coasts in the United States.*

Beauty: p110

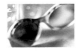

Photographer:	**CLAUDE GUILLAUMIN**
Address:	53 RUE ROCHECHOUART
	75009 PARIS
	FRANCE
Telephone:	+33 (1) 45 26 98 95
Fax:	+33 (1) 44 53 01 61
Agent:	DIDIER POUPARD
	19 RUE DE BASSANO
	75116 PARIS

	FRANCE
Telephone:	+33 (1) 47 20 20 22
Fax:	+33 (1) 47 20 55 44
Biography:	*Claude Guillaumin is a French photographer born fifty years ago. He worked for different magazines like Vogue, Bazaar, Glamour in the USA, Elle in France and Grazia in Italy. Claude became a very famous beauty photographer specialist with clients like l'Oreal, Guerlain and Clarins.*

Beauty: pp19, 39, 47, 60, 68

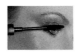

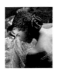
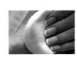

Photographer:	**MARC JOYE**
Studio:	PHOTOGRAPHY JOYE BVBA
Address:	BRUSSELBAAN 262
	1790 AFFLIGEM
	BELGIUM
Telephone:	+32 (53) 66 29 45
Fax:	+32 (53) 66 29 52
Agent:	(JAPAN) MITSUO
	NAGAMITSU
Telephone:	(3) 32 95 14 90
(France)	MARYLINE KOPKO
Telephone:	(1) 44 89 64 64
Biography:	*Photographing on Sinar 4x5in and 10x8in, he likes to do arranged set-ups both in the studio and on location. He finds it most exciting to create effects directly on transparencies.*

Beauty: p45, 127

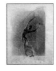

Photographer:	**BEN LAGUNAS AND ALEX KURI**
Studio:	BLAK PRODUCTIONS PHOTOGRAPHERS
Address:	MONTES HIMALAYA 801
	VALLE DON CAMILO
	TOLUCA
	MEXICO CP501 40
Telephone:	+52 (72) 17 06 57
Telephone/Fax:	+52 (72) 15 90 93
Biography:	*Ben and Alex studied in the USA and are now based in Mexico. Their photographic company, BLAK Productions, also provides full production services such as casting, scouting, etc. They are master photography instructors for Kodak; their editorial work has appeared in national and international magazines and they also work in fine art with exhibitions and*

work in galleries. Their work can also be seen in The Golden Guide, the Art Directors' Index and other publications. They work all around the world for a client base which includes advertising agencies, record companies, direct clients and magazines.

Beauty: p72, 151

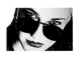
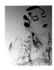

Photographer:	**LEWIS LANG**
Address:	83 ROBERTS ROAD
	ENGLEWOOD CLIFFS
	NEW JERSEY 07632 USA
Telephone:	+1 (201) 567 9622
	+1 (201) 568 9682
Agent:	SWANSTOCK
	118 SOUTH 5TH AVE STE 100
	TUCSON
	ARIZONA 85701 USA
Telephone:	+1 (520) 622 7133
Fax:	+1 (520) 622 7180
Biography:	*I began my career as a film maker, making commercials and documentaries for both broadcast and cable TV. A friend of mine, back in 1983, suggested I use 35mm photography to teach myself about lighting and composition – I ended up loving photography and leaving film making. Since then I've been both a freelance photojournalist, a fashion photographer and a fine art photographer, working on my own surrealistic narrative people and still-life photography and have exhibited at numerous fine art galleries across the USA. Some of my fine art photographs are included in Successful Black and White Photography (Roger Hicks) and Portraits (Roger Hicks and Frances Schultz). My fine art photography is also on file with Swanstock, a stock agency that specialises in fine art photography. Both my writing and photography have appeared in Shutterbug, the third largest photo magazine in the world.*

Beauty: p107

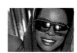

Photographer:	**PACO MACIAS**
Address:	CARRETERA MEXICO TOLUCA #1725
	LOCAL A-15
	COL. LOMAS DE PALO ALTO
	CUAJIMALPA, DF
	MEXICO CITY
	MEXICO CP 05110
Telephone:	+52 (5) 259 9390
	+52 (5) 259 9618
Fax:	+52 (5) 257 1012
	+52 (5) 257 1456
e-mail:	fmacias@netmex.com
URL:	http://www.pacomacias.com.mx
Biography:	*My speciality is photography in advertising and editorial. I'd rather start working with a concept than a layout –*

in that way I get my best photos. I search, experiment and find the unexpected. This is the most interesting act in the process of creation. Layouts – in a personal view – I see as a puzzle of pictures drawn by an art director taken from photo books. This way of work limits creativity in contemporary photography. I have 26 years experience as a professional photographer. My career began as a hobby and I went to a photography school back in 1970 for a one year course here in Mexico City. I'm 45 years old and run my own studio. I work with 4x5in, 6x6in and 35mm formats, on location or in the studio. My preferences are fashion, still lifes, effects and people. I consider myself as a photo-designer.

Beauty: p129

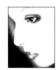

Photographer: **ANDRÉ MAIER**
Address: 104 SUFFOLK ST #12
NEW YORK
10002 USA
Telephone: +1 (212) 254 3229
Fax: +1 (212) 254 3229
e-mail: maier@artbox73.com
URL: http://www.artbox73.com/maier
Biography: *German photographer André Maier has studied professional photography at the London College of Printing in England and now lives and works in New York City. His diversity in style – from photojournalism and travel photography to conceptual portraiture – has earned him numerous exhibitions in Europe and New York. Through a collaboration with make-up artist Helene Gand, he is now concentrating on expressing creative ideas and concepts through full body make-up, original sets and some computer retouching. His clients include record companies, magazines and ad agencies.*

Beauty: p65

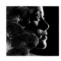

Photographer: **JULIA MARTINEZ**
Studio: VIVA PHOTOGRAPHY
Address: PORTMAN COTTAGE
2 PORT TERRACE
CHELTENHAM GL50 2NB
ENGLAND
Telephone: +44 (0) 1242 237914
Fax: +44 (0) 1242 252462
Mobile 0958 673035
Biography: *Since completing her photography degree and being sponsored by Kodak, Julia has now launched her own photographic business by the name of Viva Photography. She specialises in model portfolio shots, portraits and beauty photography commissions. She*

has also found that her career as a model has returned after shooting her own model portfolio. She now combines a career in front of and behind the lens, which makes life very confusing but always enlightening! She can be contacted for photographic commissions and model work at the number given.

Beauty: pp43, 53, 103, 143, 149

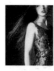
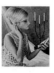

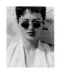
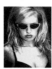

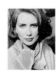

Photographer: **ENRIC MONTE**
Studio: ENRIC MONTE SL
Address: PREMIA 15-1
08014 BARCELONA
SPAIN
Telephone: +34 (3) 421 3978
Fax: +34 (3) 422 6633
Biography: *Specializes in photography for a commercial studio, but is currently taking a modern 250m² studio of his own.*

Beauty: p114

Photographer: **JAY MYRDAL**
Studio: JAM STUDIOS
Address: 11 LONDON MEWS
LONDON W2 1HY
Telephone: +44 (171) 262 7441
Fax: +44 (171) 262 7476
Biography: *An American working and living in London since the mid-1960s, Jay has worked in many areas of photography from editorial through rock and roll to advertising. His work remains wide-ranging, but he is best known for special effects and complicated shots; he works on a single image for many days if necessary. An extensive knowledge of practical electronics, computers, software and mathematics is brought into the service of photography when required, and he has a good working relationship with top-quality model-makers and post-production houses as well as working closely with third-party suppliers. In recent years he has acquired a powerful Dicomed computer platform to retouch and manipulate images in-house.*

Beauty: p90

Photographer: **SALVIO PARISI**
Address 1: VIA XX SETTEMBRE 127
20099 SESTO S. GIOVANNI
MILANO
ITALY
Telephone: +39 (2) 22 47 25 59
+39 (2) 48 95 27 16
Address 2: VIA MILISCOLA 2A TRAV. 31
80072 ARCO FELICE
NAPOLI
ITALY
Telephone: +39 (81) 866 3553
Fax: +39 (81) 866 1241
Address 3: VIA SAN CRISOGONO 40
00153 ROMA
ITALY
Telephone: +39 (6) 581 5207
Mobile: +39 336 694739
Biography: *According to the needs of commercial and editorial photography, which is what I mostly work with, I consider it essential for a photographer to always represent the "job-fiction" through his own style and in respect of (1) the main idea of the client and (2) the philosophy for a product or name and factory. Assuming this as basics, I always tend during my jobs to refer to a few fundamental "instruments" such as: a planning schedule, technical precision and overall the final aesthetic effect, in other words a professional working system.*

Beauty: pp23, 49, 85, 109, 131

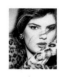
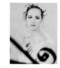

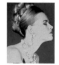

Photographer: **CHRIS ROUT**
Address: 9 HEYTHROP DRIVE
ACKLAM
MIDDLESBROUGH
CLEVELAND TS5 8QA
ENGLAND
Telephone: +44 (0) 1642 819774
Mobile: 0374 402675
Biography: *A trained commercial diver at 21, I trained as an underwater photographer and then progressed into freelance photography seven years ago. A successful professional photographer specialising in fashion and lifestyle stock photography, I am based in the*

*north-east of England. I have my own
studio and regularly take commissions
from magazines, advertising and
commercial clients.*
Beauty: pp25

Photographer: **ERIK RUSSELL**
Address: 48 COMPAYNE GARDENS
LONDON NW6 3RY
Telephone: +44 (171) 624 9788
Mobile: 0831 211823
Fax: +44 (171) 372 1445
Biography: *Scots-born Erik is passionate about
photography, Persian cats, Charles
Rennie Mackintosh, Apple Computers,
and Shirley!*
Beauty: pp79, 86

Photographer: **KAZUO SAKAI**
Studio: STUDIO CHIPS
Address: EDOBORI BUILDING 4F
1-25-26 EDOBORI
NISHI-KU
OSAKA 550
JAPAN
Telephone: +81 (6) 447 0719
Fax: +81 (6) 447 7509
Biography: *Born and raised in the Osaka area of
Japan. Independent "Studio Chips" since
1985. Traditional until 1992, now uses
both traditional and digital to achieve

Beauty: pp123, 139

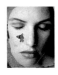 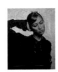

Photographer: **MYK SEMENYTSH**
Studio: PHOTOFIT PHOTOGRAPHY
ADDRESS: HAIGH PARK
HAIGH AVENUE
STOCKPORT
CHESHIRE SK4 1QR
ENGLAND
Telephone: +44 (161) 429 7188
Fax: +44 (161) 429 8037
Biography: *Cut teeth with "In camera effects"
without the nerve for retouching.
Thankfully someone invented the
Mackintosh. Now runs a busy
commercial studio in Cheshire, shooting
a variety of items from cars, trucks, room
sets, still lifes, etc. Also does creative
industrial/location photography. Currently
producing work for Reebok, GPT, Zenica,
Pickeneons, ICI, Medeva, Territorial Army.*
Beauty: p133

Photographer: **HOLLY STEWART**
Studio: HOLLY STEWART PHOTOGRAPHY
Address: 370 FOURTH STREET
SAN FRANCISCO
CALIFORNIA
USA 94107
Telephone: +1 (415) 777 1233
Fax: +1 (415) 777 2997
Beauty: pp28, 51, 105

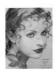 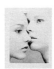

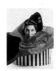

Photographer: **KIYOSHI TOGASHI**
Studio: TOGASHI STUDIOS INC.
Address: 36 WEST 20 ST
NEW YORK
10011 USA
Telephone: +1 (212) 929 2290
Fax: +1 (212) 463 9073
Agent: +1 (212) 420 0206
Fax: +1 (212) 420 0206
Biography: *Togashi was born and raised on a rice
farm in northern Japan, educated in
Tokyo and started from scratch as a
photo assistant in New York in 1975.
He has been an independent
commercial photographer since 1978.
His photography has been recognised
with a Clio award, Art Direction
Creativity awards in Print's Regional
Design Annual and the Art Directors'
Club Annual Exhibition. His clients
have included American Express,
AP & T, Avon, Bulgari Jewellers,
Chase Manhattan Bank, CPE Foods,
IBM, Iittala Crystal, US Postal Service
and Tourneau Watches. His individual
vision towards composition, detail and
colour make his images truly unique.*
Beauty: p99

Photographer: **GÜNTHER UTTENDORFER**
Studio: PHOTOGRAPHY AND VIDEO
Address: GELIUSTRASSE 9
12203 BERLIN
GERMANY
Telephone: +49 (30) 834 1214
Fax: +49 (30) 834 1214
Biography: *Self-employed for 11 years, now. I*

*moved to Berlin because this city gives
me great inspiration. My style of
photography nowadays shows my
affinity with shooting movies. If I'm
shooting girls I always try to get one
special side of their character into the
pictures.*
Beauty: p27, 63

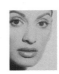 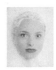

Photographer: **FRANK WARTENBERG**
Address: LEVERKUSENSTRASSE 25
HAMBURG
GERMANY
Telephone: +49 (40) 850 83 31
Fax: +49 (40) 850 39 91
Biography: *Frank began his career in photography
alongside a law degree, when he was
employed as a freelance photographer
to do concert photos. He was one of
the first photographers to take pictures
of The Police, The Cure and Pink Floyd
in Hamburg. After finishing the first
exam of his degree, he moved into the
area of fashion, working for two years as
an assistant photographer. Since 1990
he has run his own studio and is active
in international advertising and fashion
markets. He specialises in lighting
effects in his photography and also
produces black and white portraits and
erotic prints.*
Beauty: pp21, 30, 34–35, 40

 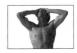

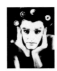 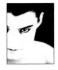

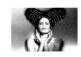

ACKNOWLEDGMENTS

First and foremost, many thanks to the photographers and their assistants who kindly shared their pictures, patiently supplied information and explained secrets, and generously responded with enthusiasm for the project. It would be invidious, not to say impossible, to single out individuals, since all have been unfailingly helpful and professional, and a pleasure to work with.

We should like to thank the manufacturers who supplied the lighting equipment illustrated at the beginning of the book: Photon Beard, Strobex, and Linhof and Professional Sales (importers of Hensel flash) as well as the other manufacturers who support and sponsor many of the photographers in this and other books.

Thanks also to Brian Morris, who devised the PRO-LIGHTING series, and to Anna Briffa, who eased the way throughout.